W. J. T. Mitchell

Iconology
Image, Text, Ideology

The University of Chicago Press
Chicago and London

W. J. T. MITCHELL is professor
in the Department of English Language and Literature,
the Committee on Art and Design,
and the College at the University of Chicago.
He is the editor of *Critical Inquiry*.

The University of Chicago Press, Chicago 60637
The University of Chicago Press, Ltd., London
© 1986 by The University of Chicago
All rights reserved. Published 1986
Printed in the United States of America

95 94 93 92 91 90 89 88 87 86 5 4 3 2 1

Library of Congress Cataloging in Publication Data

Mitchell, W. J. Thomas, 1942–
 Iconology : image, text, ideology.

 Bibliography: p.
 Includes index.
 1. Signs and symbols in art. 2. Art—Themes,
motives. I. Title.
N7565.M5 1986 704.9′4 85-1177
ISBN 0-226-53228-3

For
JOEL SNYDER

Contents

Acknowledgments

If I were to assemble a group portrait of all the people who had some-
thing to do with the writing of this book, it would probably resemble
one of Hogarth's mob scenes: a motley assembly of dignitaries, wits,
sparks, rakes, scholars, and students, some inebriated, most in a state of
distraction, many falling asleep, and some (the smallest group of all)
listening with intense and critical irritation. To this smallest group I feel
obliged to express some gratitude. Without their help, this book would
have been finished a lot sooner. My students and colleagues at the
University of Chicago, and especially the members of the Laocoon
Group from 1977 to 1985, listened patiently (sometimes) and critically
(always), helping this book disintegrate from a magisterial "Theory of
Imagery" (an "Iconology" in the proper sense) into a series of historical
essays. The members of my seminar at the 1983 School of Criticism and
Theory, especially Ellen Esrock and Herbert Hrachovec, showed me
what was missing from the argument. James Chandler and Elizabeth
Helsinger read the whole manuscript, explained to me what it was really
about, and why a third of it could be thrown away. James Heffernan
provided the most detailed and scrupulous reader's report I have ever
seen, correcting my dates, facts, reasoning, and spelling with merciless
accuracy. And many colleagues at the University of Chicago and else-
where read parts of the book and offered that most annoying of gifts,
"valuable advice." Charles Altieri, Ted Cohen, Gregory Colomb, Nelson
Goodman, Jean Hagstrum, Robert Nelson, Michael Riffaterre, Richard
Rorty, Edward Said, David Simpson and Catherine Elgin all read and
commented on various parts of the book, and it would no doubt be a
much better one if I could have taken all their suggestions. Joel Snyder
was present, in body or spirit, at the birth of just about every good idea in

the book. I would be happy to pin the blame on him for the bad ideas, too, and the best way to do this is to dedicate the book to him. The National Endowment for the Humanities provided me with a year to learn that a book like this could be written; the John Simon Guggenheim Memorial Foundation gave me a year to do the actual writing.

A version of Chapter 1 ("What Is an Image?") appeared in *New Literary History* 15:3 (Spring 1984), 503–37, and is used here with the kind permission of the editor, Ralph Cohen, and the Johns Hopkins University Press. Chapter 4 first appeared as "The Politics of Genre: Space and Time in Lessing's *Laocoon*," © 1984 by The Regents of the University of California and reprinted from *Representations* 6 (Spring 1984): 98–115, by permission of The Regents.

I must finally express something well beyond gratitude to my mother, whose values I have tried to reflect in this book, and to my wife, Janice, and my children, Carmen and Gabriel, who made all sorts of music to light up these blind reflections on images.

Introduction
Iconology

This is a book about the things people say about images. It is not primarily concerned with specific pictures and the things people say about them, but rather with the way we talk about the *idea* of imagery, and all its related notions of picturing, imagining, perceiving, likening, and imitating. It is a book about images, therefore, that has no illustrations except for a few schematic diagrams, a book about vision written as if by a blind author for a blind reader. If it contains any insight into real, material pictures, it is the sort that might come to a blind listener, overhearing the conversation of sighted speakers talking about images. My hypothesis is that such a listener might see patterns in these conversations that would be invisible to the sighted participant.

The book reflects on answers to two questions that come up regularly in these conversations: What is an image? What is the difference between images and words? It attempts to understand the traditional answers to these questions in relation to the human interests that give them urgency in particular situations. Why does it matter what an image is? What is at stake in marking off or erasing the differences between images and words? What are the systems of power and canons of value—that is, the ideologies—that inform the answers to these questions and make them matters of polemical dispute rather than purely theoretical interest?

I call these "essays in iconology" to restore something of the literal sense of this word. This is a study of the "logos" (the words, ideas, discourse, or "science") of "icons" (images, pictures, or likenesses). It is thus a "rhetoric of images" in a double sense: first, as a study of "what to say about images"—the tradition of "art writing" that goes back to Philostratus's *Imagines*, and is centrally concerned with the description and interpretation of visual art; and second, as a study of "what images

say"—that is, the ways in which they seem to speak for themselves by persuading, telling stories, or describing. I also use the term "iconology" to connect this study to a long tradition of theoretical and historical reflection on the notion of imagery, a tradition which in its narrow sense probably begins with Renaissance handbooks of symbolic imagery (the first of which, Cesare Ripa's *Iconologia* of 1592, was not illustrated) and culminates in Erwin Panofsky's renowned "studies" in iconology. In a broader sense, the critical study of the icon begins with the idea that human beings are created "in the image and likeness" of their creator and culminates, rather less grandly, in the modern science of "image-making" in advertising and propaganda. I will be concerned here with matters that lie somewhere between the broad and the narrow sense of iconology, with the ways that images in the strict or literal sense (pictures, statues, works of art) are related to notions such as mental imagery, verbal or literary imagery, and the concept of man as an image and maker of images. If Panofsky separated iconology from iconography by differentiating the interpretation of the total symbolic horizon of an image from the cataloguing of particular symbolic motifs, my aim here is to further generalize the interpretive ambitions of iconology by asking it to consider the idea of the image as such.

If all this sounds impossibly comprehensive, it may help to note that this study has very definite limits, both in terms of the questions it raises and the body of texts it considers. Except for the first chapter this is primarily a series of close readings of a few important texts in the theory of imagery, and these readings revolve around two historical centers, one in the late eighteenth century (roughly, the era of the French Revolution and the rise of Romanticism), and other in the era of modern criticism. The aim of these readings is to show how the notion of imagery serves as a kind of relay connecting theories of art, language, and the mind with conceptions of social, cultural, and political value.

These connections will lead me down a number of byways that may seem at first glance quite unrelated: Wittgenstein's critique of the "picture theory" of meaning and modern theories of poetry and mental imagery; Nelson Goodman's critique of "iconicity" in relation to semiotics; Ernst Gombrich's argument for the naturalness of imagery, and "nature" as an ideological category; Lessing's attempt to pronounce the generic laws separating poetry from painting, and German cultural independence; Burke's aesthetics of the sublime and the beautiful in relation to his critique of the French Revolution; Marx's use of the

camera obscura and the fetish as figures for the psychological and material "idols" of capitalism. The convening of this seemingly disparate assembly of writers helps us to see a number of surprising conjunctions that are not generally noted by intellectual historians: the connection between the "rhetoric of iconoclasm" that pervades Western criticism and the controversy over mental imagery in modern psychology; the link between modern semiotic theory and Hume's laws of association; the polemic against the "fascist" implications of "spatial form" in modern aesthetics and the authority of Lessing's *Laocoon*; the *ut pictura poesis* controversy and the battle of sexes, nations, and religious traditions since the Enlightenment.

My only apology for these strange conjunctions of topics and texts is that they seemed to surface as I pursued the theoretical questions that inspired the study in the first place. Every theoretical answer to the questions, What is an image? How are images different from words? seemed inevitably to fall back into prior questions of value and interest that could only be answered in historical terms. The simplest way of stating this is to admit that a book which began with the intention of producing a valid *theory* of images became a book about the *fear* of images. "Iconology" turned out to be, not just the science of icons, but the political psychology of icons, the study of iconophobia, iconophilia, and the struggle between iconoclasm and idolatry. The movement of this book is thus from modern attempts to establish a true theory of imagery (Gombrich, Goodman, the early Wittgenstein) to the "classic" accounts of imagery these theories sought to replace. In the process, my theoretical ambitions have inevitably been chastened by my narrow limits as an intellectual historian. My hope is that this critical fall into the space between theory and history will open up a region for other scholars to explore, and that it will suggest something about the necessary limits of any attempt to provide a theoretical account of symbolic practices.

Since the subtitle of this book is "Image, Text, Ideology," it might be useful to say a word about these terms. "Imagery" is the main topic of the whole book, so I won't attempt to define it here, other than to say that I have tried not to rule out any widely used sense of the term. "Textuality," on the other hand, I have treated in a relatively cavalier and unsophisticated fashion: its role in this study is simply as a foil to imagery, a "significant other" or rival mode of representation. "Ideology," finally, I have used in a deliberately ambiguous sense, to play off what I take to be a kind of doubleness in its historical usage in Marxist criticism. The

orthodox view is that ideology is false consciousness, a system of symbolic representations that reflects an historical situation of domination by a particular class, and which serves to conceal the historical character and class bias of that system under guises of naturalness and universality. The other meaning of "ideology" tends to identify it simply with the structure of values and interests that informs any representation of reality; this meaning leaves untouched the question of whether the representation is false or oppressive. In this formulation, there would be no such thing as a position outside ideology; even the most "demystified" critic of ideology would have to admit that he occupies some position of value and interest, and that socialism (for instance) is as much an ideology as capitalism.

I would like to keep both these meanings of ideology in play in this book in order to preserve and perhaps to confront certain values that seem to be entailed by each of them. Simply to work with the neutral account of ideology as a system of beliefs and interests is to forsake the critical force of the notion, its ability to mobilize interpretation, the uncovering of that which is hidden. The notion of ideology as false consciousness involves a salutary skepticism about explicit motives, rationalizations, and claims for various sorts of naturalness, purity, or necessity. The drawback of this notion, on the other hand, is that it can lead the critic of ideology into the illusion that he has no illusions, that he stands outside history, or "for" history as the agent of its inexorable laws. My notion of ideology, then, will attempt to play both sides of this street, using the interpretive procedures of ideological analysis to reveal the blind spots in various texts, but also using those procedures to criticize the very concept of ideology itself. As it happens, the notion of ideology is rooted in the concept of imagery, and reenacts the ancient struggles of iconoclasm, idolatry, and fetishism. Those struggles will be the subject of the final chapter of this book.

Part One
The Idea of Imagery

It is one thing . . . to apprehend directly an image as image, and
another thing to shape ideas regarding the nature of images in
general.

Jean-Paul Sartre, *Imagination* (1962)

Any attempt to grasp "the idea of imagery" is fated to wrestle with the
problem of recursive thinking, for the very idea of an "idea" is bound up
with the notion of imagery. "Idea" comes from the Greek verb "to see,"
and is frequently linked with the notion of the "eidolon," the "visible
image" that is fundamental to ancient optics and theories of perception.
A sensible way to avoid the temptation of thinking about images in terms
of images would be to replace the word "idea" in discussions of imagery
with some other term like "concept" or "notion," or to stipulate at the
outset that the term "idea" is to be understood as something quite
different from imagery or pictures. This is the strategy of the Platonic
tradition, which distinguishes the *eidos* from the *eidolon* by conceiving of
the former as a "suprasensible reality" of "forms, types, or species," the
latter as a sensible impression that provides a mere "likeness" (*eikon*) or
"semblance" (*phantasma*) of the *eidos*.[1]

A less prudent, but I hope more imaginative and productive, way of
dealing with this problem is to give in to the temptation to see ideas as
images, and to allow the recursive problem full play. This involves
attention to the way in which images (and ideas) double themselves: the
way we depict the act of picturing, imagine the activity of imagination,
figure the practice of figuration. These doubled pictures, images, and

1. See F. E. Peters, *Greek Philosophical Terms: A Historical Lexicon* (New York: New
York University Press, 1967).

5

figures (what I will refer to—as rarely as possible—as "hypericons") are strategies for both giving into and resisting the temptation to see ideas as images. Plato's cave, Aristotle's wax tablet, Locke's dark room, Wittgenstein's hieroglyphic are all examples of the "hypericon" that, along with the popular trope of the "mirror of nature," provide our models for thinking about all sorts of images—mental, verbal, pictorial, and perceptual. They also provide, I will argue, the scenes in which our anxieties about images can express themselves in a variety of iconoclastic discourses, and in which we can rationalize the claim that, whatever images are, ideas are something else.

I

What Is an Image?

There have been times when the question "What is an image?" was a matter of some urgency. In eighth- and ninth-century Byzantium, for instance, your answer would have immediately identified you as a partisan in the struggle between emperor and patriarch, as a radical iconoclast seeking to purify the church of idolatry, or a conservative iconophile seeking to preserve traditional liturgical practices. The conflict over the nature and use of icons, on the surface a dispute about fine points in religious ritual and the meaning of symbols, was actually, as Jaroslav Pelikan points out, "a social movement in disguise" that "used doctrinal vocabulary to rationalize an essentially political conflict."[1] In mid-seventeenth-century England the connection between social movements, political causes, and the nature of imagery was, by contrast, quite undisguised. It is perhaps only a slight exaggeration to say that the English Civil War was fought over the issue of images, and not just the question of statues and other material symbols in religious ritual but less tangible matters such as the "idol" of monarchy and, beyond that, the "idols of the mind" that Reformation thinkers sought to purge in themselves and others.[2]

If the stakes seem a bit lower in asking what images are today, it is not because they have lost their power over us, and certainly not because their nature is now clearly understood. It is a commonplace of modern

1. See Pelikan, *The Christian Tradition*, 5 vols. (Chicago: University of Chicago Press, 1974–), vol. 2, chap. 3, for an account of the iconoclastic controversy in Eastern Christendom.

2. See Christopher Hill's chapter on "*Eikonoklastes* and Idolatry" in his *Milton and the English Revolution* (Harmondsworth: Penguin Books, 1977), 171–81, for an introduction to this problem.

cultural criticism that images have a power in our world undreamed of by the ancient idolaters.[3] And it seems equally evident that the question of the nature of imagery has been second only to the problem of language in the evolution of modern criticism. If linguistics has its Saussure and Chomsky, iconology has its Panofsky and Gombrich. But the presence of these great synthesizers should not be taken as a sign that the riddles of language or imagery are finally about to be solved. The situation is precisely the reverse: language and imagery are no longer what they promised to be for critics and philosophers of the Enlightenment—perfect, transparent media through which reality may be represented to the understanding. For modern criticism, language and imagery have become enigmas, problems to be explained, prison-houses which lock the understanding away from the world. The commonplace of modern studies of images, in fact, is that they must be understood as a kind of language; instead of providing a transparent window on the world, images are now regarded as the sort of sign that presents a deceptive appearance of naturalness and transparence concealing an opaque, distorting, arbitrary mechanism of representation, a process of ideological mystification.[4]

My purpose in this chapter is neither to advance the theoretical understanding of the image nor to add yet another critique of modern idolatry to the growing collection of iconoclastic polemics. My aim is rather to survey some of what Wittgenstein would call the "language games" that we play with the notion of images, and to suggest some questions about the historical forms of life that sustain those games. I

3. Susan Sontag gives eloquent expression to many of these commonplaces in *On Photography* (New York: Farrar, Straus and Giroux, 1977), a book that would more accurately be titled, "Against Photography." Sontag opens her discussion of photography by noting that "humankind lingers unregenerately in Plato's cave, still reveling, its age-old habit, in mere images of the truth" (p. 3). Photographic images, Sontag concludes, are even more threatening than the artisanal images Plato contended with because they are "potent means for turning the tables on reality—for turning *it* into a shadow" (180). Other important critiques of modern imagery and ideology include Walter Benjamin's "The Work of Art in the Age of Mechanical Reproduction," in *Illuminations*, ed. Hannah Arendt (New York: Schocken Books, 1969), 217–51, Daniel J. Boorstin's *The Image* (New York: Harper & Row, 1961), Roland Barthes, "The Rhetoric of the Image," in *Image/Music/Text*, trans. Stephen Heath (New York: Hill & Wang, 1977, 32–51), and Bill Nichols, *Ideology and the Image* (Bloomington: Indiana University Press, 1981).

4. For a compendium of recent work predicated on the notion that images are a kind of language, see *The Language of Images*, ed. W. J. T. Mitchell (Chicago: University of Chicago Press, 1980).

don't propose, therefore, to produce a new or better definition of the essential nature of images, or even to examine any specific pictures or works of art. My procedure instead will be to examine some of the ways we use the word "image" in a number of institutionalized discourses—particularly literary criticism, art history, theology, and philosophy—and to criticize the ways each of these disciplines makes use of notions of imagery borrowed from its neighbors. My aim is to open up for inquiry the ways our "theoretical" understanding of imagery grounds itself in social and cultural practices, and in a history fundamental to our understanding not only of what images are but of what human nature is or might become. Images are not just a particular kind of sign, but something like an actor on the historical stage, a presence or character endowed with legendary status, a history that parallels and participates in the stories we tell ourselves about our own evolution from creatures "made in the image" of a creator, to creatures who make themselves and their world in their own image.

The Family of Images

Two things must immediately strike the notice of anyone who tries to take a general view of the phenomena called by the name of imagery. The first is simply the wide variety of things that go by this name. We speak of pictures, statues, optical illusions, maps, diagrams, dreams, hallucinations, spectacles, projections, poems, patterns, memories, and even ideas as images, and the sheer diversity of this list would seem to make any systematic, unified understanding impossible. The second thing that may strike us is that the calling of all these things by the name of "image" does not necessarily mean that they all have something in common. It might be better to begin by thinking of images as a far-flung family which has migrated in time and space and undergone profound mutations in the process.

If images are a family, however, it may be possible to construct some sense of their genealogy. If we begin by looking, not for some universal definition of the term, but at those places where images have differentiated themselves from one another on the basis of boundaries between different institutional discourses, we come up with a family tree something like the following:

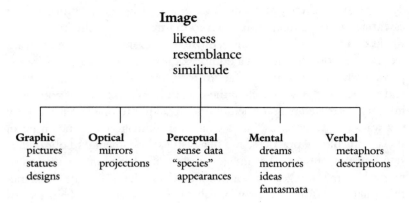

Image
likeness
resemblance
similitude

Graphic	**Optical**	**Perceptual**	**Mental**	**Verbal**
pictures	mirrors	sense data	dreams	metaphors
statues	projections	"species"	memories	descriptions
designs		appearances	ideas	
			fantasmata	

Each branch of this family tree designates a type of imagery that is central to the discourse of some intellectual discipline: mental imagery belongs to psychology and epistemology; optical imagery to physics; graphic, sculptural, and architectural imagery to the art historian; verbal imagery to the literary critic; perceptual images occupy a kind of border region where physiologists, neurologists, psychologists, art historians, and students of optics find themselves collaborating with philosophers and literary critics. This is the region occupied by a number of strange creatures that haunt the border between physical and psychological accounts of imagery: the "species" or "sensible forms" which (according to Aristotle) emanate from objects and imprint themselves on the wax-like receptacles of our senses like a signet ring;[5] the *fantasmata*, which are revived versions of those impressions called up by the imagination in the absence of the objects that originally stimulated them; "sense data" or "percepts" which play a roughly analogous role in modern psychology; and finally, those "appearances" which (in common parlance) intrude between ouselves and reality, and which we so often refer to as "images"—from the image projected by a skilled actor, to those created for products and personages by experts in advertising and propaganda.

The history of optical theory abounds with these intermediate agencies that stand between us and the objects we perceive. Sometimes, as in the Platonic doctrine of "visual fire" and the atomistic theory of *eidola* or *simulacra*, they are understood as material emanations from objects,

5. *De Anima* II.12.424a; W. S. Hett, trans. (Cambridge: Harvard University Press, 1957), 137.

subtle but nevertheless substantial images propagated by objects and forcibly impressing themselves on our senses. Sometimes the species are regarded as merely formal entities, without substance, propagated through an immaterial medium. And some theories even describe the transmission as moving in the other direction, from our eyes to the objects. Roger Bacon provides a good synthesis of the common assumptions of ancient optical theory:

> Every efficient cause acts through its own power, which it
> exercises on the adjacent matter, as the light [*lux*] of the sun
> exercises its power on the air (which power is light [*lumen*]
> diffused through the whole world from the solar light [*lux*]).
> And this power is called "likeness," "image," and "species"
> and is designated by many other names. . . . This species
> produces every action in the world, for it acts on sense, on
> the intellect, and on all matter of the world for the genera-
> tion of things.[6]

It should be clear from Bacon's account that the image is not simply a particular kind of sign but a fundamental principle of what Michel Foucault would call "the order of things." The image is the general notion, ramified in various specific similitudes (*convenientia, aemulatio, analogy, sympathy*) that holds the world together with "figures of knowledge."[7] Presiding over all the special cases of imagery, therefore, I locate a parent concept, the notion of the image "as such," the phenomenon whose appropriate institutional discourses are philosophy and theology.

Now each of these disciplines has produced a vast literature on the function of images in its own domain, a situation that tends to intimidate anyone who tries to take an overview of the problem. There are encouraging precedents in work that brings together different disciplines concerned with imagery, such as Gombrich's studies of pictorial imagery in terms of perception and optics, or Jean Hagstrum's inquiries into the sister arts of poetry and painting. In general, however, accounts of any one kind of image tend to relegate the others to the status of an unex-

6. Quoted in David C. Lindberg, *Theories of Vision from Al-Kindi to Kepler* (Chicago: University of Chicago Press, 1976), 113.
7. See Foucault, *The Order of Things: An Archaeology of the Human Sciences* (New York: Random House, 1970), chap. 2.

amined "background" to the main subject. If there is a unified study of imagery, a coherent iconology, it threatens to behave, as Panofsky warned, "not like ethnology as opposed to ethnography, but like astrology as opposed to astrography."[8] Discussions of poetic imagery generally rely on a theory of the mental image improvised out of the shreds of seventeenth-century notions of the mind;[9] discussions of mental imagery depend in turn upon rather limited acquaintance with graphic imagery, often proceeding on the questionable assumption that there are certain kinds of images (photographs, mirror images) that provide a direct, unmediated copy of what they represent;[10] optical analyses of mirror images resolutely ignore the question of what sort of creature is capable of using a mirror; and discussions of graphic images tend to be insulated by the parochialism of art history from excessive contact with the broader issues of theory or intellectual history. It would seem useful, therefore, to attempt an overview of the image that scrutinizes the boundary lines we draw between different kinds of images, and criticizes the assumptions which each of these disciplines makes about the nature of images in neighboring fields.

We clearly cannot talk about all these topics at once, so the next question is where to start. The general rule is to begin with the basic, obvious facts and to work from there into the dubious or problematic. We might start, then, by asking which members of the family of images are called by that name in a strict, proper, or literal sense, and which kinds involve some extended, figurative, or improper use of the term. It is hard

8. *Meaning in the Visual Arts* (Garden City, N.Y.: Doubleday, 1955), 32.

9. The entry on "Imagery" in *The Princeton Encyclopedia of Poetry and Poetics* (Princeton: Princeton University Press, 1974), begins with a definition that could have come straight from Locke: "an image is a reproduction in the mind of a sensation produced by a physical perception."

10. I will have more to say about the fallacy of the "copy theory" of mental imagery in what follows. For the present, it might be helpful to note that both critics and proponents of mental imagery have fallen into this fallacy when it serves the purposes of their arguments. Proponents of mental imagery see the copy theory as a guarantee of the cognitive efficacy of mental images; true ideas are regarded as faithful copies that "reflect" the objects they represent. Opponents have used this doctrine as a straw man for debunking mental images, or for claiming that mental images must be quite unlike "real images" which (so the argument goes) "resemble" what they represent. For a good introduction to the debate between modern iconophiles and iconophobes in psychology, see *Imagery,* ed. Ned Block (Cambridge: MIT Press, 1981). The best critique of the copy theory is provided by Nelson Goodman in *Languages of Art* (Indianapolis: Hackett, 1976), discussed below in chapter 2.

to resist the conclusion that the image "proper" is the sort of thing we found on the left side of our tree-diagram, the graphic or optical representations we see displayed in an objective, publicly shareable space. We might want to argue about the status of certain special cases and ask whether abstract, nonrepresentational paintings, ornamental or structural designs, diagrams and graphs are properly understood as images. But whatever borderline cases we might wish to consider, it seems fair to say that we have a rough idea about what images are in the literal sense of the word. And along with this rough idea goes a sense that other uses of the word are figurative and improper.

The mental and verbal images on the right side of our diagram, for instance, would seem to be images only in some doubtful, metaphoric sense. People may report experiencing images in their heads while reading or dreaming, but we have only their word for this; there is no way (so the argument goes) to check up on this objectively. And even if we trust the reports of mental imagery, it seems clear that they must be different from real, material pictures. Mental images don't seem to be stable and permanent the way real images are, and they vary from one person to the next: if I say "green," some listeners may see green in their mind's eye, but some may see a word, or nothing at all. And mental images don't seem to be exclusively visual the way real pictures are; they involve all the senses. Verbal imagery, moreover, can involve all the senses, or it may involve no sensory component at all, sometimes suggesting nothing more than a recurrent abstract idea like justice or grace or evil. It is no wonder that literary scholars get very nervous when people start taking the notion of verbal imagery too literally.[11] And it is hardly surprising that one of the main thrusts of modern psychology and philosophy has been to discredit the notions of both mental and verbal imagery.[12]

Eventually I will argue that all three of these commonplace contrasts between images "proper" and their illegitimate offspring are suspect. That is, I hope to show that, contrary to common belief, images

11. For the most exhaustive case against the propriety of the notion of literary imagery, see P. N. Furbank, *Reflections on the Word 'Image'* (London: Secker & Warburg, 1970). Furbank debunks all notions of mental and verbal imagery as illegitimate metaphors, and argues that we should confine ouselves to "the natural sense of the word 'image', as meaning a likeness, a picture, or a simulacrum" (1).

12. Mental imagery has, however, been making a comeback. As Ned Block observes, "after fifty years of neglect during the heyday of behaviorism, mental imagery is once again a topic of research in psychology" (*Imagery,* 1).

"proper" are not stable, static, or permanent in any metaphysical sense; they are not perceived in the same way by viewers any more than are dream images; and they are not exclusively visual in any important way, but involve multisensory apprehension and interpretation. Real, proper images have more in common with their bastard children than they might like to admit. But for the moment let us take these proprieties at face value, and examine the genealogy of those illegitimate notions, images in the mind and images in language.

The Mental Image: A Wittgensteinian Critique

> Now for the thinking soul images take the place of direct perceptions; and when it asserts or denies that they are good or bad, it avoids or pursues them. Hence the soul never thinks without a mental image.
>
> Aristotle, *De Anima* III.7.431a

A notion with the entrenched authority of three hundred years of institutionalized research and speculation behind it is not going to give up without a struggle. Mental imagery has been a central feature of theories of the mind at least since Aristotle's *De Anima,* and it continues to be a cornerstone of psychoanalysis, experimental studies of perception, and popular folk-beliefs about the mind.[13] The status of mental

13. Plato compares memory images to impressions in a wax tablet in the *Theaetatus,* and his theory of Forms is often invoked in support of innate or archetypal images in the mind. Empirical studies of mental imagery have generally followed the Aristotelian tradition, inaugurated in the *De Anima*'s account of perception: "sense is that which is receptive of the form of sensible objects without the matter, just as the wax receives the impression of the signet ring without the iron or the gold" (II.12.424a). Imagination for Aristotle is the power of reproducing these impressions in the absence of sensory stimulation by the objects, and it is given the name of "phantasia" (derived from the word for light) because "sight is the most highly developed sense" and serves as the model for all the others. While various features of this model were questioned, its fundamental assumptions remained in force through the eighteenth century. Hobbes, for instance, debunks the Aristotelian notion of the "visible species," which plays the role of the signet ring in sensory impressions, but accepts the notion of imagination as decaying sense (see *Leviathan,* chaps. I and II). Locke acknowledges the similarity between his views of perception and those of Aristotle in his *Examination of P. Malebranche's Opinion* (1706). The first real opponent of mental imagery, the Scottish philosopher Thomas Reid, regarded Aristotle's doctrine of the phantasm as the beginning (to quote Richard Rorty's summary), of "the descent down

representation in general, and the mental image in particular, has been one of the main battlegrounds of modern theories of the mind. A good index of the strengths on both sides of this issue is the fact that the most formidable critic of mental imagery in our time developed a "picture theory" of meaning as the keystone of his early work, and then spent the rest of his life fighting against the influence of his own theory, trying to expel the notion of mental imagery along with all its metaphysical baggage.[14]

Wittgenstein's way of attacking mental imagery is not, however, the direct strategy of denying the existence of such images. He freely concedes that we may have mental images associated with thought or speech, insisting only that these images should not be thought of as private, metaphysical, immaterial entities any more than real images are. Wittgenstein's tactic is to demystify the mental image by bringing it right out in the open where we can see it: "Mental images of colours, shapes, sounds, etc., etc., which play a role in communication by means of language we put in the same category with patches of color actually seen, sounds heard."[15] It is a bit hard, however, to see how we can put mental and physical images "in the same category." We certainly can't do it by cutting open someone's head to compare mental pictures with the ones on our walls. A better strategy, and more in the Wittgensteinian spirit, would be to examine the ways we put those images "into our heads" in the first place by trying to picture the sort of world in which this move would make sense. I offer the figure on the next page as just such a picture.

The figure should be read as a palimpsest displaying three overlapping relationships: (1) between a real object (the candle on the left) and a reflected, projected, or depicted image of that object; (2) between a real object and a mental image in a mind conceived (as in Aristotle, Hobbes,

the slippery slope which led to Hume." See Rorty's *Philosophy and the Mirror of Nature* (Princeton: Princeton University Press, 1979), 144.

14. Wittgenstein elaborated the picture theory in his *Tractatus Logico-Philosophicus* (first German edition, 1921) and is generally regarded as abandoning it in the work which leads up to the *Philosophical Investigations* (1953). My argument here will be that Wittgenstein's picture theory is quite compatible with his critique of mental imagery, and that he was primarily concerned to correct misinterpretation of the picture theory, particularly the sort which linked it to the empiricist account of perceptual images, or the positivist notion of an ideal language.

15. *The Blue and Brown Books* (New York: Harper & Brothers, 1958), 89.

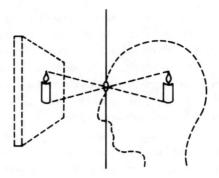

Locke, or Hume) as a mirror, *camera obscura,* or a surface for drawing or printing; (3) between a material image and a mental one. (It may help here to imagine the diagram as three overlapping transparencies, the first showing just the two candles, the left one real, the right one an image; the second adding the human head to show the mental introjection of the depicted or reflected candle; the third adding the frame around the "real" candle to make it mirror the imaginary status of the candle on the right. I assume, for simplicity, that all optical inversions have been rectified.) What the diagram displays as a whole is the matrix of analogies (particularly ocular metaphors) that govern representational theories of the mind. In particular it shows how the classic divisions of Western metaphysics (mind-matter, subject-object) translate into a model of representation, the relation between visual images and the objects they stand for. Consciousness itself is understood as an activity of pictorial production, reproduction, and representation governed by mechanisms such as lenses, receptive surfaces, and agencies for printing, impressing, or leaving traces on these surfaces.

This model is clearly subject to a wide variety of objections: it absorbs all perception and consciousness into the visual and pictorial paradigm; it posits a relation of absolute symmetry and similitude between mind and the world; and it affirms the possibility of a point by point identity between object and image, worldly phenomena and representation in the mind or in graphic symbols. I present this model graphically, not to argue for its rightness, but to make visible the way we divide up our universe in common parlance, especially in that parlance that takes sensory experience as the basis for all knowledge. The model also pro-

vides us with a way of taking literally Wittgenstein's advice to put mental and physical images "in the same category," and helps us to see the reciprocity and interdependence of these two notions.

Let me put this a slightly different way. If the half of the sketch here represented as "mind"—i.e., my mind, yours, all human consciousness—were to be annihilated, the physical world, we tend to assume, would continue to exist quite nicely. But the reverse would not be the case: if the world were annihilated, consciousness would not go on (this, by the way, is what is misleading about the symmetry of the model). When we take the model, however, as an account of the way we talk about imagery, then the symmetry is not so misleading. If there were no more minds, there would be no more images, mental or material. The world may not depend upon consciousness, but images in (not to mention *of*) the world clearly do. And this is not just because it takes human hands to make a picture or a mirror or any other kind of simulacrum (animals are capable of presenting images in some sense when they camouflage themselves or imitate one another). It is because an image cannot be seen *as such* without a paradoxical trick of consciousness, an ability to see something as "there" and "not there" at the same time. When a duck responds to a decoy, or when the birds peck at the grapes in the legendary paintings of Zeuxis, they are not seeing images: they are seeing other ducks, or real grapes—the things themselves, and not images of the things.

But if the key to the recognition of real, material images in the world is our curious ability to say "there" and "not there" at the same time, we must then ask why mental images should be seen as any more—or less—mysterious than "real" images. The problem philosophers and ordinary people have always had with the notion of mental images is that they seem to have a universal basis in real, shared experience (we all dream, visualize, and are capable, in varying degrees, of re-presenting concrete sensations to ourselves), but we cannot point to them and say "There—that is a mental image." Exactly the same sort of problem occurs, however, if I try to point to a real image and explain what it is to someone who doesn't already know what an image is. I point at Xeuxis's painting and say "There, that is an image." And the reply is, "Do you mean that colored surface?" Or "Do you mean those grapes?"

When we say, then, that the mind is like a mirror or drawing surface, we inevitably postulate another mind to draw or decipher the pictures in it. But it must be understood that the metaphor cuts the other way at the

same time: the physical "blank slate" on the classroom wall, the mirror in my vestibule, the page before me are what they are because the mind uses them to represent the world, and itself, to itself. If we begin talking as if the mind is a tabula rasa or a camera obscura, it won't be long before the blank page and the camera begin to have minds of their own, and become sites of consciousness in their own right.[16]

This is not to be taken as a claim that the mind really is a blank slate or a mirror—only that these are ways the mind is capable of picturing itself. It might picture itself in other ways: as a building, a statue, as an invisible gas or fluid, as a text, a narrative, or a melody, or as nothing in particular. It might decline to have a picture of itself, and refuse all self-representation, just as we can look at a picture, a statue, or a mirror and not see it as a representational object. We might look at mirrors as shiny vertical objects, paintings as masses of colors on flat surfaces. There is no rule that the mind has to picture itself, or see pictures in itself, any more than there is a rule that we must go into a picture gallery, or that once inside we must look at the pictures. If we eliminate the notion that there is something necessary, natural, or automatic about the formation of both mental and material images, then we can do as Wittgenstein suggests, and put them "in the same category" as functional symbols, or, as in our model, in the same logical space.[17] This does not eliminate all differences between mental and physical images, but it may help to demystify the metaphysical or occult quality of this difference, and to allay our suspicion that mental images are somehow improper or illegitimately modeled on the "real thing." The path of derivation from original model to illegitimate analogy could as easily be traced in the opposite

16. This sort of reciprocity between our picture of material signs and mental activity is described aptly by Aristotle when he says that "what the mind thinks must be in it in the same sense as letters are on a tablet which bears no actual writing" (*De Anima* III.4.430a. Ideas, images, "what the mind thinks" (or what it "thinks *in*") are no more "in" the mind than the words on this page are "on" it prior to being printed there.

17. My argument here runs parallel to Jerry Fodor's in *The Language of Thought* (New York: Crowell, 1975). Fodor discusses the many decisive arguments against the "ur-doctrine" of mental imagery in empiricism, focussing particularly on the notion that "thoughts are mental images and they refer to their objects just insofar as (and just by virtue of the fact that) they resemble them." As Fodor points out, the fact that there are strong arguments against this doctrine does not tell against other hypotheses that would not base the notion of mental imagery in a "copy" theory, but would regard images as conventional signs that must be interpreted in a cultural framework. See 174ff. for Fodor's discussion of these issues.

direction. Wittgenstein may say that "we could perfectly well . . . replace every process of imagining by a process of looking at an object or any painting, drawing, or modelling; and every process of speaking to oneself by speaking aloud or by writing,"[18] but this "replacement" could (and does) move in the other direction as well. We could just as easily replace what we call "the physical manipulation of signs" (painting, writing, speaking) with locutions such as "thinking on paper, out loud, in images, etc."

A good way to clarify the relation of mental and physical images is to reflect on the way we have just used a diagram to illustrate the matrix of analogies that connects theories of representation to theories of mind. We might be tempted to say that a mental version of this diagram was in our heads all along, before it appeared on the page, and that it was governing the way we discussed the boundary between mental and physical images. Well, perhaps it was; or perhaps it only occurred to us at a certain point in the discussion, when we began to use words like "boundary line" and "realm." Or perhaps it never occurred to us at all while thinking about these things or writing them down, and it was only later, after many revisions, that it came to mind. Does that mean that the mental diagram was there all along as a kind of unconscious deep structure determining our usage of the word "image"? Or is it a posterior construction, a graphic projection of the logical space implied in our propositions about imagery? In either case we certainly cannot regard the diagram as something mental in the sense of "private" or "subjective"; it is rather something that surfaced in language, and not just my language, but a way of speaking that we inherit from a long tradition of talking about minds and pictures. Our diagram might just as well be called a "verbal image" as a mental one, which brings us to that other notoriously illegitimate branch in the family tree of imagery, the notion of imagery in language.

A Short History of Verbal Imagery

Thoughts are the images of things, as words are of thoughts; and we all know that images and pictures are only so far true as they are true representations of men and things. . . . For poets as well as

18. *The Blue and Brown Books,* 4.

painters think it their business to take the likeness of things from
their appearance."

Joseph Trapp, *Lectures on Poetry* (1711)[19]

It is no more necessary to the understanding of a proposition that
one should imagine anything in connexion with it, than that one
should make a sketch from it.

Wittgenstein, *Philosophical Investigations,* no. 396 [20]

In contrast to mental imagery, verbal images seem immune to the charge
of being unknowable metaphysical entities locked away in a private,
subjective space. Texts and speech-acts are, after all, not simply affairs of
"consciousness," but are public expressions that belong right out there
with all the other kinds of material representations we create—pictures,
statues, graphs, maps, etc. We don't have to say that a descriptive
paragraph is exactly like a picture to see that they do have similar
functions as public symbols that project states of affairs about which we
can reach rough, provisional agreements.

One of the strongest claims for the propriety of the notion of verbal
imagery appears ironically enough in the early Wittgenstein's claim that
"A proposition is a picture of reality . . . a model of reality as we imagine
it," and that this is no metaphor but a matter of "ordinary sense":

At first sight a proposition—one set out on the printed
page, for example—does not seem to be a picture of the
reality with which it is concerned. But neither do written
notes seem at first sight to be a picture of a piece of music,
nor our phonetic notation (the alphabet) to be a picture of
our speech. And yet these sign languages prove to be pic-
tures, even in the ordinary sense, of what they represent."
(*Tractatus,* 4.01)

This "ordinary sense" turns out to be just that: Wittgenstein goes on to
claim that a proposition is "a likeness of what is signified (4.012), and
suggests that "in order to understand the essential nature of a proposi-
tion, we should consider hieroglyphic script, which depicts the facts that
it describes" (4.106). It is important to realize that the "pictures" that

19. From Lecture VIII: "Of the Beauty of Thought in Poetry," trans. William Clarke
and William Bowyer (London, 1742). Quoted from Scott Elledge, ed., *Eighteenth Century
Critical Essays,* 2 vols. (Ithaca, N.Y.: Cornell University Press, 1961), 1:230–31.
20. Trans. G. E. M. Anscombe (New York: Macmillan, 1953), 120.

direction. Wittgenstein may say that "we could perfectly well . . . replace every process of imagining by a process of looking at an object or any painting, drawing, or modelling; and every process of speaking to one-self by speaking aloud or by writing,"[18] but this "replacement" could (and does) move in the other direction as well. We could just as easily replace what we call "the physical manipulation of signs" (painting, writing, speaking) with locutions such as "thinking on paper, out loud, in images, etc."

A good way to clarify the relation of mental and physical images is to reflect on the way we have just used a diagram to illustrate the matrix of analogies that connects theories of representation to theories of mind. We might be tempted to say that a mental version of this diagram was in our heads all along, before it appeared on the page, and that it was governing the way we discussed the boundary between mental and physical images. Well, perhaps it was; or perhaps it only occurred to us at a certain point in the discussion, when we began to use words like "boundary line" and "realm." Or perhaps it never occurred to us at all while thinking about these things or writing them down, and it was only later, after many revisions, that it came to mind. Does that mean that the mental diagram was there all along as a kind of unconscious deep structure determining our usage of the word "image"? Or is it a posterior construction, a graphic projection of the logical space implied in our propositions about imagery? In either case we certainly cannot regard the diagram as something mental in the sense of "private" or "subjec-tive"; it is rather something that surfaced in language, and not just my language, but a way of speaking that we inherit from a long tradition of talking about minds and pictures. Our diagram might just as well be called a "verbal image" as a mental one, which brings us to that other notoriously illegitimate branch in the family tree of imagery, the notion of imagery in language.

A Short History of Verbal Imagery

Thoughts are the images of things, as words are of thoughts; and we all know that images and pictures are only so far true as they are true representations of men and things. . . . For poets as well as

18. *The Blue and Brown Books*, 4.

painters think it their business to take the likeness of things from their appearance."

Joseph Trapp, *Lectures on Poetry* (1711)[19]

It is no more necessary to the understanding of a proposition that one should imagine anything in connexion with it, than that one should make a sketch from it.

Wittgenstein, *Philosophical Investigations,* no. 396 [20]

In contrast to mental imagery, verbal images seem immune to the charge of being unknowable metaphysical entities locked away in a private, subjective space. Texts and speech-acts are, after all, not simply affairs of "consciousness," but are public expressions that belong right out there with all the other kinds of material representations we create—pictures, statues, graphs, maps, etc. We don't have to say that a descriptive paragraph is exactly like a picture to see that they do have similar functions as public symbols that project states of affairs about which we can reach rough, provisional agreements.

One of the strongest claims for the propriety of the notion of verbal imagery appears ironically enough in the early Wittgenstein's claim that "A proposition is a picture of reality . . . a model of reality as we imagine it," and that this is no metaphor but a matter of "ordinary sense":

At first sight a proposition—one set out on the printed page, for example—does not seem to be a picture of the reality with which it is concerned. But neither do written notes seem at first sight to be a picture of a piece of music, nor our phonetic notation (the alphabet) to be a picture of our speech. And yet these sign languages prove to be pictures, even in the ordinary sense, of what they represent." (*Tractatus*, 4.01)

This "ordinary sense" turns out to be just that: Wittgenstein goes on to claim that a proposition is "a likeness of what is signified (4.012), and suggests that "in order to understand the essential nature of a proposition, we should consider hieroglyphic script, which depicts the facts that it describes" (4.106). It is important to realize that the "pictures" that

19. From Lecture VIII: "Of the Beauty of Thought in Poetry," trans. William Clarke and William Bowyer (London, 1742). Quoted from Scott Elledge, ed., *Eighteenth Century Critical Essays,* 2 vols. (Ithaca, N.Y.: Cornell University Press, 1961), 1:230–31.
20. Trans. G. E. M. Anscombe (New York: Macmillan, 1953), 120.

reside in language, threatening (in Wittgenstein's view) to trap us with their false models, are not quite the same thing as these likenesses and hieroglyphics. The pictures of the *Tractatus* are not occult forces or mechanisms of some psychological process. They are translations, iso-morphisms, structural homologies—symbolic structures which obey a system of rules for translation. Wittgenstein sometimes calls them "logi-cal spaces," and the fact that he sees them as applicable to musical notation, phonetic script, and even the groove on a gramaphone record indicates that they are not to be confused with graphic images in the narrow sense. Wittgenstein's notion of verbal imagery might be illus-trated, as we have seen, by the model that displays the relations between mental and material imagery in empirical models of perception. It is not that this model corresponds to some mental image we necessarily have as we think about this topic. It is just that it displays in graphic space the logical space determined by a typical set of empiricist propositions.

And yet the whole question of whether verbal images are properly called "images" gives us what Wittgenstein would call a "mental cramp," because the very distinction it assumes between literal and figurative expressions is, in literary discourse, entangled with the notion we want to explain, the verbal image. Literal language is generally understood (by literary critics) as straight, unadorned, unpicturesque expression, free of verbal images and figures of speech. Figurative language, on the other hand, is what we ordinarily mean when we talk about verbal imagery.[21] The phrase, "verbal imagery," in other words, seems to be a metaphor for metaphor itself! Small wonder that many literary critics have sug-gested retiring the term from critical usage.

Before the term is retired, however, we ought to subject it to critical and historical reflection. We might begin by noticing that the notion of verbal imagery designates two very different, perhaps antithetical, kinds of linguistic practice. We speak of verbal imagery as, on the one hand, metaphoric, figurative, or ornamented langauge, a technique that deflects attention away from the literal subject of the utterance and toward something else. But we also speak of it in Wittgenstein's manner, as the way a proposition "like a tableau vivant . . . presents a state of affairs" (*Tractatus*, 4.0311). This view of verbal imagery treats it as just the literal sense of a proposition, that state of affairs which, if it obtained in

21. This is the second meaning (after "images produced in the mind by language") for verbal imagery cited by *The Princeton Encyclopedia of Poetry and Poetics*, 363.

the real world, would make the proposition true. In modern poetic theory this version of verbal imagery has been given its clearest formulation by Hugh Kenner, who says that a verbal image is just "what the words actually name," a definition that leads toward a view of poetic language as literal, nonmetaphoric expresison.[22]

Kenner's modernist notion of verbal images as simple, concrete objects of reference has ample precedent in a body of common assumptions about language that goes back at least to the seventeenth century.[23] This is the assumption that what words signify are the "mental images" that have been impressed on us by the experience of objects. On this account we are to think of a word (such as "man") as a "verbal image" twice removed from the original that it represents. A word is an image of an idea, and an idea is an image of a thing, a chain of representation that may be depicted by adding another link to the sketch of the empirical model of cognition:

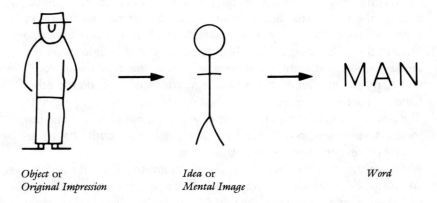

Object or Idea or Word
Original Impression Mental Image

I have depicted the "real man" (or the "original impression" of him) here with more pictorial detail than the stick figure which represents the mental image or "idea." This contrast could be used to illustrate Hume's

22. *The Art of Poetry* (New York: Holt, Rinehart, & Winston, 1959), 38. The usual strategy with the two meanings of verbal imagery is to blue them together as C. Day Lewis does when he speaks in one sentence of poetic imagery as "an epithet, a metaphor, a simile," and as a "purely descriptive" passage (*Poetic Image* [London: Jonathan Cape, 1947], 18).

23. I rely here on Ray Frazer's important article, "The Origin of the Term 'Image,'" *ELH* 27 (1960), 149–61.

distinction between impressions and ideas in terms of "force and liveliness," terms employed in the vocabulary of pictorial representation to differentiate realistic or lifelike paintings from mannered, abstract, or schematic pictures. Hume follows Hobbes and Locke in his use of pictorial metaphors to describe the chain of cognition and signification: ideas are "faint images" or "decayed sensations" that become linked by conventional association with words. Hume regards the proper method of clarifying the meaning of words, especially abstract terms, as a retracing of the chain of ideas to its origin:

> When we entertain . . . any suspicion that a philosophical term is employed without any meaning or idea (as is but too frequent), we need but inquire, *from what impression is that supposed idea derived?*[24]

The poetic consequences of this sort of language theory are of course a thoroughgoing pictorialism, an understanding of the art of language as the art of reviving the original impressions of sense. Addison probably expressed the confidence in this art most eloquently:

> Words, when well chosen, have so great force in them that a description often gives us more lively ideas than the sight of things themselves. The reader finds a scene drawn in stronger colors and painted more to the life in his imagination by the help of words than by an actual survey of the scene which they describe. In this case the poet seems to get the better of nature; he takes, indeed, the landscape after her but gives it more vigorous touches, heightens its beauty, and so enlivens the whole piece that the images which flow from objects themselves appear weak and faint in comparison of those that come from the expressions.[25]

For Addison and other eighteenth-century critics, the verbal image is neither a metaphorical concept nor a term for (literally) designating metaphors, figures, or other "ornaments" of ordinary language. The verbal image (usually glossed as "description") is the keystone of all language. Accurate, precise descriptions produce images that "come

24. *An Inquiry Concerning Human Understanding* (1748), sec. II; ed. Charles W. Hendel (New York: Bobbs-Merrill, 1955), 30; The emphasis is Hume's.

25. *The Spectator,* no. 416, June 27, 1712 ("The Pleasures of the Imagination, VI"), in Elledge, *Eighteenth Century Critical Essays,* 1:60.

from the verbal expressions" more vividly than the "images which flow from objects" themselves. The "species" Aristotle postulated as flowing from objects to impress themselves on our senses are, in Addison's theory of writing and reading, made into properties of words themselves.

This view of poetry, and of language in general, as a process of pictorial production and reproduction was accompanied in seventeenth- and eighteenth-century English literary theory by a decline in the prestige of rhetorical figures and tropes. The notion of "image" replaced that of "figure," which began to be regarded as a feature of old-fashioned "ornamented" language. The literary style of verbal *imagery* is "plain" and "perspicuous," a style that reaches right out to objects, representing them (as Addison claims) even more vividly than the objects can represent themselves. This in contrast to the "deceptive ornament" of rhetoric, which is now seen as nothing but a matter of relations among signs. When the rhetorical figures are mentioned, they are either dismissed as the artificial excesses of a prerational, prescientific age, or they are redefined in ways that accommodate them to the hegemony of the verbal image. Metaphors are redefined as "short descriptions"; "allusions and similes are descriptions placed in an opposite point of view . . . and hyperbole is often nothing more than a description carried beyond the bounds of probability."[26] Even abstractions are treated as pictorial, visual objects, projected in the verbal imagery of personification.[27]

In Romantic and modern poetics the verbal image retained its hold over the understanding of literary language, and the confused application of the term to both literal and figuative expression continued to encourage a lumping of notions such as description, concrete nouns, tropes, "sensory" terms, and even recurrent semantic, syntactic, or phonemic motifs under the rubric of "imagery." In order to do all this work, however, the notion of imagery had to be sublimated and mystified. Romantic writers typically assimilate mental, verbal, and even pictorial imagery into the mysterious process of "imagination," which is typically defined in contrast to the "mere" recall of mental pictures, the "mere" description of external scenes, and (in painting) the "mere" depiction of external visibilia, as opposed to the spirit, feeling, or "poetry" of a scene.[28]

26. John Newberry, *The Art of Poetry on a New Plan* (London, 1762), 43.

27. See Earl Wasserman, "Inherent Values of Eighteenth-Century Personification," *PMLA* 65 (1950), 435–63.

28. The classic studies of this "sublimation" of the poetic image are Frank Kermode,

Under the aegis of "imagination," in other words, the notion of imagery is split in two, and a distinction is made between the pictorial or graphic image which is a lower form—external, mechanical, dead, and often associated with the empiricist model of perception—and a "higher" image which is internal, organic, and living. Despite M. H. Abrams's claim that figures of "expression" (like the lamp) replace figures of mimesis (the mirror), the vocabulary of imagery and picturing continues to dominate discussions of verbal art in the nineteenth century. In Romantic poetics, however, imagery is refined and abstracted into such notions as the Kantian schematism, the Coleridgean symbol, and the nonrepresentational image of "pure form" or transcendental structure. And this sublimated, abstracted image displaces and subsumes the empiricist notion of the verbal image as a perspicuous representation of material reality, just as that picture had earlier subsumed the figures of rhetoric.[29]

This progressive sublimation of the image reaches its logical culmination when the entire poem or text is regarded as an image or "verbal icon," and this image is defined, not as a pictorial likeness or impression, but as a synchronic structure in some metaphorical space—"that which" (in Pound's words) "presents an intellectual and emotional complex in an instant of time." The Imagists's emphasis on concrete, particular descriptions in their poetry is, by itself, a residue of the eighteenth-century notion we have seen in Addison that poetry strives to outdo in vividness and immediacy the "images which flow from objects themselves" (Williams's "no ideas but in things" would seem to be another version of this idea). But the distinctive modernist emphasis is on the image as a sort of crystalline structure, a dynamic pattern of the intellectual and emotional energy bodied forth by a poem. Formalist criticism is both a poetics and a hermeneutics for this kind of verbal image, showing us how poems contain their energies in matrices of architectonic tension, and demonstrating the congruence of these matrices with the propositional content of the poem.

With the modernist image as pure form or structure I come back to my starting point in this tour of the verbal image, back to the young

The Romantic Image (New York: Random House, 1957), and M. H. Abrams, *The Mirror and the Lamp* (New York: Oxford University Press, 1953).

29. See my essay, "Diagrammatology," *Critical Inqiry* 7:3 (Spring, 1981), 622–33, for a discussion of Wordsworth's interest in geometry and his tendency to evoke "vanishing" or "erased" poetic images.

Wittgenstein's claim that the really important verbal image is the "picture" in "logical space" that is projected by a proposition. This picture was mistaken by the logical positivists, however, for a kind of unmediated window on reality, a fulfilment of the seventeenth-century dream of a perfectly transparent language that would give direct access to objects and ideas.[30] Wittgenstein spent much of his career trying to correct this misreading by insisting that the pictures in language are not unmediated copies of any reality. The pictures that seem to reside in our language, whether they are projected in the mind's eye or on paper, are artificial, conventional signs no less than the propositions with which they are associated. The status of these pictures is like that of a geometrical diagram in relation to an algebraic equation.[31] That is why Wittgenstein suggests that we demystify the notion of mental imagery by replacing it with its material equivalent ("replace every process of imagining by a process of looking at an object or by painting, drawing, or modelling"). That is why "thinking" is, for Wittgenstein, not a private, occult process, but "the activity of working with signs," both verbal and pictorial.[32]

The force of Wittgenstein's critique of the mental and verbal image may be illustrated by showing a new way of reading our picture of the links between word, idea, and image in empirical epistemology:

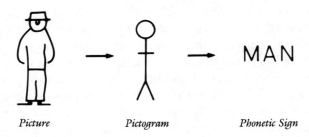

Picture	*Pictogram*	*Phonetic Sign*

30. This misunderstanding is generally traced to one of the first readers of the *Tractatus*, Bertrand Russell, whose introduction in 1922 set the stage for its reception: "Mr Wittgenstein is concerned with the conditions for a logically perfect language—not that any language is logically perfect, or that we believe ourselves capable, here and now, of constructing a logically perfect language, but that the whole function of language is to have meaning, and it only fulfills this function in proportion as it approaches to the ideal language which we postulate" (*Tractatus*, x).

31. In this respect, Wittgenstein's "pictures" are very much like C. S. Peirce's "icons." See Peirce, "The Icon, Index, and Symbol," in *Collected Papers*, 8 vols., ed. Charles Hartshorne and Paul Weiss (Cambridge: Harvard University Press, 1931–58) 2:158, on the "iconicity" of diagrams and algebraic equations.

32. *The Blue and Brown Books*, 4, 6.

Try reading this tableau now, not as a movement from world to mind to language, but from one kind of sign to another, as an illustrated history of the development of systems of writing. The progression is now from picture to a relatively schematic "pictogram" to expression by phonetic signs, a sequence that may be fleshed out by the insertion of a new, intermediary sign, the hieroglyph or "ideogram" (recall here Wittgenstein's suggestion in the *Tractatus* that a proposition is like "hieroglyphic script" which "depicts the facts that it describes"):

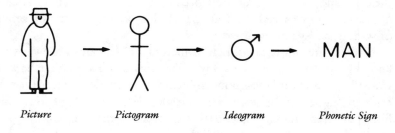

| Picture | Pictogram | Ideogram | Phonetic Sign |

What the hieroglyph shows is a displacement of the original image by a figure of speech, technically, a synecdoche or metonymy. If we read the circle and arrow as pictures of a body and phallus, then the symbol is synecdochic, presenting part for whole; if we read it as a shield and spear, then it is metonymic, substituting associated objects for the thing itself. This sort of substitution can, of course, also proceed by verbal-visual punning, so that the *name* of the thing pictured is associated with another thing with a similar sounding name, as in the familiar rebus:

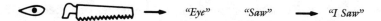

These illustrations should suggest another "literal" sense of the notion of verbal imagery—the most literal of all, clearly, in that it denotes *written* language, the translation of speech into a visible code. Insofar as language is written it is bound up with material, graphic figures and pictures that are abridged or condensed in a variety of ways to form alphabetical script. But the figures of writing and of drawing are from the first

inseparable from figures of speech, manners of speaking. The picture of an eagle in Northwest Indian petroglyphs may be a signature of a warrior, an emblem of a tribe, a symbol of courage, or—just a picture of an eagle. The meaning of the picture does not declare itself by a simple and direct reference to the object it depicts. It may depict an idea, a person, a "sound image" (in the case of the rebus), or a thing. In order to know how to read it, we must know how it speaks, what is proper to say about it and on its behalf. The idea of the "speaking picture" which is often invoked to describe certain kinds of poetic presence or vividness on the one hand, and pictorial eloquence on the other hand, is not merely a figure for certain special effects in the arts, but lies at the common origin of writing and painting.

If the figure of the pictogram or hieroglyph demands a viewer who knows what to say, it also has a way of shaping the things that can be said. Consider further the ambiguous emblem/signature/ideogram of the petroglyph "eagle." If the warrior is an eagle, or "like" an eagle, or (more likely) if "Eagle himself" goes to war, and returns to tell about it, we can expect the picture to be extended. Eagle will no doubt see his enemies from afar and swoop down on them without warning. The "verbal image" of Eagle is a complex of speech, depiction, and writing that not only describes what he does, but predicts and shapes what he can and will do. It is his "character," a signature that is both verbal and pictorial, both a narrative of his actions and a summation of what he is.

The figure of the hieroglyph has a history that runs parallel to the stories of the verbal and mental image. The elaborate figures of rhetoric and allegory that were abandoned as "superstitious" or Gothic excesses by seventeenth-century critics were often compared to hieroglyphics. Shaftesbury called them "false imitations," "magical, mystical, monkish and Gothic emblems," and contrasted them to a true, perspicuous "mirror-writing" that would call attention to the writer's subject, not his witty artifices.[33] But there was one way of saving hieroglyphs for a modern, enlightened age, and that was to detach them from their association with magic and mystery, and to see them as models for a new, scientific language that would guarantee perfect communication and

33. *Characteristics of Men, Manners, Opinions, Times* (1711), quoted from Elledge, *Eighteenth Century Critical Essays*, I. 180. Shaftesbury's remarks on hieroglyphics appear in *Second Characters or the Language of Forms*, ed. Benjamin Rand (Cambridge, 1914), 91.

perspicuous access to objective reality. This hope for a universal, scientific language was associated by Vico and Leibniz with the invention of a new system of hieroglyphics based in mathematics. The pictorial image, meanwhile, was being psychologized and given a privileged mediating role between word and thing in the epistemology of empiricism and in literary theories based in the model of the mirror. And the Egyptian hieroglyphics themselves were subjected to a revisionist, antihermetic interpretation (most notably by Bishop Warburton in the eighteenth century) that treated the ancient symbols as transparent, universally readable signs that had been occulted by the passage of time.[34]

The verbal image as hieroglyph recovered much of its sublimity and mystery in the poetics of Romanticism, as we might expect, and it has had a central function in modernism as well. Wittgenstein's use of the hieroglyphic as a model for the picture theory of language and Ezra Pound's fascination with Chinese picture-writing as a model for the poetic image might be taken as marking the boundaries of this role. And most recently we see the figure of the hieroglyph revived in postmodern criticism in Jacques Derrida's notion of a "grammatology," a "science of writing" that removes spoken language from its dominant place in the study of language and communication, and replaces it with the general notion of the *graphein* or *gramme*, the graphic mark, trace, character, or other sign that makes "language . . . a possibility founded on the general possibility of writing."[35] Derrida reinstates the ancient figure of the world as a text (a figure which, in Renaissance poetics, made nature itself a system of hieroglyphics), but with a new twist. Since the author of this text is no longer with us, or has lost his authority, there is no foundation for the sign, no way of stopping the endless chain of signification. This realization can lead us to a perception of the *mise en abime*, a nauseating void of signifiers in which a nihilistic abandonment to free play and arbitrary will seems the only appropriate strategy. Or it can lead to a sense that our signs, and thus our world, are a product of human action and understanding, that although our modes of knowledge and representation may be "arbitrary" and "conventional," they are the constit-

34. For this antihermetic account of hieroglyphics, see Warburton's *Divine Legation of Moses Demonstrated,* bk. IV, sec. 4 (1738, 1754), in *Works of . . . William Warburton,* ed. Richard Hurd (London, 1811), 4:116–214.

35. *Of Grammatology* (Baltimore: Johns Hopkins University Press, 1976), 52.

uents of the forms of life, the practices and traditions within which we must make epistemological, ethical, and political choices. Derrida's answer to the question, "What is an image?" would undoubtedly be: "Nothing but another kind of writing, a kind of graphic sign that dissembles itself as a direct transcript of that which it represents, or of the way things look, or of what they essentially are." This sort of suspicion of the image seems only appropriate in a time when the very view from one's window, much less the scenes played out in everyday life and in the various media of representation, seem to require constant interpretive vigilance. Everything—nature, politics, sex, other people—comes to us now as an image, preinscribed with a speciousness that is nothing but the Aristotelian "species" under a cloud of suspicion. The question for us now would seem to be not just "What is an image?" but "How do we transform images, and the imagination that produces them, into powers worthy of trust and respect?"

One way of answering this question has been to dismiss the whole notion of imagination and mental representation as a Cartesian mirage. The concept of mental and verbal images, and all their stage machinery of mirrors and surfaces for writing, printing, and drawing, all this (as Richard Rorty argues) is to be abandoned as the machinery of an outmoded paradigm, the confusion of philosophy with psychology that has dominated Western thought under the name of "epistemology" for the last three hundred years.[36] This is one of the main thrusts of behaviorism, and I agree with it to the extent that it opposes the notion that knowledge is a copy or image of reality imprinted on the mind. It seems clear that knowledge is better understood as a matter of social practices, disputes, and agreements, and not as the property of some particular mode of natural or unmediated representation. And yet there is something curiously anachronistic about the modern attack on the notion of mental images as "privileged representations" when the main thrust of modern studies of *material* images has been to take away these privileges. It's hard to debunk a picture theory of language when we no longer have a picture theory of pictures themselves.[37]

36. This answer has been popular at least since Thomas Reid's attack on Hume's concept of "idea" as mental image. In the following discussion I draw on Richard Rorty's critique in *Philosophy and the Mirror of Nature*.

37. I echo here Colin Murray Turbayne's argument in "Visual Language from the Verbal Model," *The Journal of Typographical Research* 3:4 (October, 1969), 345–54.

The solution to our difficulties, then, would not seem to be a jettison-ing of representational theories of mind or language. That would be as futile as iconoclastic attempts to purge the world of images have always been. What we might do, however, is retrace the steps by which the notion of the image as a transparent picture or "privileged representa-tion" took over our notions of mind and language. If we can understand how images have come to possess their present power over us, we may be in a position to repossess the imagination that produces them.

Image as Likeness

I have been proceeding up to this point on the assumption that the literal sense of the word "image" is a graphic, pictorial representation, a con-crete, material object, and that notions such as mental, verbal, or percep-tual imagery are improper derivations from this literal sense, figurative extensions of the pictorial into regions where pictures have no real business. It's time now to acknowledge that this whole story could be told another way, from the standpoint of a tradition which sees the *literal* sense of the word "image" as a resolutely non- or even anti-pictorial notion. This is the tradition which begins, of course, with the account of man's creation "in the image and likeness" of God. The words we now translate as "image" (the Hebrew *tselem*, the Greek *eikon*, and the Latin *imago*) are properly understood, as the commentators never tire of telling us, not as any material picture, but as an abstract, general, spiritual "likeness."[38] The regular addition, after "image," of the phrase "and likeness" (the Hebrew *demuth*, the Greek *homoioos*, and the Latin *simili-tude*) is to be understood, not as adding new information, but as prevent-ing a possible confusion: "image" is to be understood not as "picture" but as "likeness," a matter of spiritual similarity.

It should come as no surprise that a religious tradition obsessed with

38. Clarke's commentary provides a typical gloss on Genesis 1:26, dividing God's proclamation, "Let us make man in our own image, after our likeness" into two parts. "What is said above ["let us make man"] refers only to the *body* of man; what is here said ["in our own image, after our likeness"] refers to his *soul*. This was made in the *image* and *likeness* of God. Now as the Divine Being is infinite, he is neither limited by parts, nor definable by passions; therefore he can have no *corporeal image* after which he made the body of man. The image and likeness must necessarily be intellectual" (*The Holy Bible . . . with a Commen-tary and Critical Notes by Adam Clarke* [New York: Ezra Sargeant, 1811] vol. 1).

taboos against graven images and idolatry would want to stress a spir-
itual, immaterial sense of the notion of images. The commentary of a
Talmudic scholar such as Maimonides helps us see the precise terms in
which this spiritual sense was understood: "the term *image* is applied to
the natural form, I mean to the notion in virtue of which a thing is
constituted as a substance and becomes what it is. It is the true reality of
the thing in so far as the latter is that particular being."[39] It must be
stressed that for Maimonides the image (*tselem*) is literally this essential
reality of a thing, and it is only by a kind of corruption that it becomes
associated with corporeal things like idols: "the reason why idols are
called images lies in the fact that what was sought in them was deemed to
subsist in them, and not in their shape or configuration."[40] The true,
literal image is the mental or spiritual one; the improper, derivative,
figurative image is the material shape perceived by our senses, especially
the eye.[41]

 This, at any rate, is a radical statement of the view that an image is a
likeness, not a picture. In practical usage even Maimonides admits that
image is an "equivocal" or "amphibolous" term that may refer to "specific
form" (i.e., the identity or "species" of a thing) or "artificial form" (its
corporeal shape).[42] But he is very clear about the difference between the
two meanings, and very sure about which one is original and authentic,
which one derived by improper application. His tendency to privilege
the abstract, ideal version of the image epitomizes, I would suggest, both
Jewish and Christian thinking on this issue.[43] This sense of an original

 39. Moses Maimonides (1135–1204), *The Guide of the Perplexed*, 2 vols., trans. Shlomo
Pines (Chicago: University of Chicago Press, 1963), 1:22.
 40. Ibid., Maimonides, 1:22.
 41. Cf. St. Augustine's analysis of idolatry as the subordination of the true spiritual
image to the false material one: "that people . . . worshipped the head of a four-footed
beast instead of thee, turning in their heart back towards Egypt; and bowing thy image
(their own soul) before the image of a calf that eateth hay" (*Confessions*, bk. VII, chap. 9,
trans. William Watts (1631), Loeb Classical Library, 2 vols. (Cambridge: Harvard Univer-
sity Press, 1977), 1:369.
 42. Maimonides' "specific form" might be contrasted with Aristotle's use of "species"
in its literal, material "specular" sense, as the image propagated by a body and imprinted on
our senses. Aristotle's "species" is Maimonides' "artificial form."
 43. A good index to the power of the essentialist notion of the image as the bearer of the
inner presence of that which it represents is the fact that this assumption was shared by both
iconoclasts and iconophiles in the battle over religious images in eighth- and ninth-century
Byzantium. (There is a striking similarity here in the tendency of modern iconophobes and

"spiritual" meaning for a word and a later, derived "material" application may be difficult for us to comprehend, largely because our understanding of the history of words has been oriented around the empirical epistemology I described earlier: we tend to think of the most concrete, material application of a word as its original, primitive sense because we have a model of the derivation of words from things by way of images. This model has no greater power than in our understanding of the word "image" itself.

But what exactly is this "spiritual" likeness which is not to be confused with any material image? We should note first that it seems to include a presumption of difference. To say that one tree, or one member of a species of tree, is like another, is not to argue that they are identical but that they are similar in some respects and not in others. Normally, however, we don't say that every likeness is an image. One tree is like another, but we don't call one the image of the other. The word "image" only comes up in relation to this sort of likeness when we try to construct a theory about the way we perceive the likeness between one tree and another. This explanation will typically resort to some intermediate or transcendental object—an idea, form, or mental image—that provides a mechanism for explaining how our categories arise. The "origin of species" is not just a matter of biological evolution then, but of the mechanisms of consciousness as they are described in representational models of the mind.

But we should note that these ideal objects—forms, species, or images—need not be understood as pictures or impressions. These kinds of "images" could just as well be understood as lists of predicates enumerating the characteristics of a class of objects, such as: tree (1) tall, vertical object; (2) spreading green top; (3) rooted in ground. There is no possibility of mistaking this group of propositions for a picture of a tree,

iconophiles in psychology to agree on "natural resemblance" theories of the image). Both parties to the debate regarded the Eucharist, for instance, as one of "the true and present signs of the body and blood of Christ," and therefore "worthy of worship" (*The Liturgy of Basil*, quoted from Pelikan, 2:94). The "question between them," as Pelikan notes, "was not . . . the nature of the eucharistic presence, but its implications for the definition of 'image' and for the use of images. Was the eucharistic presence to be extended to a general principle about the sacramental mediation of divine power through material objects, or was it an exclusive principle that precluded any such extension to other means of grace, such as images?" (2:94).

but it is, I submit, the sort of thing we mean when we talk about an image which is not (just) a picture. We might use the words "model" or "schema" or even "definition" to explain the sort of thing we mean when we talk about an image that is not (just) a picture.[44] The image as likeness, then, can be understood as a series of predicates listing similarities and differences.[45] But if that is all this sort of "spiritual" image involves, we must wonder why it ever took on the name of "image," which confused it with pictorial representation. It was certainly not in the interests of foes of idolatry to foster this usage; one can only surmise that the terminology of the image was the result of a sort of metaphorical "drift," a search for a concrete analogy that became literalized under the pressure of idolatrous tendencies among surrounding peoples and

44. This verbal or "descriptional" account of the image is frequently invoked by iconophobes of cognitive psychology such as Daniel Dennett. "All 'mental imagery,'" argues Dennett, stressing the scare quotes, "including seeing and hallucinating, is descriptional." Dennett suggests that cognition is more like writing and reading than like painting or looking at pictures: "The writing analogy has its pitfalls but is still a good antidote to the picture analogy. When we perceive something in the environment, we are not aware of every fleck of color all at once, but rather of highlights of the scene, an edited commentary on the things of interest" (from "The Nature of Images and the Introspective Trap," in *Imagery*, ed. Ned Block, 54–55). Dennett's analysis seems to me unexceptionable but misdirected. He could as easily apply his "writing analogy" to the construction and perception of real, graphic images as to mental images; the "all at once" awareness which is so often postulated of pictorial cognition is simply a strawman. We see graphic images, like everything else, selectively and in time (which is not to deny that there are special habits and conventions for the seeing of various kinds of images). Dennett's claim that mental images are not like real images can only be sustained by a dubious characterization of real images as things that involve some holistic, instantaneous cognition to the exclusion of all temporality, and by an insistence that real images, unlike mental ones, "must *resemble* what they represent"(52).

45. This notion of the image as fundamentally a matter of words has its theological precedent in the claim that the spiritual image, the *imago dei,* is not only the soul or mind of man, but the word of God. Here is Clement of Alexandria's comment on this issue:

> For "the image of God" is His Word (and the divine Word, the light who is the archetype of light, is a genuine son of Mind); and an image of the Word is the true man, that is, the mind in man, who on this account is said to have been created "in the image" of God and "in His likeness," because through his understanding heart he is made like the divine Word or Reason, and so reasonable. But statues in human form, being an earthen image of visible, earthborn man, and far away from the truth, plainly show themselves to be but a temporary impression upon matter.

Clement also calls statues such as the Olympian Zeus "an image of an image" (*Exhortation to the Greeks,* trans. G. W. Butterworth, Loeb Classical Library (Cambridge: Harvard University Press, 1979), 215.

among the Israelites themselves. The confusion between likeness and
picture could also be useful for a priesthood concerned with the educa-
tion of an illiterate laity. The priest would know that the "true image" is
not in any material object, but is encoded in the spiritual—that is, the
verbal and textual—understanding, while the people could be given an
outward image to gratify their senses and encourage devotion.[46] The
distinction between the spiritual and material, inner and outer image,
was never simply a matter of theological doctrine, but was always a
question of politics, from the power of priestly castes, to the struggle
between conservative and reform movements (the iconophiles and icon-
oclasts), to the preservation of national identity (the Israelites' struggle
to purge themselves of idolatry).

The tension between the appeals of spiritual likeness and material
image is never expressed more poignantly than in Milton's treatment of
Adam and Eve as the *imago dei* in the fourth book of *Paradise Lost*:

> Two of far nobler shape erect and tall,
> Godlike erect, with native honour clad
> In naked majesty seemed lords of all
> And worthy seemed, for in their looks divine
> The image of thir glorious Maker shone,
> Truth, Wisdom, Sanctitude severe and pure,
> Severe, but in true filial freedom plac't.

> (*P.L.* 4:288–93)

Milton deliberately confuses the visual, pictorial sense of the image with
an invisible, spiritual, and verbal understanding of it.[47] Everything
hinges on the equivocal function of the key word "looks," which may

46. See, in the preceding note, Clement of Alexandria's claim that the true image is the
word of God. The iconophiles were quite resourceful in making subtle distinctions to
preserve the popular and widespread use of images and to answer the charge (very powerful
on the face of it) that they were practicing idolatry. Distinctions were drawn between
images for worship, for veneration, and for educational purposes (the Eucharist, the cross,
statues of saints, and scenes from Scripture exemplify this descending scale of sacred "aura"
attributed to imagery). And the iconoclasts' appeal to scriptural texts prohibiting the use of
graven images were turned against them by a logic of "guilt by association": since these
prohibitions were taken literally and practiced faithfully only by Jews and Muslims, the
iconoclasts could be characterized as heretical conspirators against immemorial Christian
traditions. See Pelikan, vol 2, chap. 3 for more on these strategies.

47. For an account of the use of this equivocation in Milton's larger design for *Paradise
Lost,* see Anthony C. Yu, "Life in the Garden: Freedom and the Image of God in *Paradise
Lost,*" *The Journal of Religion* 60:3 (July, 1980), 247–71.

refer us to the outward appearance of Adam and Eve, their "nobler shape," nakedness, and erectness, or to the less tangible sense of "looks" as the quality of their gazes, the character of their "expressions." This quality is not a visual image that looks like something else; it is more like the light by which an image can be seen at all, a matter of radiance rather than reflection. And to explain how this image "shone" in "their looks divine," Milton must resort to a series of predicates, a list of abstract spiritual attributes that Adam and Eve have in common with God— "Truth, Wisdom, Sanctitude severe and pure"—along with a qualifying difference to stress that man is not identical with God: "Severe, but in true filial freedom placed." God in his perfect solitude has no need of filial relationships, but for his image to be perfected in mankind the social and sexual relation of man and woman must be instituted in "true filial freedom."[48]

Is man created in the image of God, then, in that he looks like God, or in that we can say similar things about man and God? Milton wants to have it both ways, a desire we can trace to his rather unorthodox materialism, or perhaps more fundamentally, to a historic transformation in the concept of imagery which tended to identify the notion of spiritual likeness—particularly the "rational soul" that makes man an image of God—with a certain kind of material image. Milton's poetry is the scene of a struggle between iconoclastic distrust of the outward image and iconophilic fascination with its power, a struggle which manifests itself in his practice of proliferating visual images in order to prevent readers from focusing on any particular picture or scene. In order to see how the stage was set for this struggle we need to look more closely at the revolution which identified pictures or "artificial forms" with images as "likenesses" (Maimonides' "specific forms").

48. Milton's treatment of Adam and Eve's relationship and fall from grace can be understood quite precisely in terms of the dialectic between inner and outer image, iconoclasm and iconophilia. Eve is the creature of the outward image, her "looks" offering a temptation both to herself and to Adam. Adam is the creature of the inner, spiritual image; he is the verbal, intellectual being in contrast to Eve's silence and passivity. Eve is guilty of a narcissistic idolatry, tempted by Satan's treatment of her as a goddess; Adam, in turn, makes Eve the goddess of his idolatry. Milton's point, however, is not simply to denigrate the outer, sensible image, but to affirm its necessity in the human image of God, and to dramatize its tragic, ineluctable appeal.

The Tyranny of the Picture

The revolution I am thinking of here was, of course, the invention of artificial perspective, first systematized by Alberti in 1435. The effect of this invention was nothing less than to convince an entire civilization that it possessed an infallible method of representation, a system for the automatic and mechanical production of truths about both the material and the mental worlds. The best index to the hegemony of the artificial perspective is the way it denies its own artificiality and lays claims to being a "natural" representation of "the way things look," "the way we see," or (in a phrase that turns Maimonides on his head) "the way things really are." Aided by the political and economic ascendance of Western Europe, artificial perspective conquered the world of representation under the banner of reason, science, and objectivity. No amount of counterdemonstration from artists that there are other ways of picturing what "we really see" has been able to shake the conviction that these pictures have a kind of identity with natural human vision and objective external space. And the invention of a machine (the camera) built to produce this sort of image has, ironically, only reinforced the conviction that this is the natural mode of representation. What is natural is, evidently, what we can build a machine to do for us.

Even E. H. Gombrich, who has done so much to reveal the historical and conventional character of this system, seems unable to break the spell of scientism which surrounds it, and frequently reverts to a view of pictorial illusionism as providing "keys to the locks of our senses," a phrase which ignores his own warning that "our" senses are windows through which a purposive and acculturated imagination is looking, not a door that springs open to one master key.[49] Gombrich's scientistic understanding of artificial perspective is especially vulnerable when it is couched in this sort of ahistorical and sociobiological claim that "our senses" dictate certain privileged modes of representation. It sounds more plausible, however, when presented in the sophisticated terminology of information theory and Popperian accounts of scientific discovery. Gombrich seems to save the purposive imagination by treating perspective not as a fixed canon of representation but as a flexible method

49. *Art and Illusion*, 359.

of trial and error in which pictorial schemata are likened to scientific hypotheses tested against the facts of vision. The "making" of schematic pictorial hypotheses always precedes, for Gombrich, the "matching" of them against the visible world.[50] The only problem with this formulation is that there is no neutral, univocal, "visible world" there to match things against, no unmediated "facts" about what or how we see. Gombrich himself has been the most eloquent exponent of the claim that there is no vision without purpose, that the innocent eye is blind.[51] But if vision itself is a product of experience and acculturation—including the experience of making pictures—then what we are matching against pictorial representations is not any sort of naked reality but a world already clothed in our systems of representation.

It is important to guard against misunderstanding here. I am not arguing for some facile relativism that abandons "standards of truth" or the possibility of valid knowledge. I am arguing for a hard, rigorous, relativism that regards knowledge as a social product, a matter of dialogue between different versions of the world, including different languages, ideologies, and modes of representations. The notion that there is "a" scientific method so flexible and capacious that it can contain all these differences and adjudicate among them is a handy ideology for the scientist and a social system committed to the authority of science, but it seems mistaken in both theory and practice. Science, as Paul Feyerabend has argued, is not an orderly procedure of erecting hypotheses and "falsifying" them against independent, neutral facts; it is a disorderly and highly political process in which "facts" derive their authority as constituent parts of some world model that has come to seem natural.[52] Scientific progress is as much a matter of rhetoric, intuition, and counterinduction (i.e., the adopting of assumptions which contradict the

50. Ibid., 116.
51. Gombrich has also been one of the leading spokesmen for the linguistic approach to imagery. He never tires of telling us that vision, picturing, painting, and plain seeing are activities much like reading and writing. And yet in recent years he has steadily drawn back from this analogy in favor of a naturalistic and scientistic account of certain kinds of images as containing inherent epistemological guarantees. See, for instance, his distinction between "man-made" and "machine-made" or "scientific" images in "Standards of Truth: The Arrested Image and the Moving Eye," in Mitchell, *The Language of Images*, 181–217. For a fuller account of Gombrich's complex reversals on the question of natural and linguistic accounts of imagery, see chapter 3 below.
52. See *Against Method* (New York: Schocken, 1978).

apparent facts) as it is of methodical observation and information gathering. The greatest scientific discoveries have often followed decisions to ignore the apparent "facts" and to look for an explanation that would account for a situation that can never be observed. "Experiment," as Feyerabend observes, is not just passive observation but "the invention of a *new kind of experience*," made possible by a willingness to let "reason . . . affirm what sensible experience seemed to contradict."[53]

The principle of counterinduction, of ignoring the apparent, visible "facts," in order to produce a new kind of experience, has a direct counterpart in the world of image-making, and it is this: the pictorial artist, even one who works in the tradition known as "realism" or "illusionism," is as much concerned with the invisible as the visible world. We can never understand a picture unless we grasp the ways in which it shows what cannot be seen. One thing that cannot be seen in an illusionistic picture, or which tends to conceal itself, is precisely its own artificiality. The whole system of assumptions about the innate rationality of the mind and the mathematical character of space is like the grammar which allows us to make or recognize a proposition. As Wittgenstein puts it: "a picture cannot depict its pictorial form: it displays it," just as a sentence cannot describe its own logical form but can only employ it to describe something else (*Tractatus*, 2.172). This notion of "picturing the invisible" may seem a bit less paradoxical if we remind ourselves that painters have always claimed to present us with "more than meets the eye," generally under the rubric of terms like "expression." And we have seen in our brief look at the ancient concept of the image as a spiritual "likeness" that there was always a sense, a primary sense in fact, in which images were to be understood as something inward and invisible. Part of the power of perspectival illusionism was that it seemed to reveal not just the outward, visible world but the very nature of the rational soul whose vision is represented.[54]

It is no wonder that the category of realistic, illusionistic, or naturalistic images has become the focus of a modern, secular idolatry linked with the ideology of Western science and rationalism, and that the hegemony of these images has generated iconoclastic reactions in art, psychology,

53. Ibid., 92 and 101.

54. As Joel Snyder puts it, "to an early Renaissance lover of paintings, the sight of these pictures must have been extraordinary—something akin to looking into the soul." See his "Picturing Vision," in Mitchell, *The Language of Images*, 246.

philosophy, and poetics. The real miracle has been the successful resistance of pictorial artists to this idolatry, their insistence on continuing to show us more than meets the eye with whatever resources they can muster.

Picturing the Invisible

Sometimes the best way to demystify a miracle, especially when it has hardened into a mystery, is to take a fresh look at it through the eyes of an unbeliever. The notion that painting is capable of expressing some invisible essence made very little impression on the skeptical eyes of Mark Twain. Standing before Guido Reni's famous painting of Beatrice Cenci he had this to say:

> A good legible label is usually worth, for information, a ton of significant attitude and expression in a historical picture. In Rome, people with fine sympathetic natures stand up and weep in front of the celebrated "Beatrice Cenci the Day Before Her Execution." It shows what a label can do. If they did not know the picture, they would inspect it unmoved, and say, "Young Girl with Hay Fever; Young Girl with Her Head in a Bag."[55]

Twain's skeptical response to the finer things in art is an echo of a more sophisticated critique of the limits of pictorial expresison. In his *Laocoon*, Lessing has argued that "expression," whether of persons, ideas, or narrative progressions, is inappropriate, or at best of secondary importance in painting. The sculptor of the Laocoön group showed the faces in a kind of repose not because of any Stoic doctrine requiring the suppression of pain but because the proper goal of sculpture (and of all the visual arts) is the depiction of physical beauty. Any expression of the strong emotions attributed to Laocoön in Greek poetry would have required deforming the harmonious equilibrium of the statue, and distracted from its primary end. Lessing argued along similar lines that painting was incapable of telling stories because its imitation is static rather than progressive, and that it should not try to articulate ideas because these are

55. *Life on the Mississippi*, chap. 44, "City Sights."

properly expressed in language rather than in imagery. The attempt to "express universal ideas" in pictorial form, warns Lessing, produces only the grotesque forms of allegory; ultimately it can lead painting into "abandoning its proper sphere and degenerating into an arbitrary method of writing"—the pictogram or hieroglyph.[56]

If we discount the obvious hostility from Twain and Lessing's comments on the poverty of pictorial expression, we find a rather perspicuous account of what is meant by the notion of painting the invisible. What expression amounts to is the artful planting of certain clues in a picture that allow us to form a act of ventriloquism, an act which endows the picture with eloquence, and particularly with a nonvisual and verbal eloquence. A picture may articulate abstract ideas by means of allegorical imagery, a practice which, as Lessing notes, approaches the notational procedures of writing systems. The image of an eagle may depict a feathered predator, but it expresses the idea of wisdom, and thus works as a hieroglyph. Or we may understand expression in dramatic, oratorical terms, as did the Renaissance humanists who formulated a rhetoric of history painting complete with a language of facial expression and gesture, a language precise enough to let us verbalize what depicted figures are thinking, feeling, or saying. And expression need not be limited to predicates we can attach to pictured objects: the setting, compositional arrangement, and color scheme may all carry expressive charge, so that we can speak of moods and emotional atmospheres whose appropriate verbal counterparts may be something on the order of a lyric poem.

The expressive aspect of imagery may, of course, become such a predominant presence that the image becomes totally abstract and ornamental, representing neither figures nor space, but simply *presenting* its own material and formal elements. The abstract image may seem at first glance to have escaped from the realm of representation and verbal eloquence, leaving behind both figural mimesis and literary features like narrative or allegory. But abstract expressionist painting is, to use Tom Wolfe's phrase (but not his debunking attitude) a "painted word," a pictorial code requiring a verbal apologetics as elaborate as that of any

56. *Laocoon: An Essay upon the Limits of Poetry and Painting* (1766), trans. Ellen Frothingham (1873; rpt., New York: Farrar, Straus, and Giroux, 1969), x.

traditional mode of painting, the ersatz metaphysics of "art theory."[57] The colored daubs and streaks on the canvas become, in the proper context—that is, in the presence of the proper ventriloquist—statements about the nature of space, perception, and representation.

If I seem to be taking Twain's ironic attitude toward the claims of pictorial expression, it is not because I think that expression is impossible or illusory, but because our understanding of it is so often clouded by the same mystique of "natural representation" that obstructs our understanding of mimetic representation. Twain says that the label is worth more, for information, than "a ton of significant expression." But we might ask Twain how much the label would be worth, for information or for anything else, without this picture by Guido Reni, or the entire tradition of representing in pictorial, dramatic, or literary images the story of the Cenci. The painting is a confluence of pictorial and verbal traditions, neither of which is apparent to the innocent eyes of Twain, and so he can scarcely see what it is, much less respond to it.

Twain and Lessing's skepticism about pictorial expression is useful insofar as it reveals the necessarily verbal character of imaging the invisible. It is misleading in that it condemns this verbal supplementation of the image as improper or unnatural. The devices of representation that allow people with "fine, sympathetic natures" to respond to Reni's painting of Beatrice Cenci may be arbitrary, conventional signals that depend on our prior knowledge of the story. But the devices of representation that allow Twain to see a "Young Girl with Hay Fever; Young Girl with Her Head in a Bag" are, though more easily learned, no less conventional and no less bound up with language.

Image and Word

The recognition that pictorial images are inevitably conventional and contaminated by language need not cast us into an abyss of infinitely regressive signifiers. What it does imply for the study of art is simply that

57. See Wolfe's *The Painted Word* (New York: Farrar, Straus, and Giroux, 1975). Wolfe, like Twain and Lessing, regards the reliance of painting on verbal contexts as somehow inherently inappropriate. My view here is that it is inevitable, and that appropriateness is a separate question which can only be settled in the aesthetic judgment brought to particular images.

something like the Renaissance notion of *ut pictura poesis* and the sisterhood of the arts is always with us. The dialectic of word and image seems to be a constant in the fabric of signs that a culture weaves around itself. What varies is the precise nature of the weave, the relation of warp and woof. The history of culture is in part the story of a protracted struggle for dominance between pictorial and linguistic signs, each claiming for itself certain proprietary rights on a "nature" to which only it has access. At some moments this struggle seems to settle into a relationship of free exchange along open borders; at other times (as in Lessing's *Laocoon*) the borders are closed and a separate peace is declared. Among the most interesting and complex versions of this struggle is what might be called the relationship of subversion, in which language or imagery looks into its own heart and finds lurking there its opposite number. One version of this relation has haunted the philosophy of language since the rise of empiricism, the suspicion that beneath words, beneath ideas, the ultimate reference in the mind is the image, the impression of outward experience printed, painted, or reflected in the surface of consciousness. It was this subversive image that Wittgenstein sought to expel from language, which the behaviorists sought to purge from psychology, and which contemporary art-theorists have sought to cast out of pictorial representation itself. The modern pictorial image, like the ancient notion of "likeness," is at last revealed to be linguistic in its inner workings.

Why do we have this compulsion to conceive of the relation between words and images in political terms, as a struggle for territory, a contest of rival ideologies? I try to suggest some detailed answers to this question in subsequent chapters, but a short answer may be provided here: the relationship between words and images reflects, within the realm of representation, signification, and communication, the relations we posit between symbols and the world, signs and their meanings. We imagine the gulf between words and images to be as wide as the one between words and things, between (in the largest sense) culture and nature. The image is the sign that pretends not to be a sign, masquerading as (or, for the believer, actually achieving) natural immediacy and presence. The word is its "other," the artificial, arbitrary production of human will that disrupts natural presence by introducing unnatural elements into the world—time, consciousness, history, and the alienating intervention of symbolic mediation. Versions of this gap reappear in the distinctions we apply to each type of sign in its own turn. There is the natural, mimetic image, which looks like or "captures" what it represents, and its pictorial

rival, the artificial, expressive image which cannot "look like" what it represents because that thing can only be conveyed in words. There is the word which is a natural image of what it means (as in onomatopoeia) and the word as arbitrary signifier. And there is the split in written language between "natural" writing by pictures of objects, and the arbitrary signs of hieroglyphics and the phonetic alphabet.

What are we to make of this contest between the interests of verbal and pictorial representation? I propose that we historicize it, and treat it, not as a matter for peaceful settlement under the terms of some all-embracing theory of signs, but as a struggle that carries the fundamental contradictions of our culture into the heart of theoretical discourse itself. The point, then, is not to heal the split between words and images, but to see what interests and powers it serves. This view can only be had, of course, from a standpoint which begins with skepticism about the adequacy of any particular theory of the relation of words and images, but which also preserves an intuitive conviction that there is some difference that is fundamental. It seems to me that Lessing, for instance, is absolutely right insofar as he regards poetry and painting as radically different modes or representation, but that his "mistake" (which theory still participates in) is the reification of this difference in terms of analogous oppositions like nature and culture, space and time.

What sorts of analogies would be less reified, less mystifying, more appropriate as a basis for historical criticism of the word-image difference? One model might be the relation between two different languages that have a long history of interaction and mutual translation. This analogy is, of course, far from perfect. It immediately loads the case in favor of language, and it minimizes the difficulties in making connections between words and images. We know how to connect English and French literature more precisely than we do English literature and English painting. The other analogy which offers itself is the relationship between algebra and geometry, the one working by arbitrary phonetic signs read progressively, the other displaying equally arbitrary figures in space. The attraction of this analogy is that it looks rather like the relation of word and image in an illustrated text, and the relation between the two modes is a complex one of mutual translation, interpretation, illustration, and embellishment. The problem with the analogy is that it is too perfect: it seems to hold out an impossible ideal of systematic, rule-governed translation between word and image. Sometimes an impossible ideal can be useful, however, so long as we recognize its impossibility.

The advantage of the mathematical model is that it suggests the interpretive and representational complementarity of word and image, the way in which the understanding of one seems inevitably to appeal to the other.

In the modern era the main direction of this appeal would seem to be from the image, conceived as a manifest, surface content or "material," to the word, conceived as the latent, hidden meaning lying behind the pictorial surface. In *The Interpretation of Dreams* Freud comments on "the incapacity of dreams" to express logical, verbal connections and latent dream-thoughts by comparing "the psychical material out of which dreams are made" to the material of visual art:

> The plastic arts of painting and sculpture labour, indeed, under a similar limitation as compared with poetry, which can make use of speech; and here once again the reason for their incapacity lies in the nature of the material which these two forms of art manipulate in their effort to express something. Before painting became acquainted with the laws of expression by which it is governed, it made attempts to get over this handicap. In ancient paintings small labels were hung from the mouths of the persons represented, containing in written characters the speeches which the artist despaired of representing pictorially.[58]

For Freud, psychoanalysis is a science of the "laws of expression" that govern the interpretation of the mute image. Whether that image is projected in dreams or in the scenes of everyday life, analysis provides the method for extracting the hidden verbal message from the misleading and inarticulate pictorial surface.

But we have to remind ourselves that there is a countertradition which conceives of interpretation as going in just the opposite direction, from a verbal surface to the "vision" that lies behind it, from the proposition to the "picture in logical space" that gives it sense, from the linear recitation of the text to the "structures" or "forms" that control its order. The recognition that these "pictures" which Wittgenstein found residing in language are no more natural, automatic, or necessary than any other sorts of images we produce may put us in a position to make use of them in a less mystified way. Chief among these uses would be, on the one

58. Trans. and ed. James Strachey (New York: Avon Books, 1965), 347.

hand, a renewed respect for the eloquence of images and, on the other hand, a renewed faith in the perspicuousness of language, a sense that discourse does project worlds and states of affairs that can be pictured concretely and tested against other representations. Perhaps the redemption of the imagination lies in accepting the fact that we create much of our world out of the dialogue between verbal and pictorial representations, and that our task is not to renounce this dialogue in favor of a direct assault on nature but to see that nature already informs both sides of the conversation.

Part Two
Image versus Text
Figures of the Difference

Emerson once noted that the most fruitful conversations are always between two persons, not three. This principle may help to explain why the dialogue between poetry and painting has tended to dominate general discussions of the arts, and why music has seemed something of an outsider to the conversation. All the arts may aspire to the condition of music, but when they set out to argue, poetry and painting hold the stage. One reason for this is that they both lay claim to the same territory (reference, representation, denotation, meaning), a territory that music has tended to renounce. Another reason is that the differences between words and images seem so fundamental. They are not merely *different* kinds of creatures, but *opposite* kinds. They attract to their contest all the contrarieties and oppositions that riddle the discourse of criticism, the very discourse that takes as one of its projects a unified theory of the arts, an "aesthetics" which aspires to a synoptic view of artistic signs, a "semiotics" which hopes to comprehend all signs whatsoever.

Despite these ambitions for theoretical unity, then, the relation between verbal and pictorial signs seems to resist stubbornly the attempt to make it a matter of neutral classification, a mere problem in taxonomy. Words and images seem inevitably to become implicated in a "war of signs" (what Leonardo called a *paragone*) in which the stakes are things like nature, truth, reality, and the human spirit. Each art, each type of sign or medium, lays claim to certain things that it is best equipped to mediate, and each grounds its claim in a certain characterization of its "self," its own proper essence. Equally important, each art characterizes itself in opposition to its "significant other." Thus, poetry, or verbal expression in general, sees its signs as arbitrary and conventional—that is, "unnatural" in contrast to the natural signs of imagery. Painting sees

itself as uniquely fitted for the representation of the visible world, whereas peotry is primarily concerned with the invisible realm of ideas and feelings. Poetry is an art of time, motion, and action; painting an art of space, stasis, and arrested action. The comparison of poetry and painting dominates aesthetics, then, precisely because there is so much resistance to the comparison, such a large gap to be overcome.

This gap has two important functions in discussions of the arts and their symbol systems: it lends an air of tough-minded common sense to assertions of difference between the arts, and it gives an air of paradoxical daring and ingenuity to assertions of sameness or transference. The topic of the text-image difference provides an occasion for the exercise of the two great rhetorical skills, wit and judgment, "wit," as Edmund Burke noted, being "chiefly conversant in tracing resemblances," and judgment concerned mainly with "finding differences."[1] Since aesthetics and semiotics dream of a theory that will satisfy both the need to discriminate artistic signs and to identify the principles that unite them, both these approaches to the topic have established themselves as traditional alternatives within the discourse of criticism.

The mode of wit, the "tracing of resemblances," is the foundation of the *ut pictura poesis* and "sister arts" tradition in criticism, the construction of analogies or critical conceits that identify points of transference and resemblance between texts and images. Although these conceits are almost always accompanied by acknowledgments of differences between the arts, they are generally perceived as violations of good judgment that criticism ought to correct. Lessing opens the *Laocoon* by observing that "the first compared painting with poetry was a man of fine feeling," not a critic or philosopher.[2] He was, as Lessing goes on to explain, Simonides of Ceos, the legendary founder of the *ut pictura poesis* tradition. Lessing characterizes Simonides as a man of feeling and wit, "the Greek Voltaire," whose "dazzling antithesis that painting is dumb poetry and poetry speaking painting, stood in no textbook. It was one of those conceits, occurring frequently in Simonides, the inexactness and falsity of which we feel constrained to overlook for the sake of the truth they contain."[3]

1. *A Philosophical Enquiry into the Origin of Our Ideas of the Sublime and the Beautiful*, ed. James T. Boulton (Notre Dame, Ind.: Notre Dame University Press, 1968), 16.
2. *Laocoon*, trans. Ellen Frothingham (New York: Farrar, Straus, and Giroux, 1969), vii.
3. *Lacoon*, ix.

In the following section I shall be concerned primarily with writers who have, like Lessing, focused their attention on the "inexactness and falsity" of the comparison of poetry and painting, who have been concerned with defining the generic difference between texts and images, and with stating the laws that govern the boundaries between the arts. I focus on these writers partly because the tradition they attack, the discourse of the sister arts and *ut pictura poesis*, has claimed most of the attention of scholars and critics, both as a tradition to explain and as a procedure to attack or correct. This emphasis on the witty comparative mode has tended to deflect our attention from the foundations of our own claims as scholars and critics to be working in a mode of judgment, of judicious discrimination and respect for difference. Specifically, it has tended to conceal from us the figurative basis of our own canons of judgment. We tend to think, in other words, that to compare poetry with painting is to make a metaphor, while to differentiate poetry from painting is to state a literal truth. What I would like to examine here is the way in which differences between the arts are instituted by figures— figures of difference, of discrimination, of judgment.

In suggesting that these judicious discriminations are figurative I do not mean to assert that they are simply false, illusory, or without efficacy. On the contrary, I want to suggest that they are powerful distinctions that effect the way the arts are practiced and understood. I do mean to imply, however, that they are literally false, or (more generously) figuratively true. My argument here will be twofold: (1) there is no *essential* difference between poetry and painting, no difference, that is, that is given for all time by the inherent natures of the media, the objects they represent, or the laws of the human mind; (2) there are always a number of differences in effect in a culture which allow it to sort out the distinctive qualities of its ensemble of signs and symbols. These differences, as I have suggested, are riddled with all the antithetical values the culture wants to embrace or repudiate: the *paragone* or debate of poetry and painting is never just a contest between two kinds of signs, but a struggle between body and soul, world and mind, nature and culture.

The tendency of poetry and painting to mobilize these hosts of opposing values is perhaps becoming more evident to us now just because we live in a world where it seems a bit odd to think of the realm of aesthetic signs as divided between poetry and painting. Since the end of the eighteenth century Western culture has witnessed a steady stream of innovations in the arts, media, and communication that make it hard

to see exactly where the line ought to be drawn. In a culture that has seen everything from the eidophusikon to the laser light-show, and which is surrounded by photography, film, television, and computers equipped for graphics, games, word-processing, information storage, computation, and general design ("programming"), it is no wonder that the polarity of "painting versus poetry" seems obsolete, and that we prefer more neutral terms like "text versus image." Of course, we might credit Lessing with having seen that all this was on the horizon. He tells us in the preface to the *Laocoon* "that, under the name of painting, I include the plastic arts generally; as under that of poetry, I may have allowed myself sometimes to embrace those other arts, whose imitation is progressive."[4] Painting and poetry for Lessing thus comprehend all possible artistic signs, since they serve as synecdoches for the entire range of temporal and spatial signification. The oddness of this figure may now be more evident to us, but that doesn't seem to prevent us from renewing it in new forms of complementary antitheses to survey the realm of signs: text and image, sign and symbol, symbol and icon, metonymy and metaphor, signifier and signified—all these semiotic oppositions reinstate, I will suggest, versions of the traditional figures of the difference between poetry and painting.

Instead of trying to survey the immense number of writers who have invoked various versions of the difference between texts and images, I have chosen to concentrate here on four prominent figures who exemplify major ways of drawing the boundary lines. I begin by looking at Nelson Goodman in the context of modern attempts to construct a general theory of symbols. Goodman's *Languages of Art* is widely recognized as one of the most rigorous and systematic approaches to such a theory, taking into consideration not only poetry and painting but a wide range of other arts and symbol systems, from music and dance to architecture, dramatic scripts, maps, diagrams, and models. From Goodman I move to the work of E. H. Gombrich, focusing on Gombrich's attempt to distinguish the share of "natural" and "conventional" signification in the pictorial arts, a distinction most fundamentally exemplified, Gombrich argues, in the difference between words and images. With this background in modern theory established, I then turn to two texts that are central to the critique of the *ut pictura poesis* tradition, Lessing's *Laocoon* and Burke's *Philosophical Enquiry into . . . the Sublime*

4. *Lacoon*, xi.

and the Beautiful. Lessing's *Laocoon* is generally acknowledged as the most formidable defense of distinct boundaries between poetry and painting, and is cited with ritual regularity on this question. Burke's *Enquiry*, on the other hand, is perhaps less widely known as an important statement on the text-image difference, but its powerful critique of the pictorialist theory of neoclassical poetics, and its association of the primary aesthetic modes (sublimity and beauty) with poetry and painting respectively, make his work central to this question.

The work of Goodman, Gombrich, Lessing, and Burke also provides a thematic overview of what seem to be the major figures of differentiation between texts and images. Goodman exemplifies the modern attempt to describe what might be called a "grammar of difference," an analysis of the text-image boundary based on the structure and function of symbolic systems. Gombrich relies on what is probably the most ancient figure of difference between verbal and pictorial signs, the opposition of nature and convention. Lessing's *Laocoon*, while it uses the entire ensemble of traditional figures of difference between the arts, grounds its categories most fundamentally in the opposition of space and time. And Burke, with his empirical, almost physiological orientation, grounds the genres in categories drawn from the structure of sensation (vision and hearing), feeling (imitation and sympathy), and aesthetic mode (the beautiful and the sublime).

The movement from Goodman to Gombrich to Lessing to Burke provides, in addition to this thematic survey, a steadily increasing sense of the moral and political significance that attaches to these figures. In Goodman's work, questions of value are deliberately suspended in favor of a purely technical analysis of sign functions: Gombrich and Lessing, I will argue, disclose an ambivalent attitude toward ideological matters, ostensibly presenting their theories as neutral inquiries into the structure of different sign-types but regularly falling into a rhetoric that appeals to structures of power and value. And Burke, finally, makes the connection between aesthetics, ethics, and politics unmistakably central. For Burke, I will argue, semiotics and ideology are inseparable.

My method in this investigation is a combination of critical analysis and historical contextualism. I am concerned, that is, with two sorts of questions about these writers. First, how adequate are the distinctions they propose as general, theoretical answers to the question of the difference between texts and images? Second, what sorts of historical pressures give rise to their work and lend it an air of authority? It may be

helpful to note that I will be discussing these writers in reverse historical order, beginning with the most recent and working toward the most remote. Each pair, moreover, has a historical and critical relationship. Goodman regularly cites Gombrich, invoking his authority on the conventionality of the pictorial arts, but also criticizing Gombrich for not having gone far enough toward conventionalism. Lessing, in a similar way, was heavily influenced by Burke's *Enquiry* in writing the *Laocoon*, although he never mentions Burke in his test and (I will argue) seems to have suppressed his debt to his predecessor.

Two final observations: first, the reader will find that the proportion of historical to critical material steadily increases as we move backward from Goodman to Burke. By the time we reach Burke, I will assume that a critique of his figures of differentiation can almost take care of itself. The primary question with Burke will be how his categories for signs and aesthetic modes take on political force in his reflections on the French Revolution. Second, it may be helpful if I simply state that, from the standpoint of pure critical theory, these readings employ a perspective closest to Nelson Goodman's. From the standpoint of historical method, they are perhaps at the greatest possible remove from Goodman, in that they attempt to raise questions of power and value in specific historical contexts.

2

Pictures and Paragraphs
Nelson Goodman and the
Grammar of Difference

Modern discussions of the relation between texts and images have tended to reduce this question to a problem of grammar. The traditional distinctions expressed in notions like time and space, nature and convention, have, in the work of modern theorists, been replaced by distinctions between different kinds of sign functions and communicative systems. We now speak of the difference between images and texts in terms such as the analogical and the digital, the iconic and the symbolic, the single- and the double-articulated.[1] These terms, drawn from fields such as systems analysis, semiotics, and linguistics, seem to promise a new, more scientific understanding of the boundaries between painting and poetry. They hold out the hope for a more rigorous definition of the difference and, especially in the work of the structuralists, the hope for a systematic way of comparing the arts. Modern theory has, in short, promised something to both sides of the traditional quarrel between the witty comparatists and the judicious differentiators of the arts: to the former it promises a higher level of generality and the prospect of large structural homologies between the arts; to the latter it offers a rigorous taxonomy that allows precise differentiation of sign-types and aesthetic modes.

In the following pages I want to suggest some reasons for suspecting that these hopes have largely been disappointed in the actual results of modern theory. While I cannot provide any thing like a full-scale anatomy of modern theory here, I do hope to show that semiotics, the very field which claims to be a "general science of signs," encounters special difficulties when it tries to describe the nature of images and the differ-

1. See Anthony Wilden, *System and Structure* (London: Tavistock, 1972), especially chapter 7 on "Analog and Digital Communication," for an encyclopedic survey of these semiotic oppositions.

ence between texts and images. These difficulties, I will suggest, are very much like the ones that plagued traditional accounts of these problems. My instrument in this anatomy will be the symbol theory of Nelson Goodman, a philosopher whose work is often linked with the modern attempt to a construct a general grammar of symbol systems, but whose ideas tend to undermine this very project as it is conceived in many modern theories. Goodman helps us to see why the supposed "advances" of modern symbol theory have largely been illusory, but he also may give us a way of understanding why they have been so influential, and what sort of questions a more adequate theory might lead us to ask.

Semiotics and Symbol Theory

Goodman's relation to other theories of symbolism is not all that obvious at first glance, partly because he is more concerned with creating his own system than with marking off his differences from others. In *Languages of Art* he acknowledges his awareness of "contributions to symbol theory by such philosophers as Peirce, Cassirer, Morris, and Langer"—the first and second generations of semiotics and neo-Kantian symbol theory— but he declines the task of spelling out his disagreements with these writers on the grounds that such a task would be "a purely historical matter" that would distract from the main project, "a general theory of symbols."[2] It is easy enough to see why Goodman would part company with the neo-Kantians, Cassirer and Langer. Of all the modern symbol theorists, they are the ones who have stayed closest to the idealist or essentialist conception of the relations between different symbol types. Langer, for instance, essentializes the media of painting and music in terms of the a-priori Kantian modes of time and space:

> Each of the great orders of art has its own primary appari-
> tion which is the essential feature of all its works. This thesis
> has two consequences for our present discussions: it means
> that the distinctions commonly made between the great
> orders—the distinction between painting and music, or po-
> etry and music, or sculpture and dance—are not false, arti-
> ficial divisions due to a modern passion for pigeonholes, but

2. *Languages of Art* (Indianapolis: Hackett, 1976), xi–xiii, cited in text hereafter as *LA*.

are founded on empirical and important facts; secondly, it means that there can be no hybrid works, belonging as much to one art as to another.[3]

For an arch-conventionalist like Goodman, the phrase that would probably stand out in this passage is the one that equates "artificial divisions" between the arts with "false" divisions, thus implying that man-made, conventional distinctions are, by virtue of their artificiality, automatically false. The contrast implied between these "false, artificial divisions" and "essential" features founded on "empirical and important facts" sets off a warning bell in the mind of a conventionalist; it also ought to sound an alarm for anyone who dislikes red herrings in arguments, and send them off in search of counterexamples to those "empirical facts" that lead us to Langer's categorical imperative: "there can be no hybrid works." An empirical survey of works that attempt graftings of verbal and pictorial signs (illustrated books, narrative paintings, films and dramas) does not immediately lead us to the conclusion that such hybrids are impossible. Even Langer's own logic of "essential" differences between the arts, aside from what the empirical facts tell us, leads to no such conclusion. One could as easily argue that such differences are a necessary condition for hybridization; the "crossing" of disparate forms to form new, composite unities makes no sense without an established set of differences, artificial or natural, to be overcome. Langer's notorious claim that "there are no happy marriages in art—only successful rape" (86) illustrates perfectly the sense of violence and violation she associates with the conjunction of artistic media, and hints (rather vividly) at its ideological basis in categories of gender.

If it is clear why Goodman—or almost anyone—would want to resist the fetishizing of artistic media that comes with Langer's neo-Kantianism, it is perhaps less obvious what grounds he would have for dispute with the semioticians. The paradigm of semiotics has always been linguistics, a field that would seem tailor-made for a conventionalist who is also a nominalist. The very title of Goodman's major book on symbol theory, *Languages of Art*, suggests that language will provide the model for all the symbolic systems, including the pictorial, that constitute the arts. Roland Barthes claims that this is precisely the thrust of semiotics as a discipline:

3. "Deceptive Analogies: Specious and Real Relationships Among the Arts," in *Problems of Art* (New York: Scribner's, 1957), 81–82.

> Though working at the outset on non-linguistic substances, semiology is required, sooner or later, to find language (in the ordinary sense of the term) in its path, not only as a model, but also as a component, relay or signified. . . . it appears increasingly more difficult to conceive a system of images and objects whose signifieds can exist independently of language: to perceive what a substance signifies is inevitably to fall back on the individuation of language; there is no meaning which is not designated, and the world of signifieds is none other than that of language.[4]

Many semioticians would be uneasy, of course, with this sort of linguistic imperialism.[5] They would want to resist Barthes' claim that "linguistics is not a part of the general science of signs, even a privileged part, it is semiology which is part of linguistics,"[6] in favor of an approach that recognizes the distinctiveness of other types of signs. As it happens, the sign-type that has proved most difficult to assimilate into semiotics has been the *icon*, the traditional contrary to the verbal sign.[7] The semiotic notion of iconicity has greater ambitions, however, than simply providing a definition of images or pictures. The icon, as C. S. Peirce defines it, is any sign that "may represent its object mainly by its similarity,"[8] a definition that expands to include everything from diagrams to maps to algebraic equations to metaphors. For Peirce, the world of signs is fully described by the trio of icon, symbol, and index—signs, that is, by resemblance or analogy, by convention (words and other arbitrary signs), and by "causal" or "existential" connection (a trace that signals its cause; a pointing finger).

One reason the icon has proved so difficult for semiotics to define is that similarity is such a capacious relationship that almost anything can be assimilated into it. Everything in the world is similar to everything

4. *Elements of Semiology,* trans. Annette Lavers and Colin Smith (1968; rpt., New York: Hill and Wang, 1977), 10–11.

5. Umberto Eco, for instance, notes that "during the sixties, semiotics was dominated by a dangerous verbocentric dogmatism whereby the dignity of 'language' was only conferred on systems ruled by a double articulation" (*A Theory of Semiotics* [Bloomington: Indiana University Press, 1976], 228).

6. *Elements of Semiology,* 11

7. Jonathan Culler dismisses the icon as "more properly the concern of a philosophical theory of representation than of a linguistically based semiology" (*Structuralist Poetics* [Ithaca, N.Y.: Cornell University Press, 1975], 17).

8. "The Icon, Index, and Symbol," in *Collected Papers,* 8 vols., ed. Charles Hartshorne and Paul Weiss (Cambridge: Harvard University Press, 1931–58), 2.276, 2:157.

else in some respects, if we look hard enough. But more fundamentally, as Nelson Goodman demonstrates, resemblance is neither a necessary nor a sufficient condition for any sort of representation, pictorial, iconic, or otherwise:

> An object resembles itself to the maximum degree but rarely represents itself; resemblance, unlike representation is reflexive. Again, unlike representation, resemblance is symmetric: B is as much like A as A is like B, but while a painting may represent the Duke of Wellington, the Duke doesn't represent the painting. Furthermore, in many cases neither one of a pair of very like objects represents the other: none of the automobiles off an assembly line is a picture of any of the rest; and a man is not normally a representation of another man, even his twin brother. Plainly, resemblance in any degree is no sufficient condition for representation. . . . Nor is resemblance *necessary* for reference; almost anything can stand for anything else. A picture that represents—like a passage that describes—an object refers to and more particularly, *denotes* it. Denotation is the core of representation and is independent of resemblance. (*LA*, 4)

One way out of this problem is to follow Umberto Eco's suggestion that semiotics consider "getting rid of 'iconic signs'" altogether:

> iconic signs are partially ruled by convention but are at the same time motivated; some of them refer to an established stylistic rule, while others appear to propose a new rule. . . . In other cases the constitution of similitude, although ruled by operational conventions, seems to be more firmly linked to the basic mechanisms of perception than to explicit cultural habits. . . . One and only one conclusion seems possible at this point: *iconism is not a single phenomenon*, nor indeed a uniquely semiotic one. It is a collection of phenomena bundled together under an all-purpose label (just as in the Dark Ages the word "plague" probably covered a lot of different diseases). . . . *It is the very notion of sign which is untenable* and which makes the derived notion of "iconic sign" so puzzling.[9]

9. *A Theory of Semiotics*, 216. Emphases are Eco's.

The problem with the notion of icon is not just that it embraces too many sorts of things, but, more fundamentally, that the whole concept of "sign" drawn from linguistics seems inappropriate to iconicity in general, and to pictorial symbols in particular. The project of linguistic imperialism runs aground on the very notion that seemed to keep it afloat, and the hope for a rigorous distinction between images and texts, pictorial and verbal signs, once again eludes us.

Or, more accurately, one might say that the same old distinctions whose inadequacy motivated the search for a "general science of signs" tend to crop up in spite of the best efforts to weed them out. The disparities within the field of iconic signs that lead Eco to regard it as an incoherent category are precisely those sorts of oppositions that have traditionally figured the difference between texts and images. Some icons are "ruled by convention but are at the same time motivated." The word "motivated" in this context stands in the place occupied by terms like "nature" in traditional accounts of the text-image difference: "motivated" signs have a natural, necessary connection with what they signify; "unmotivated" signs are arbitrary and conventional. Eco's observation that icons sometimes seem "to be more firmly linked to the basic mechanisms of perception than to explicit cultural habits" is, similarly, a semiotic redaction of the notion that (some) images are "natural signs," and amounts to a contradiction in terms for a system that begins with the notion of the sign based in language.

The failure of semiotics to provide a coherent account of imagery in its relations to other sign-types might have been predicted, I suspect, if its tendency to reintroduce these traditional distinctions in new terms had been acknowledged early on. It might have struck our notice, for instance, that Peirce's icon, symbol, and index are very much like Hume's three principles of association of ideas—resemblance, contiguity, and cause and effect:

> That these principles serve to connect ideas will not, I believe, be much doubted. A picture naturally leads our thoughts to the original. The mention of one apartment in a building naturally introduces an inquiry or discourse concerning the others; and if we think of a wound, we can scarcely forbear reflecting on the pain which follows it.[10]

10. *An Enquiry Concerning Human Understanding*, chap. 3. The weak link in this comparison is that between "juxtaposition" and the verbal symbol. It may be helpful to

Resemblance, contiguity, and causation are, in Peirce's system, converted from mental mechanisms into types of signification. A similar sort of transformation occurs in Roman Jakobson's claim that the world of figurative language is divided between metaphor, based in resemblance, and metonymy, based in juxtaposition. Jakobson's claim that the contrast between these rhetorical figures can be exemplified by the contrasting mental dysfunction in different types of aphasia makes the link between the linguistic and psychological descriptions explicit.[11]

There would be nothing wrong with this sort of redescription if it were not advertised as a liberation from metaphysics into a new science. The translation of Hume's laws of association into sign-types or modes of figuration has considerable interest. Among other things, it helps us to see just how riddled with notions of indirect, symbolic mediation are the supposedly "direct" perceptual mechanisms of the empirical tradition. The most striking example of this sort of mediation is, as we have seen, the notion of the mental or perceptual image ("ideas" and "sense-data"), which, on the one hand, seem to guarantee veridical access to the world, on the other hand to indefinitely and irretrievably distance the world through a system of intermediate signs. This double bind may be seen most clearly in the attempt of semioticians to come up with an account of the "photographic sign."

Peirce's account established the pattern for later semiotics by defining photographs as composites of iconic and indexical signs:

> Photographs, especially instantaneous photographs, are very
> instructive, because we know that they are in certain respects
> exactly like the objects they represent. But this resemblance
> is due to the photographs having been produced under such
> circumstances that they were physically forced to correspond

think of juxtaposition, not just in Hume's spatial terms, but as any sort of customary, habitual conjunction of things or signs in space or time. "Convention," then, as a "convening" or bringing together of things in associative structures, is fundamentally an act of juxtaposition which may be figurative (the bringing together of associated terms in metonymy), semiotic (the syntactic or semantic linking of signs in communication), or social (the convening of human associations). It is worth noting here that Hume regards *all* the "principles of association" as "natural" to man (i.e., "second nature") and does not single out resemblance as the uniquely natural relation.

11. "Two Aspects of Language and Two Types of Aphasic Disturbances," in Roman Jakobson and Morris Halle, *Fundamentals of Language* (The Hague: Mouton, 1956), 55–82.

point by point to nature. In that aspect, then, they belong to the second class of signs, those by physical connection.[12]

The photograph occupies the same position in the world of material signs that the "impression" does in the world of mental signs or "ideas" in empirical epistemology. And the same mystique of automatism and natural necessity hovers around these cognate notions. The idea has a double connection with the object it represents: it is a sign by resemblance, a picture painted on the mind by sensory experience; it is also a sign by causation, an effect of the object that imprinted it on the mind.

These doubly natural signs, iconic and indexical, then serve as the foundation for all further intellection and discourse. Among other things, they stand as the referents for words, which unlike the idea-impression-mental image, signify (as Locke puts it) "not by any natural connexion . . . but by a voluntary imposition, whereby such a word is made arbitrarily the mark of such an idea."[13] Ideas, by contrast, are naturally imprinted by experience and reflection: they are natural signs that (ideally) stand behind the arbitrary signs of language. The relation of words and ideas, discourse and thought, turns on the very same hinge that, in semiotics, connects the symbol with the indexical icon, the arbitrary code with the "natural" code.[14] Small wonder, then, that Roland Barthes finds himself saying the following sorts of things about photographs:

> The photograph (in its literal state), by virtue of its absolutely analogical nature, seems to constitute a message without a code. Here, however, structural analysis must differentiate, for of all the kinds of image only the photograph is able to transmit the (literal) information without forming it by means of discontinuous signs and rules of transformation. The photograph, message without a code, must thus be opposed to the drawing which, even when denoted, is a coded message.[15]

12. *Collected Papers*, 2.281, 2:159.
13. *An Essay Concerning Human Understanding*, bk. III, chap. 2, 1.
14. See Bernard Rollin, *Natural and Conventional Meaning*, (The Hague: Mouton, 1976), for a history of this distinction, mainly as it operates between symbols and indices. Rollin argues that the distinction is one of "origin," not of kind (95).
15. "Rhetoric of the Image," in *Image-Music-Text*, trans. Stephen Heath (New York: Hill & Wang, 1977), 43.

As a comment on the anthropology of photographs, a remark about the peculiar cultural status of a certain class of images, this passage seems quite accurate. The photograph, like its parent notion, the mental impression, enjoys a certain mystique in our culture that can be described by terms such as "absolutely analogical" and "message without a code." The photograph does, as Barthes claims, seem to involve a different sort of "ethic" from that associated with drawings and paintings. As a deduction of a "general science of signs," however, a research program that claims to leave metaphysics and "naive empiricism" behind, Barthes' observation seems full of blind spots. Far from leaving metaphysics and empiricism behind, it merely redescribes their basic categories in a new jargon of sign functions.

In saying that semiotics "merely redescribes" traditional accounts of the mind and aesthetic objects in terms drawn mainly from language theory, I don't mean to suggest that this redescription is lacking in force or interest. On the contrary, as a conventionalist/nominalist, I would have to admit that a systematic renaming of a field of inquiry is, in effect, an important change in the nature of that field. The shift of terms reflects important changes in the culture's understanding of its own symbolic productions, and effects changes in the way those symbols are produced and consumed. As Wendy Steiner points out:

> Semiotics has made the painting-literature analogy once
> more an interesting area to investigate, for even the dissimi-
> larities that emerge are different from those understood to
> exist before. Sign theory, we might say, has changed the
> rules of the game, and so made it worth playing. Artists in
> this century have responded to this stimulus, producing new
> orders of phenomena to be studied from this angle. The
> concrete poets, for example, quote an astonishing array of
> semiotic theories, and at least one, Max Bense, is himself a
> semiotician who composes concrete poems often in order to
> realize the theories that he has previously proposed.[16]

Understood this way, as a kind of modernist or "Cubist" rhetoric, an ensemble of terms for reflection on symbolic practices, semiotics has considerable interest. Where it "fails," however, is in its claim to be a science, its claim not merely to have changed the rules of the game but to

16. *The Colors of Rhetoric* (Chicago: University of Chicago Press, 1982), p. 32.

have a theoretical account that explains why the game must have the rules that it does. Semiotics would be better understood, in my view, in something like the way we understand Renaissance rhetoric, as a burgeoning meta-language that proliferates endless networks of distinctions and semiotic "entities." Renaissance rhetoric displays exactly the same tendency to multiply names for the tropes and figures of discourse, and the same tendency to make these figures into entities. Here is the way Gerard Genette describes this process:

> One can grasp easily enough . . . the way in which rhetoric produces figures: it ascertains a *quality* in the text that might not have been there—the poet describes (instead of designating with a word), the dialogue is abrupt (instead of connected); then it substantializes this quality by naming it—the text is no longer descriptive or abrupt, it *contains* a description or an abruption. It is an old scholastic habit: opium does not put one to sleep, it possesses a soporific power. There is in rhetoric a *passion to name* which is a mode of self-expansion and self-justification: it operates by increasing the number of objects in one's purview. . . . Rhetorical promotions are arbitrary; the important thing is to promote and thus to found an Order of literary dignity.[17]

Semiotics may be understood, similarly, as a promotional strategy for elevating the dignity of all sorts of signs and communicative activities. It is hardly an accident that semiotics breaks down the preserves of "literariness" and aesthetic elitism, that it fans out into the fields of popular culture, ordinary language, and into the realms of biological and mechanical communication. Signs are everywhere; there is nothing that is not potentially or actually a sign. The honorific title of "significance" is given to everything from the Highway Code to the Culinary Code to the Genetic Code. Nature, Society, the Unconscious all become "texts" riddled with signs and figures that refer only to other texts.

This sort of situation is tailor-made, I would suggest, for a nominalist—the sort of philosopher who tries to resist the proliferation of entities, and yet who also believes that worlds are made out of names. It is not the sort of situation that admits of regulation by gruff appeals to

17. *Figures of Literary Discourse,* trans. Alan Sheridan (New York: Columbia University Press, 1982), 53.

"objectivity" or "the real world" as a sort of gold standard to measure against the inflation in signs.[18] Nor are we likely to go back to the gold standard of aesthetic excellence, or the timeless values of humanism to establish criteria for the regulation of the uncontrolled growth of signs. What we need is a hard, rigorous relativism that regards the proliferation of signs, versions, and systems with skepticism, and yet which recognizes that they are the materials we have to work with.

Nelson Goodman's nominalism (or conventionalism, or relativism, or "irrealism") provides, in my opinion, just the sort of Occam's razor we need for cutting through the jungle of signs so that we may see just what sort of flora we are dealing with. I will be concerned here mainly with Goodman's symbol theory, and particularly his account of the difference between images and texts. My interest is not so much in his resolution of the epistemological problems connected with sign theory, but with his taxonomy of signs, and the way that taxonomy opens up the historical study of the interplay between imagery and textuality.

Goodman's Grammar of Difference

It is easy to mistake Nelson Goodman for a semiotician at first glance. He is interested in the same subjects. His study of the "languages of art" does not stop at the boundaries of the aesthetic but goes on to consider things like maps, diagrams, models, and measuring devices. His choice of "language" as a master-term suggests that he practices the same sort of linguistic imperialism as the semioticians. Indeed, a recent monograph on Goodman's work is subtitled, "Semiotics from a Nominalistic Point of View."[19] Goodman's relativism and conventionalism look, from a certain distance, very much like the pantextualism of semiotics, a way of world-making based in language.

Goodman's account of the central anomaly in semiotics, the notion of the icon, seems to confirm his allegiance to the linguistic model. Here is Goodman's summary of his classic essay, "The Way the World Is," a

18. See Gerald Graff, *Literature Against Itself* (Chicago: University of Chicago Press, 1979), for just such an appeal.

19. Jens Ihwe, Eric Vos, and Heleen Pott, "Worlds Made from Words: Semiotics from a Nominalistic Point of View," monograph (University of Amsterdam, Department of General Literary Studies, 1982).

statement that might equally well describe the course of many a philo-
sophical career in the modern era:

> The devastating charge against the picture theory of lan-
> guage was that a description cannot represent or mirror
> forth the world as it is. But we have since observed that a
> picture doesn't do this either. I began by dropping the pic-
> ture theory of language and ended by adopting the language
> theory of pictures. I rejected the picture theory of language
> on the ground that the structure of a depiction does not
> conform to the structure of the world. But I then concluded
> that there is no such thing as the structure of the world for
> anything to conform or fail to conform to. You might say
> that the picture theory of language is as false and as true as
> the picture theory of pictures; or, in other words, that what
> is false is not the picture theory of language but a certain
> absolutistic notion concerning both pictures and language.[20]

It's easy to see how this sort of talk could be misconstrued as a kind of
"absolute relativism." How can any version of the world be right or
wrong if there is no world for it to be right about? It also exhibits the
semiotic gesture of promising a "language theory of pictures" that will
destroy the boundary lines between texts and images—perhaps, like the
semioticians, to reinstate them for certain privileged exceptions such as
photographs or other images that are, as Eco puts it, "more firmly linked
to the basic mechanisms of perception than to explicit cultural habits."[21]

As *Languages of Art* unfolds, however, Goodman seems to have
outdone the semioticians at their own game. The "basic mechanisms of
perception" that seem to distinguish and endow with cognitive efficacy
certain types of images (photographs, pictures in perspective, illusion-
istic representations) turn out to be just as bound up with habit and
convention as any text: "pictures in perspective," Goodman argues, "like
any others, have to be read; and the ability to read has to be acquired"
(*LA*, 14). Photographs, for Goodman, do not have any special status as
replicas of visual experience or as "uncoded messages": "a likeness lost in
a photograph may be caught in a caricature" (*LA*, 14). The test of fidelity
is never simply "the real world" but some standard construction of the

20. *Problems and Projects* (New York: Bobbs-Merrill, 1972) 31–32.
21. *Theory of Semiotics,* 216.

world. "Realistic representation . . . depends not upon imitation or illusion or information but upon inculcation" (*LA*, 38). Goodman cites as evidence for this culturally relative view of realistic imagery the familiar observation of ethnographers that peoples who have never seen photographs have to learn how to see, that is, how to *read* what is depicted (*LA*, 15n). The "basic mechanisms of perception" that are so often invoked as transcultural foundations for the understanding of certain kinds of pictures seem to play no part at all in Goodman's theory of imagery.

It looks, in short, as if Goodman is guilty of just about every possible crime against common sense. He denies that there is a world to test our representations and descriptions against; he denies that photographs and realistic pictures depend for their status as representations on resemblance to the way things look; he reduces all symbolic forms, and perhaps even all acts of perception, to culturally relative constructions or interpretations. And this reduction of all symbols to referential conventions seems to eliminate all essential differences between different types of signs: "The relation between a picture and what it represents is . . . assimilated to the relation between a predicate and what it applies to . . ."(*LA*, 5). The trope of *ut pictura poesis* seems, in Goodman's work, to have achieved its verbal apotheosis. Pictures, like paragraphs, have to be read as an arbitrary code. The result, as E. H. Gombrich characterizes it, is "an extreme conventionalism" that would abolish all boundaries between sign-types and lead us to "the assertion that there is no difference between pictures and maps," much less between images and texts.[22]

The truth is, however, that Goodman's extreme conventionalism, while it may violate some cherished dogmas of common sense, facilitates a much more subtle and discriminating sense of generic differences among sign-types than the metaphysical categories of the neo-Kantians or the semioticians. Goodman might be faulted for overindulging the "cubist rhetoric" of semiotic relativism, but it is not difficult to see that beneath this rhetoric he in fact produces a highly rigorous set of distinctions between things like maps and pictures, images and texts. These distinctions, unlike the kinds proposed by Gombrich and the semioticians, do not depend upon an appeal to a "*share* of convention" to be

22. "Image and Code: Scope and Limits of Conventionalism in Pictorial Representation," in *Image and Code,* ed. Wendy Steiner (Ann Arbor: University of Michigan Studies in the Humanities, no. 2, 1981), 14.

divided with some proportionate share of nature. Convention, for Goodman, possesses all the shares in the enterprise of signification. For that very reason it is possible to take a clear look at exactly what sort of conventions operate in different symbolic forms such as scores, scripts, texts, diagrams, and images, and these differences need not be parsed out between the loaded binary oppositions of nature and convention but can be derived from a study of the rules that govern the actual use of symbolic forms.[23]

It must be admitted, however, that of all the generic differences in sign-types defined in *Languages of Art*, the difference between texts and images is the one that is approached most circuitously. Goodman notes at the end of his first chapter that his assault upon "copy" theories of representation has involved what may be a misleading metaphor:

> Throughout, I have stressed the analogy between pictorial and verbal description because it seems to me both corrective and suggestive. . . . The temptation is to call a system of depiction a language; but here I stop short. The question of what distinguishes representational from linguistic systems needs close examination. (*LA*, 41)

It is not till the final chapter of *Languages of Art*, after pursuing what Goodman calls an "improbable route" that includes discussions of expression and exemplification, authenticity and forgery, and the theory of notation, that he advances a direct answer to this question:

> Nonlinguistic systems differ from languages, depiction from description, the representational from the verbal, painting from poems, primarily through lack of differentiation—indeed through density (and consequent total absence of articulation)—of the symbol system. (*LA*, 226)

It may seem at first glance that Goodman is simply reiterating the traditional invidious comparison that regards imagery as an impoverished stepsister of language: the phrases "lack of differentiation" and "absence of articulation" recall the familiar claim that pictures cannot make statements or communicate precise ideas. But a closer look reveals

23. The clearest indication of Goodman's resistance to the lures of semiotic binarism is his extended treatment of musical notation in *Languages of Art*. Instead of centering everything on the difference between pictures and texts, Goodman's paradigmatic sign-types are "score, script, and sketch."

that Goodman has a positive term for these "lacks" and "absences," and that is the notion of "density," which is the contrary term to "differentiation" in his theory of notation. The difference between density and differentiation may best be illustrated by Goodman's own example of the contrast between a graduated and an ungraduated thermometer. With a graduated thermometer every position of the mercury is given a determinate reading: either the mercury has reached a certain point on the scale or it is read as being closest to that point. A position between any two points on the scale does not count as a character in the system; we round off to the closest determinate reading. In an ungraduated thermometer, on the other hand, no unique, determinate reading is possible at *any* point on the thermometer: everything is relational and approximate, and every point on the ungraduated scale (an infinite number, obviously), counts as a character in the system. Every tiny difference in the level of the mercury counts as a different indication of the temperature, but none of these differences can be assigned a unique, determinate reading. There is no possibility of finite differentiation or the "articulation" of a single reading.

How does this homely example apply to the difference between images and texts? Simply this: a picture is normally "read" in something like the way we read an ungraduated thermometer. Every mark, every modification, every curve or swelling of a line, every modification of texture or color is loaded with semantic potential. Indeed, a picture, when compared to an ungraduated thermometer or a graph, might be called a "super-dense" or what Goodman calls a "replete" symbol, in that relatively more properties of the symbol are taken into account. We don't normally see any significance in the width or color of the mercury column, but such features would make a difference in a replete graphic symbol. The image is syntactically and semantically dense in that no mark may be isolated as a unique, distinctive character (like a letter of an alphabet), nor can it be assigned a unique reference or "compliant." Its meaning depends rather on its relations with all the other marks in a dense, continuous field. A particular spot of paint might be read as the highlight on Mona Lisa's nose, but that spot achieves its significance in the specific system of pictorial relations to which it belongs, not as a uniquely differentiated character that might be transferred to some other canvas.

A differentiated symbolic system, by contrast, is not dense and continuous, but works by gaps and discontinuities. The most familiar exam-

ple of such a system is the alphabet, which works (somewhat imperfectly) on the assumption that every character is distinguishable from every other (syntactic differentiation), and each has a compliant that is unique and proper to that character. An "a" and a "d" might be written to look almost indistinguishable, but the working of the system depends upon the possibility of their differentiation, regardless of the vagaries of writing. The system also depends upon their transferability from one context to another, so that all inscriptions of "a," regardless of how they are written, count as the same letter. There are also a finite number of characters in the system, and the gaps between them are empty; there are no intermediate characters between "a" and "d" that have any function in the system, whereas a dense system provides for the introduction of an infinite number of meaningful new marks into the symbol. The picture is, in Goodman's words, syntactically and semantically "continuous," while the text employs a set of symbols that are "disjunct," constituted by gaps that are without significance.

Goodman elaborates the distinction between density and differentiation with a number of ancillary distinctions. Perhaps the most important (and potentially misleading) is the contrast between analog and digital systems. The ungraduated thermometer is "a pure and elementary example of what is called an analog computer (*LA*, 159). Any measuring device, on the other hand, that reports its reading with a determinate figure is a digital computer. Goodman warns, however, against using these terms to slip back into the symbol-icon distinction and the notion of representation by resemblance:

> Plainly, a digital system has nothing special to do with digits, or an analog system with analogy. The characters of a digital system may have objects or events of any kind as their inscriptions; and the compliants of an analog system may be as remote as we please from the characters. . . . A symbol *scheme* is analog if syntactically dense; a system is analog if syntactically and semantically dense. Analog systems are thus both syntactically and semantically undifferentiated in the extreme. (*LA*, 160)

Another distinction that is closely related to the conditions of density and differentiation is that between what Goodman calls "autographic" and "allographic" symbols—works in which the inscriptional authenticity and history of production is or is not an issue. Pictures and engravings

are autographic: it makes a difference whether we have an original or a copy, an authentic Rembrandt or a fake. With a text, on the other hand, these sorts of considerations do not normally enter in the same way. It would seem odd to speak of a forgery of *King Lear*, but if one were to attempt a forgery of a particular quarto, one would have to pay careful attention to considerations of density in the inscription of the text. Every difference would make a difference.

This last phrase may be taken as a summary of Goodman's approach to the theory of symbols. He insists that we approach any symbol system by asking what difference is made by its constitutive differences. He would agree, I suspect, with the starting postulate of the semioticians and linguists, that every symbol takes its meaning in a system of differences. But he does not begin with the assumption that we know what the difference between various symbol types is as a consequence of some prior knowledge of the essential, internal structure of their media, the mind, or the world. The differences between sign-types are matters of use, habit, and convention. The boundary line between texts and images, pictures and paragraphs, is drawn by a history of practical differences in the use of different sorts of symbolic marks, not by a metaphysical divide. And the differences that give rise to meaning within a symbol system are similarly dictated by use; we need to ask of a medium, not what "message" it dictates by virtue of its essential character, but what sort of functional features it employs in a particular context.

Goodman's system allows us to look at the differences between sign-types without reifying them in terms like "nature" and "convention," terms which inevitably import some invidious ideological comparison while claiming to be nothing more than neutral descriptions.[24] The difference between a seismographic chart of an earthquake and a line drawing of Mount Fuji is not that the former is "more conventionalized" than the latter, and not that former has a kinetic, the latter a visual, reference. The difference is between kinds of convention, a matter of contrasting syntactic and semantic function. The diagram is dense, but partly analog, partly digital; the picture is a dense, replete, analog symbol. Every difference in the thickness of the lines, every change in color or texture makes a difference for our reading of the picture. The diagram, while not completely differentiated, is subject to more constraints and

24. See chapter 3 below on Gombrich's use of nature and convention for a detailed argument on this point.

"gaps" than the sketch. Differences in color of ink, thickness of line, shade or texture of paper, do not count as differences in meaning. Only the position of the coordinates matters.

Using Goodman's terms, we can discriminate sign-types with a precision that cannot be achieved by essentialist oppositions based in the supposed "nature" of different media. His terms also serve to neutralize the vocabulary of sign-types, thus eliminating the built-in claims for epistemological or ideological superiority that so often appear in distinctions between symbolic systems. We are not tempted to found a theory of perception on the epistemological efficacy of a "dense" symbolic system, the sort of foundational move so familiar in empiricist appeals to "sense data" and "impressions." We know at the outset, in fact, that such a system has some advantages (infinite differentiation and sensitivity) and some disadvantages (it cannot give us a unique, determinate answer), and we know further that it is not likely to exist in any pure state. There is nothing in Goodman's terms to prescribe what artists can or cannot do. Hybrid works are not only possible but are eminently describable in his system. A text, whether a concrete poem, an illuminated manuscript, or a page from a novel, may be constructed or scanned as a dense, analogical system, and the results may be noted without worries over whether this violates a law of nature.[25] The only question is whether the results are interesting. The boundaries of difference are preserved: "No amount of familiarity turns a paragraph into a picture; and no degree of novelty makes a picture into a paragraph" (*LA*, 231). And at the same time the possibility of experimental or routine shifts of attention and use is allowed for: "A picture in one system may be a description in another" (*LA*, 226). A paragraph may be turned on its side and "read" as a city skyline; a picture may be riddled with alphabetic characters, and may be constructed to be read from left to right in a descending series of sequences. The particular marks or inscriptions do not dictate, by virtue of their internal structure or natural essence, the way in which they must be read. What determines the mode of reading is the symbol system that happens to be in effect, and this is regularly a matter of habit, convention, and authorial stipulation—thus, a matter of choice, need, and interest.

The attractive thing about Goodman's account of symbolism is that he is able to explain why things are so regular, what sorts of rules they

25. Textual "density," moreover, is not limited to "literal" features of the material inscription. The sounds of words, their connotation, roots, histories may all count as features in a reading that regards every difference as making a difference.

follow, while at the same time leaving plenty of room for innovation, choice, and unprecedented shifts in either the production or consumption of symbolic forms. Goodman achieves this Olympian neutrality and generality at a certain price. He deliberately avoids "questions of value and offers no canons of criticism" (*LA*, xi).[26] He professes no interest in the history of any of the arts, or even of the philosophical inquiry he is pursuing. He has little to say about certain time-honored topics such as censorship, the moral or didactic functions of art, the issues of politics and ideology that enter inevitably into the making and using of art. He doesn't question, most fundamentally, the historicity of the concept of art itself, and seems to proceed on the assumption that this is simply a universal category that can be described from a neutral, analytic perspective.[27] These severe limitations open Goodman to certain kinds of predictable objections. One would be that his stance "beyond ideology" is a typical piece of bourgeois self-deception, and that no theory of art worth the name can proceed without implicit or explicit alignments. Goodman's work, historically speaking, could then be dismissed as a typical product of a certain kind of modern mentality, the same attitude that gave us things like analytic philosophy and "value-free" social science.

There is, in one sense, no answer to this kind of criticism, and I am not all that sure that this is any grounds for dissatisfaction with Goodman's system. Goodman is, without a doubt, totally uninterested in politics,

26. *Languages of Art*, xi. See, however, *Ways of Worldmaking* (Indianapolis: Hackett, 1978), 138–40, where Goodman suggests that aesthetic "rightness" is "primarily a matter of fit"—fit between versions, worlds, and practices, and conformity to "authoritative" texts for rightness. Goodman's aesthetic values are both formalist and functionalist, grounded in "fitness" as a matter of utility and conformity. "Good" or "valuable" or "right" innovations in art, therefore, are not just violations of previous criteria of fitness but coherent articulations of new criteria: "A Mondrian design is right if projectible to a pattern effective in seeing a world. When Degas painted a woman seated near the edge of the picture and looking out of it, he defied traditional standards of composition but offered by example a new way of seeing, of organizing experience." What Goodman's formalism might rule out, then, would be a work of art whose value was seen to lie in its failure to project a coherent world, its refusal to adhere to any criteria of fitness.

27. Goodman's suggestion that we replace the question "What is Art?" with "When is Art?" in *Ways of Worldmaking*, 57–70, indicates the openness of his categories to historical application. When Goodman pursues this question in search of "symptoms of the aesthetic," however, the symptoms turn out to be very much like the canons of modern formalism: density, repleteness, expressive or exemplificational richness, and "multiple or complex reference" (see pp. 67–68). A historical application of Goodman's terms, then, would have to begin by asking whether there are practices in or out of the modern, Western tradition of the arts that violate many of these symptoms.

and if he has any aesthetic preferences or moral program, they are not paraded in *Languages of Art*. The closest approximation to Goodman's ideology would be liberal pluralism, a systematic tolerance for a variety of competing versions, theories, and systems, but with certain limitations to this tolerance. Goodman is intolerant of Platonists in philosophy and absolutists in life (the imputation of ideological bad faith from a position of Marxist "objectivity" would probably leave him quite unmoved). There is a certain puritanical severity about his structures on mysticism, and his continual debunking of both purist and "gee whiz" theories of art. His great values are rigor, simplicity, clarity, scope, and rightness. All the relativism notwithstanding, Goodman's work has been devoted to the problem of how we tell a right version from a wrong version. There may be many true accounts of the world, in his view, but there are surely even more false ones.

The one place where Goodman's refusal to consider ideological matters might conceivably blind him to matters of central importance to his theory is in his treatment of realism. Goodman dissolves the whole problem of realistic representation by treating it as a matter of habit and inculcation rather than illusion, information, or resemblance.

> Realism is relative, determined by the system of representation standard for a given culture or person at a given time. Newer or older or alien systems are accounted artificial or unskilled. For a Fifth-Dynasty Egyptian the straightforward way of representing something is not the same as for an eighteenth century Japanese; and neither way is the same as for an early twentieth century Englishman. . . . We usually think of paintings as literal or realistic if they are in a traditional European style of representation. (*LA*, 37)

The problem with this equation of realism with the familiar, the traditional, and the "standard," is that it fails to take into account the prior question of what values may underwrite the standard. It is entirely possible for some style of depiction to become familiar, standard, and normal without its ever laying claim to "realism." The standard way of representing the Goddess Durga in Bengali ritual is with a clay pot, and this pot is thought of as an "icon" of the Goddess, a symbol that contains the essential reality it denotes.[28] Yet the familiar, habitual, and standard

28. I owe this example to Ralph Nicholas of the Department of Anthropology, University of Chicago.

way of depicting Durga is not regarded as "realistic" in anything like the way we regard realistic pictures in Western culture.[29] "Realism" cannot simply be equated with the familiar standard of depiction but must be understood as a special project within a tradition of representation, a project that has ideological ties with certain modes of literary, historical, and scientific representation. No amount of familiarity will make Cubism or Surrealism "look" (or, more importantly) *count as* realistic, because the values that underwrite these movements work at cross-purposes with those of realism.[30]

Goodman's refusal to deal with these sorts of values may leave him with certain blind spots, but it does not, I think, lead to any serious or damaging objections to his system. The great value of Goodman's severe self-limitation, his refusal to engage questions of ideology in his discussions of symbols, is that this very neutrality, paradoxically, provides a basis for gauging more precisely the ideological appeals built into the work of other writers on the theory of symbols. Goodman's ahistorical, functionalist approach to sign-types clears the ground for a positively historical understanding of symbols by making it evident just what sorts

29. In conversations with Goodman about this point he has suggested that ritual objects such as the clay pot symbolizing Durga may not be "representations" in his sense—i.e., characters in dense or replete symbolic systems. While it is true that this sort of ritual object does not have the sort of *visual* density and repleteness we associate with Western pictorial representation, it does have other features that seem answerable to the criteria of representationality in Goodman's special sense. The pot is an autographic symbol in that the history of its production and preparation for use is crucial; it has, as a literal and metaphoric "vessel," analogical aspects; most fundamentally, its use entails a system in which a great many features of the pot make a syntactic or semantic difference, thus satisfying something like the conditions of density and repleteness, though not, to be sure, in a visual or pictorial sense.

30. Goodman has refined his account of realism in "Realism, Relativism, and Reality," *New Literary History* 14:2 (Winter, 1983), 269–72, without changing it in essentials. He discriminates three sorts of realism: (1) that which "depends upon familiarity; . . . the accustomed, standard mode of representation;" (2) that which achieves "what amounts to a revelation," as in the invention of perspective and the rediscovery of the "Oriental mode by late nineteenth century painters"; and (3) the "depiction of actual as contrasted with imaginary beings," with "actual" understood, not as historically existent, but as a type of fictional entity (Harry Angstrom as contrasted with the March Hare). It is interesting to note that Goodman's first example of "revelatory" realism (the invention of perspective) is identical with his main examples of customary or standard realism. My only demurral here would be that some revelations (perspective for instance) have a special status in a culture that cannot be explained simply by the fact that "practice palls"(269), leading us to look for "fresh and forceful" new modes of representation. The question of why a practice palls, and why a new, revelatory mode rapidly acquires the status of a transhistorical, transcultural standard can't be answered in terms of familiarity or novelty, but must take up questions of value, interest, and power.

of habits and choices are involved in the construction of particular conventions. He makes it possible to ask, for instance, just what values and interests are served by the traditional figures of difference between the arts, especially poetry and painting. While it is no doubt inevitable that his work will be superseded and become part of that history of philosophy he declines to reflect on, and while his particular agenda of values and interests may come to seem less compelling as it becomes more clear, in the meantime he provides a point of departure for a historical inquiry into the question of the text-image difference, an inquiry that raises all the questions of human interest Goodman chooses to suspend.

Not that Goodman is completely successful in suppressing his sense of the values associated with his position. In his summary remarks concerning the text-image difference, Goodman hints that his neutrality may not be so neutral after all:

> This all adds up to open heresy. Descriptions are distinguished from depictions not through being more arbitrary but through belonging to articulate rather than to dense schemes; and words are more conventional than pictures only if conventionality is construed in terms of differentiation rather than of artificiality. Nothing here depends upon the internal structure of a symbol; for what describes in some systems may depict in others. Resemblance disappears as a criterion of representation, and structural similarity as a requirement upon notational or any other languages. The often stressed distinction between iconic and other signs becomes transient and trivial; thus does heresy breed iconoclasm. Yet so drastic a reformation was imperative. (*LA*, 230–31)

We need to ask ourselves what words like "heresy," "iconoclasm," and "reformation" are doing in this context. Perhaps Goodman's neutrality is not so Olympian after all; perhaps his puritanism is not so pure but has certain remote connections with the kind that has linked political reformation to the destruction of certain kinds of images and notions of imagery. For Goodman's iconoclasm to make any sense, then, we need to look at the sort of idolatry that provokes it, an inquiry that leads us directly to E. H. Gombrich.

3

Nature and Convention
Gombrich's Illusions

> I believe that painting's power over men is greater than that of
> poetry, and base this opinion on two reasons. The first is that
> painting works on us by means of the sense of sight. The second is
> that painting does not employ artificial signs, as does poetry, but
> natural signs. It is with these natural signs that painting makes its
> imitations.
>
> Abbé Dubos, *Critical Reflections on Poetry and Painting* (1719)

The most ancient and influential figure of the difference between images
and words is unquestionably the distinction between "natural" and
"conventional" signs. Plato is credited with being the first to have
systematized this distinction (in the *Cratylus*), but it seems to be such a
universal commonplace that there is no reason to suppose it originated
with him. On the contrary, if the nature-convention distinction is, as its
proponents claim, just a true and inevitable way of defining the differ-
ence between texts and images—that is, if it is a "natural" distinction for
us to make—then it is hard to see how human beings could ever have
done without it. It can hardly be a historical invention, or an intervention
in history, but must be more like a foundational moment for whatever
we understand by human nature. To be human at all is to sense a
difference between ourselves and the rest of creation, to sense ourselves
as creatures living in time, creating tools and symbols, and fashioning for
ourselves an environment that is "unnatural"—i.e., conventional, cul-
tural, and artificial. Insofar as the difference between words and images is
a matter of nature versus convention, then, it tends to present itself as
primal, immemorial, and originary. Man may be created "in the image"
of God, but the distinctly human capacity is neither the production nor

the perception of images, abilities which man seems to share with animals. To be human is to be endowed with the power of speech, the capacity that lifts us out of the state of nature and makes culture, society, and history possible.

The distinction between nature and convention is applied, of course, to many other matters besides sign-types, and to other signs besides words and images. Some critics have argued that musical signs are also "natural" in contrast to the conventional signs of language,[1] and the distinction plays an important role in ethics and theory of knowledge, where the issue is whether goodness and truth are matters of objective, natural necessity or "mere" convention, custom, and agreement. Nature has tended to get the worst of this debate in recent years. A modern consensus of cultural relativism, skepticism, and historicism has made the old notion of "Nature" with a capital N something of an anachronism.[2] But anachronisms have a way of coming back to haunt us in new forms. One strategy for retrieving the force of the natural has always been available in the venerable concept of "second nature," the level of cultural and social custom that is so habitual, so regular, that it seems beyond dispute. This way of using the term "nature," however, makes it virtually synonymous with "convention," as we might note from our tendency to use the word "natural" interchangeably with "normal" and "customary." This version of the distinction between nature and convention is simply a matter of degree, not kind, the difference between conventions that are abiding, deep, and widespread, and conventions that seem relatively arbitrary, changeable, and super-ficial.

In the following pages I will not be primarily concerned with this "soft" version of the nature-convention distinction, but with the harder, more "metaphysical" version that is generally traced back to Plato. The hard version of the nature-convention distinction treats it as a difference of kind, not degree, regarding "nature" as something biological, objec-

1. See James Harris, "A Discourse on Music, Painting, and Poetry," in *Three Treatises* (London, 1744), 58n: "A figure painted, or a composition of musical sounds have always a natural relation to that, of which they are intended to be a resemblance. But a description in words has rarely any such natural relation to the several Ideas, of which those words are the symbols. None therefore understand the description, but those who speak the language. On the contrary, musical and picture-imitations are intelligible to all men."

2. For an excellent survey of recent thinking on the nature-convention distinction in analytic philosophy, see Hilary Putnam, "Convention: A Theme in Philosophy," *New Literary History* 13:1 (Autumn, 1981), 1–14.

tive, and universal, "convention" as something social, cultural, and local or regional. I will not be concerned primarily with the general use of this strong version of the distinction, but with its application, as in Plato's *Cratylus*, to the particular question of the difference between words and images, and even more narrowly, to the difference between various kinds of images. I have selected the work of Ernst Gombrich as a case study in this problem because he is probably the most influential modern commentator on the relative share of nature and convention in imagery, and because he has been identified at various items with both sides of the debate. Gombrich has appeared at some times as an arch-conventionalist, arguing for an understanding of imagery based in the model of language. More recently he has tended to argue for "the commonsense distinction between images which are naturally recognizable because they are imitations and words which are based on conventions," a position whose authority he traces back to Plato's *Cratylus*. What concerns Gombrich is not the rather fanciful arguments made by Socrates for a "picture theory" of language in which words naturally resemble what they represent, but the fact that "the participants in the dialogue take it for granted that whatever may hold for words, pictures, visual images, are natural signs."[3]

I will return to Gombrich's use of the nature-convention distinction and his reliance on Plato's *Cratylus* later in this chapter. First, however, it may be useful to take an overview of just what the issues are in the commonplace distinction between words and images as conventional and natural signs. The debate over the role of nature and convention intersects in two places with the distinction between words and images. The first might be called the issue of "right labeling": are images properly labeled as "natural signs," and words as conventional (i.e., arbitrary, customary, or "instituted") signs? The second issue might be called the question of "relative goodness": once the labels of different sign-types are in place, what follows with regard to their relative power as signs? What sorts of claims to truth and communicative efficacy can be made on behalf of conventional and natural signs? The debate of Plato's *Cratylus* perfectly illustrates the interplay of these two questions: most of the dialogue is concerned with the issue of right labeling, exemplified by Socrates' efforts to convince Cratylus that words are not conventional,

3. Gombrich, "Image and Code: Scope and Limits of Conventionalism in Pictorial Representation," in *Image and Code*, ed. Wendy Steiner (Ann Arbor: University of Michigan Studies in the Humanities, no. 2, 1981), 11. Hereafter cited as LC.

customary signs but have a natural connection of resemblance with what they name, just as images do. This debate rests, of course, on prior assumptions which are not explicitly in question: the assumption that "whatever may hold for words," as Gombrich puts it, "pictures, visual images, are natural signs" (LC 11); and the assumption expressed by Cratylus and confirmed by Socrates that "representing by likeness the thing represented is absolutely and entirely superior to representation by chance signs."[4]

The use of the nature-convention distinction to underwrite claims for the superiority of images to words or vice versa is best illustrated in the tradition of the *paragone,* or contest of painting and poetry. Leonardo da Vinci, for instance, employs the Platonic assumption of the superiority of "natural likeness" to support his claim that painting is a higher art than poetry. For Leonardo, painting is an art which is doubly natural: it imitates natural objects, the handiwork of God, in contrast to poetry, which contains "only lying fictions about human actions"; and it performs this imitation with the techniques of a natural, scientific means of representation that guarantees its truth.[5] Shelley, on the other hand, uses the nature-convention distinction to make precisely the opposite case. Poetry is superior to the other arts precisely because its medium is *unnatural:* "language is arbitrarily produced by the Imagination and has relation to thoughts alone."[6]

It should be clear that acceptance of the distinction between nautral and conventional signs does not dictate any particular position about the relative superiority of sign-types. But it should also be clear that these terms are rarely used without some claims for relative value. The typical rhetorical moves that occur in the contest between word and image have an almost ritual familiarity because they repeat, in the context of a debate over sign-types, the age-old quarrel between nature and culture. Thus, when the conventionality of language is invoked to make a case for its superiority to imagery, the arbitrary sign becomes a token of our freedom from and superiority to nature; it signifies spiritual, mental things, in contrast to images which can only represent visible, material objects; it

4. *Cratylus* 434a, trans. H. N. Fowler (Cambridge: Harvard University Press, 1926); 169. All further references will be to this edition.

5. *Treatise on Painting,* trans. A. Philip McMahon (Princeton: Princeton University Press, 1956), 19, 16.

6. *Shelley's Poetry and Prose,* ed. Donald H. Reiman and Sharon B. Powers (New York: W. W. Norton, 1977), 483.

is capable of articulating complex ideas, stating propositions, telling lies, expressing logical relations, whereas images can only show us something in a mute display. When claims are made that some kinds of images (allegories, history paintings) can tell stories or articulate complex ideas, the answer is usually that the image "in itself" does not express these things, except by parasitical dependence on verbal supplements—titles, commentaries, etc. The notion that images are "natural signs," then, can be used to their disadvantage by construing "nature" as a lower region of brute necessity, inarticulate instinct, and irrationality. Pictures, precisely because they are "natural signs," can convey only a limited and relatively inferior sort of information, suitable for beings in a "state of nature"— children, illiterates, savages, or animals.

All these examples of the natural inferiority of imagery can be turned around to make a case for its superiority. The naturalness of the image makes it a universal means of communication that provides a direct, unmediated, and accurate representation of things, rather than an in- direct, unreliable report about things. The legal distinction between eyewitness evidence and hearsay, or between a photograph of a crime and a verbal account of a crime, rests on this assumption that the natural and visible sign is inherently more credible than the verbal report. The fact that the natural sign can be decoded by lesser beings (savages, children, illiterates, and animals) becomes, in this context, an argument for the greater epistemological power of imagery and its universality as a means of communication. Gombrich makes this point in his discussion of the famous "Beware of the Dog" mosaic in Pompeii: "you will soon understand a radical difference between the picture and the word. . . . To understand the notice you must know Latin, to understand the picture you must know about dogs" (LC 18).

For Gombrich, the verbal inscription gets to its meaning through an indirect, circuitous route, the mediation of an arbitrary code known only to a few scholars. The picture, on the other hand, reaches right out to the object it represents, and to the viewer it addresses. It is a "natural sign," according to Gombrich, because it does not depend to the same degree upon "acquired knowledge." I am convinced," says Gombrich, "that we do not have to acquire knowledge about teeth and claws in the same ways in which we learn a language" (LC 20). If the image involves a code, it is not an arbitrary or conventional one, but something like a biological program: "our survival often depends on our recognition of meaningful features, and so does the survival of animals. Hence we are programmed

to scan the world in search of objects which we must seek or avoid"
(LC 20).

Gombrich's testimony on the subject of natural and conventional
signs is especially interesting because he has been one of the chief
proponents of the view that pictorial signs are riddled with convention.
There was a time when we could have expected him to argue that we
need to know about more than dogs and teeth and claws to understand
the Pompeiian mosaic: we would need to know something about the
"language" or conventions of pictorial representation, especially the
highly stylized conventions of mosaic.[7] This position has now become
something of an embarrassment to him. He opens his recent article on
the "Limits of Convention" with the following confession: "I am afraid
I must plead guilty to having undermined this plausible view" that
"images . . . are naturally recognizable because they are imitations and
words . . . are based on conventions" (LC 11).

Gombrich's "undermining" of the nature-convention distinction
occurs most notably in *Art and Illusion* (1956), unquestionably his most
influential book. There Gombrich argued that pictorial representation is
not simply a matter of copying what we see, but is a complex process
involving stylized "schemata," a vocabulary of conventional forms that
must be manipulated in their own terms before any "matching" to visible
appearances can occur. Gombrich expanded this formula beyond the
traditional boundaries of the aesthetic to include what we might call the
"ordinary languages" of imagery in advertising and popular culture.
"Even pin-ups and comics," Gombrich argued

> may provide food for thought. Just as the study of poetry
> remains incomplete without an awareness of the language of
> prose, so I believe, the study of art will be increasingly sup-
> plemented by inquiry into the linguistics of the visual image.
> Already we see the outlines of iconology, which investigates
> the function of images in allegory and symbolism and their
> reference to what might be called the "invisible world of
> ideas." The way the language of art refers to the visible
> world is both so obvious and so mysterious that it is still
> largely unknown except to artists themselves who can use it

7. The mosaics of Ravenna, in fact, are cited as examples of conventionalized art in the
same essay where the "Cave Canem" mosaic is adduced as an example of a "natural" image.
Cf. LC 12 and 18.

as we use all languages—without needing to know its grammar and semantics.[8]

This notion of a "language of art," Gombrich insists later in *Art and Illusion,* is "more than a loose metaphor"; it is a founding premise of an iconology or "linguistics of the image," and it "clashes with the traditional distinction . . . between spoken words which are conventional signs and painting which uses 'natural' signs to 'imitate' reality." The Gombrich of 1956 declared that the distinction was "plausible . . . but it has led to certain difficulties," and "we have come to realize that this distinction is unreal" (*Art and Illusion,* 87).

If the comparison of images to language was "more than a loose metaphor," however, it was not without limits, even in *Art and Illusion,* and much of Gombrich's subsequent work has been devoted to spelling out those limits. Gombrich's vast array of examples and his rhetorical virtuosity make it difficult to decide just how firmly, and at what specific points, he wants to reinstate the distinction. Sometimes it seems as if he is simply clarifying what should have been obvious all along in *Art and Illusion,* other times as if he has really changed his mind. My view is that his position has not changed in fundamentals, and that he was committed to the nature-convention distinction from the first. What has changed is the audience and context for Gombrich's work. Convinced by his arguments for a "linguistic" view of imagery, a generation of scholars has pursued the implications of this metaphor in far-reaching and systematic ways that go well beyond the limits Gombrich had in mind. When Gombrich argues this question nowadays, then, he feels no need to argue for the conventionality of imagery but sees his task as one of arguing against the conventionalist consensus he helped to form. His argument is no longer with the naive "copy theory" of representation but with what he tends to regard as the oversophisticated relativism and conventionalism of semioticians and symbol theorists.[9]

What, then, are the limits of Gombrich's conventionalism? In his essay on this subject, Gombrich reviews some of his own claims "that there is something like a language of pictorial representation" (LC 12). He notes the uncontroversial character of this claim, pointing out "that most art historians have agreed that in past styles images were frequently

8. *Art and Illusion* (Princeton: Princeton University Press, 1956), 9.
9. Nelson Goodman and Marx Wartofsky are the theorists Gombrich mentions in "Limits of Convention" as "extreme relativists."

made with the aid of conventions that had to be learned." He suggests that this analysis is "particularly compelling" in the study of "closed and hieratic" styles like that of Egyptian art, or of "comparable conventions . . . in the painting of the Far East" (LC 12). It is important to note the reservations that Gombrich builds into his acknowledgment of the power of convention, reservations that are not spelled out but implied by certain crucial qualifiers. Art historians have agreed that conventions were operative in "past styles," a phrase which suggests that they are less important in more recent or present styles. Convention seems to be "particularly compelling" in imagery that comes from long ago or far away—the "closed and hieratic style of Egypt," and the "painting of the Far East." The implication is that the rule of convention is *not* particularly compelling in Western art, which as a consequence, is *not* "closed and hieratic" but (presumably) open and demotic.

But Gombrich is too skilled a rhetorician to let us settle the boundaries between conventional and naturalistic images quite so easily. Just when we are ready to read these boundaries in terms of the opposition between ancient and modern, Eastern and Western, he pulls the rug from under us by bringing up examples of convention in more recent Western art:

> Any art historian will remember examples from other fields; thus, I elsewhere [*The Heritage of Apelles,* 1976] discussed the convention of rendering rocks which extends from late antiquity, as in the mosaics of Ravenna, to the art of the quattrocento and beyond. Even Leonardo made use of them in the grandiose visions of landscapes he drew from his imagination. I never asserted that Leonardo's drawings do not represent nature more closely than earlier conventions, let alone that no picture of a landscape—for instance a picture postcard—can be a more faithful rendering of a view than the background of the *Mona Lisa.* (LC 12)

The double negatives at the end of this passage make it difficult to see at first glance just what Gombrich is asserting, or claiming that he did assert at one time. Two things seem clear: Gombrich believes that Leonardo's drawings "represent nature more closely than earlier conventions," and there are some other pictures (postcards, for instance) that can provide an even "more faithful rendering of a view" than we find in Leonardo's backgrounds. Conventions seem to get attenuated in this account: they extended "to the art of the quattrocento and beyond," and

"even Leonardo made use of them"—but only, it should be noted, in "landscapes he drew from his imagination," not (presumably) in those he drew from nature. At some point—it is difficult to say just where—convention lost its control over pictorial representation. Was it in Leonardo's "realistic" landscapes? In picture postcards? Or does it continue to function in a different way even in these relatively naturalistic images? Is it just that some kinds of conventions are more suitable than others for "faithful rendering of a view"? If this is the case, then we have certainly not found the *limits* of convention, but have simply observed that *some* conventions are credited with special powers of fidelity and naturalness. The entire range of images remains within the realm of convention, but some conventions are for some purposes ("realism," say) and some are for other purposes (religious inspiration, for instance). "Nature" is not antithetical to convention, but is simply a figure for a certain special kind of convention—the kind found in postcards and, to a lesser extent perhaps, in the *Mona Lisa*. "Nature," in this reading of Gombrich's argument, is only "Second Nature," not physical necessity.

I suspect that Gombrich would resist this reading. It seems clear from the rest of his essay that he regards the claim for the "naturalness" of illusionistic painting since the invention of perspective as a literal truth, not as a figure. Perspective is not simply one way, one conventional procedure, for representing the visible world, but occupies a privileged position that Gombrich sees epitomized by "the objective, non-conventional element in a photograph" (LC 16):

> Perspective is the necessary tool if you want to adopt what I now like to call the "eye-witness principle," in other words if you want to map precisely what any one could see from a given point, or, for that matter what the camera could record. (LC 16)

Gombrich concedes that a photograph (or "a black and white photograph at any rate") "is not a replica of what is seen" (thus implying that a color photograph *is* a replica?) but a "transformation which has to be re-translated to yield up the required information" (LC 16). But this admission that some photographs (black and white, not color) are "transformations" rather than "replicas" does not, Gombrich insists, justify our seeing them as conventional representations:

> the fact that they are thus transformed does not entitle us to call them an arbitrary code. They are not arbitrary, because a

gradation from dark to light observed in the motif will still appear as such a gradation even if reduced in span. It was to secure this analogy, after all, that from the very beginnings of the technical process photographers converted their "negatives" into "positives." It is perfectly true that the trained eye can also read a negative, but I am convinced that more learning is involved in this transformation than in the reading of a normal photograph. The lack of correspondence between image and reality is less obtrusive in the latter case than in the former. In fact the widespread view has recently been challenged that the conventional element in photographs bar naive subjects from reading them. . . . At any rate it appears that learning to read an ordinary photograph is very unlike learning to master an arbitrary code. A better comparison would be with learning the use of an instrument. (LC 16)

It is important to take note of the way the distinction between natural and arbitrary signs has shifted its ground in the course of Gombrich's argument, always approaching but never quite reaching the goal of the natural sign, and leaving in its wake a host of examples that begin by looking "natural" but end by looking relatively arbitrary. First it is images in general that are natural signs in comparison to the conventional signs of language. Then it is certain kinds of images (Western illusionistic paintings, photographs) that are natural compared to the relatively stylized and conventional images of Egyptian or Far Eastern art. Then it is color photography versus black and white, and finally, the positive versus the negative, that occupies the relative position of naturalness. At the point when the "natural" comes to seem little more than that which is easily learned, however, Gombrich seems to realize that the whole distinction is in trouble:

As soon as we approach our problem from this angle, the angle of ease of acquisition, the traditional opposition between "nature" and "convention" turns out to be misleading. What we observe is rather a continuum between skills which come naturally to us and others which may be next to impossible for anyone to acquire. . . . If we grade the so-called conventions of the visual image according to the relative ease of difficulty with which they can be learned, the problem

shifts to a very different plane. What must be learned, as we
have seen, is a table of equivalences, some of which strike us
as so obvious that they are hardly felt to be conven-
tions . . . while others are chosen "ad hoc" and must be
memorized piecemeal for the occasion. (LC 16–17)

So much for the "natural sign," which turns out to be nothing more
than the easy or convenient sign, the one we are accustomed to, the one
we learn to use without difficulty. On this basis, of course, the whole
distinction between images and words as natural and conventional signs
collapses. Is it easier for us to acquire linguistic or pictorial skills? The fact
that we call the arbitrary codes of French, German, and English "natural
languages," and that children learn them without much deliberate effort
suggests that they are, in terms of ease of acquisition, no less natural than
images. That does not mean that there is no difference between words
and images; only that the difference cannot be coherently defined on the
basis of nature and convention understood as the "easy" and the "dif-
ficult." On the basis of ease of acquisition, we could make the argument
that images are the more "conventional" sign, since their production
requires special skills and training that not everyone is expected to
master, whereas everyone is expected to speak the natural language of his
or her community.

But Gombrich is not willing to relinquish the master distinction
between natural and conventional signs even when his own analysis
reveals it to be "misleading." His argument for the "naturalness" of
imagery is based, he might point out, on the *consumption* rather than the
production of images. It may be an artificial act requiring special skill to
make an image, but to *see* what it means or represents is just as natural as
opening your eyes and seeing objects in the world.[10] Thus, certain
essential features of imagery are not arbitrary or conventional but are just
"given" by the nature of our sensory equipment:

10. There are several ways to answer this rejoinder. One would be to point out that the
comparison of consumption processes is pitched at the wrong level, and that *hearing*, not
reading, is the proper counterpart to seeing the world. Another would be to note that the
viewing of images is quite different from looking at the world. But the most fundamental
response would be to ask just how "natural" the viewing of "the world" is. If by "natural"
we mean that there is considerable agreement about the way the world looks, then we need
to look into the bases of those agreements to ascertain which ones are based in biology and
which are conventions grounded in shared understandings of what the world is.

> It has often been said that the outline is a convention be-
> cause the objects of our environment are not bounded by
> lines. No doubt this is true and as any photograph shows,
> outlines can easily be dispensed with as long as there are suf-
> ficient gradients in the distribution of light to indicate the
> termination of individual things in space. And yet it appears
> that the traditional view of the contour as a convention is
> based on an oversimplification. Things in our environment
> are indeed clearly separated from their background, at least
> they so detach themselves as soon as we move. The contour
> is the equivalent of this experience. (LC 17)

Contour is not just one conventional way of indicating the separations
of things from their background; it is the "equivalent" of this experience,
not a "sign" for it. This claim is made in the same breath with what
one would suppose to be a devastating counterexample; photographs,
which previously have served as the paradigmatic "objective, non-
conventional" image, show that "outlines can easily be dispensed with"
and that there are other ways of representing the separation of objects
from their backgrounds. Indeed, we must suspect that there are many
other ways (contrasts of light and dark; color differentials; differences in
texture, reflectivity, hue, saturation; differences in materials, as in col-
lage; differences in notational schemes, such as cross-hatching and dot-
and-lozenge in engraving), and that these ways would be limited only by
the inventiveness of graphic artists in coming up with new conventions.
Contour is simply one device among many used by graphic artists to
mark differences, contrasts, or express meaning. And it has to be noted
that contour is not limited to the demarcation of objects from their
backgrounds; it can indicate differences within an object (folds, creases,
wrinkles) or on its surface, or it can express meanings that have nothing
whatsoever to do with the representation of objects in space. Far from
being the "nature" that is represented by the "convention" of outline,
contour is simply one among many interpretations that may be given to
an outline.

Why, then, does Gombrich single out contour as the natural, noncon-
ventional sign, the "equivalent" of what it stands for? Or perhaps we
should ask a more fundamental question: why does Gombrich persist in
trying to isolate *any* kind of sign as the natural one, in view of his
admission that the whole distinction between natural and conventional

signs is misleading? What is it that leads him to junk this distinction on one page in favor of a continuum between the easy and the difficult, and then to reinstate "a radical difference between the picture and the word" on the very next page? I don't mean to suggest that Gombrich has any sinister motives in these apparent contradictions, or that he is the kind of thinker who likes to be thought paradoxical. The question of why these arguments seem convincing to Gombrich, why the contradictions are not evident, might just as easily be addressed to ourselves, the generation of readers who have been beguiled by Gombrich's vast learning, wit, and argumentative skill. What is it in our own cultural habits of image production and consumption that makes Gombrich's notion of the image as a "natural sign" so persuasive and conceals its contradictory character?

One answer is simply Gombrich's uncanny rhetorical agility, particularly his knack for playing both sides of the street on the nature-convention question. Call Gombrich a naturalist or naive realist and he will parade before you a host of examples showing conventional elements in imagery; call him a conventionalist or relativist and he will come back with a statement like the following:

> Western art would not have developed the special tricks of naturalism if it had not been found that the incorporation in the image of all the features which serve us in real life for the discovery and testing of meaning enabled the artist to do with fewer and fewer conventions. This, I know, is the traditional view, I believe it to be correct. (LC 41)

Gombrich's power stems from his ability to retain "the traditional view" of imagery while flirting with notions that seem innovative, modern, or which approach the boundaries of common sense. When the philosophers object that one of Gombrich's favorite terms, "likeness," is useless unless it is stipulated in what respects two things are to be compared, Gombrich's reply is likely to be that "this would be all very well if images were made by students of logic for students of logic" (LC 18). In the world of common experience to which Gombrich appeals, the power of things like likeness and resemblance is precisely that their "respects" don't have to be stipulated. Photographs just look like the world: we can see what a picture is of without having to learn any codes. And Gombrich's axioms of common experience, uncorrupted by philosophical quibbles, are invariably ratified by a further appeal to the "state

of nature," the realm of animal behavior. This is the world of Konrad Lorenz and the sociobiologists, the place where the "natural sign" appears in its purest form: "the fish that snaps at the artificial fly does not ask the logician in what respect it is like a fly and in what unlike." In this realm the logician must "replace the difficult word 'resemblance' by the idea of 'equivalence '" (LC 20–21). "I always like to remind extreme relativists or conventionalists," concludes Gombrich, "of this whole area of observations to show that the images of nature, at any rate, are not conventional signs, like the words of human language, but show a real visual resemblance, not only to our eyes or our culture but also to birds or beasts" (LC 21).

It is useless to object at this point that the analogy between animal and human behavior is misleading, that "resemblance" (in some respects, and recognizable differences in others) is radically different from "equivalence," or that the fish snapping at the artificial fly is not seeing it as an image or sign, but as a fly. It is useless to point out that a dog will fetch a stick and ignore a photograph of a duck, that it will ignore its own image in a mirror, but respond instantly to the call of its name or other (arbitrary) verbal commands. These objections are useless because Gombrich always seems to have taken them into account:

> I am well aware of the fact that there is a difference here between men and animals, and that difference is precisely the role which culture, conventions, laws, traditions can make in our reactions; we not only have a nature, *physis,* but what in English parlance is so aptly called "second nature." . . . Recognizing an image is certainly a complex process which draws on many human faculties, both inborn and acquired. But without a natural starting point we could never have acquired that skill. (LC 21)

Precisely: the natural sign is natural only in its "starting point," a point which, Gombrich neglects to mention, is shared by the artificial, conventional signs of language. If we did not have some innate capacity, some "natural starting point," we could never acquire the skill of using *either* words or images.

But somehow Gombrich manages to convince us that images are *more* natural than words, and in every possible sense of the word "natural." They are more easily learned; they are the sign we share with animals; they are objective and scientific; they are naturally fitted to our senses;

they are grounded in the strategic perceptual skills that man must have for survival in a hostile "state of nature" ("we are programmed to scan the world in search of objects which we must seek or avoid"). They are even designed to satisfy our baser instincts, as Gombrich suggests when he cites as his final example of natural, nonconventional images, "the erotic nudes displayed with such monotonous regularity on the covers and pages of magazines on sale in our cities. It seems very unlikely," Gombrich observes, "that response to this genre much depends on 'inculcation'" (LC 40).

This claim for the "naturalness" of pornographic imagery raises two interesting questions. First, what medium is more effective in producing the appropriate pornographic effect? My suspicion is that, in general, words are much more powerful than images, and that images have relatively little effect unless they are verbalized by the addition of narrative fantasy. If we do have an "instinct" for pornography, words would seem to be the natural sign to gratify it. The second question is more fundamental. Is pornography in fact a gratification of a natural human instinct? Many women would deny that it is, and it is hard to argue with the overwhelming evidence suggesting that pornography is produced mainly by and for males. What is natural to "man" turns out to be what is natural to *men*. And it is still, so far as I know, a moot question whether this sort of masculine nature is a biological instinct or a matter of "second nature," the habits, codes, and conventions that arise in certain specific cultural and historical conditions. My guess would be that, while some sexual instinct is innate to human beings of either sex, the taste for pornography is an acquired one, a highly complex cultural phenomenon riddled with elaborate rituals and conventions.

Gombrich's argument for the naturalness of pornographic imagery may help us to see more clearly why his rhetoric seems so convincing despite the incoherence of its central distinction between nature and convention. In what kind of culture does it make sense to isolate as "natural" a sign with the following attributes:

(1) it originates in our innate, biological equipment for dominating our environment, our genetic "program" for survival in a hostile world;

(2) it evolves in a progressive fashion toward greater mastery over the environment, identifying itself with the scientific,

rational, objective representation of reality, claiming for itself a
universal, international validity, and contrasting itself with less
"advanced" modes of understanding that rely on tradition and
convention;

(3) it has as its goal the effortless, automatic, mechanical repre-
sentation of reality, and reproduction of itself, epitomized by
the camera.

The "nature" implicit in Gombrich's theory of the image is, it should
be clear, far from universal, but is a particular historical formation, an
ideology associated with the rise of modern science and the emergence of
capitalist economies in Western Europe in the last four hundred years. It
is the nature found in Hobbes and Darwin, nature as antagonist, as
evolutionary competition for survival, as object for aggression and
domination. It is, therefore, a nature in which man is imagined chiefly in
figures like the (male) hunter, predator, or warrior rather than the farmer
or nomadic gatherer. The predatory character of Gombrich's image
reveals itself most clearly in its involvement with processes of entrap-
ment, illusion, and capture. The naturalness of the image is epitomized
by the *decoy,* the perfect illusion which, from the legendary grapes of
Zeuxis to the fish-fly, serves as an artificial sign that is not a sign, an icon
that is an "equivalent" rather than a "likeness." Or the image is the figure
of strategic, predatory perception itself, the iconic projection (in per-
spectival or "realistic" pictorial modes) of the "program" we use "to scan
the world in search of objects which we must seek or avoid" (LC 20). It
is, finally, the figure of production without labor, the unlimited con-
sumption of reality, the fantasy of instantaneous, unmediated appro-
priation.

The notion of the image as a "natural sign" is, in a word, the fetish or
idol of Western culture. As idol, it must be constituted as an embodi-
ment of the real presence it signifies, and it must certify its own efficacy
by contrasting itself with the false idols of other tribes—the totems,
fetishes, and ritual objects of pagan, primitive cultures, the "stylized" or
"conventional" modes of non-Western art. Most ingenious of all, the
Western idolatry of the natural sign disguises its own nature under the
cover of a ritual iconoclasm, a claim that *our* images, unlike "theirs," are
constituted by a critical principle of skepticism and self-correction, a
demystified rationalism that does not worship its own projected images

but subjects them to correction, verification, and empirical testing against the "facts" about "what we see," "how things appear," or "what they naturally are."

It will no doubt seem a bit odd to characterize the Western attitude toward "natural images" as idolatrous, since these objects do not seem to be the center of any particular reverence, adoration, or worship. On the contrary, they seem to be eminently disposable and trivial, the sort of thing we find in glossy magazine ads, posters, photo albums, postcards, newspapers, and pornographic magazines. The proper scenario for idolatry, in our view, is a bunch of naked savages bowing and scraping before an obscene stone monolith. But suppose we began to suspect that this scenario was our own ethnocentric projection, a fantasy devised to secure a conviction that *our* images are free from any taint of superstition, fantasy, or compulsive behavior? Suppose we began to think of our ordinary, rational behavior with images as just a bit strange, as permeated with odd, cultish prejudices and ideological determinations? I don't think (and I certainly don't recommend) that this shift in attention would lead us to burn all our photo albums and back issues of *Playboy*. But it might put us in a position to take a critical view of imagery, to see it in its cultural and historical relations, not just as part of nature, but as part of us.

It might also take us back to the legendary foundation of the distinction between artificial and natural signs in Plato's *Cratylus,* and lead us to ask what use is made of the distinction there. I noted earlier Gombrich's assumption that "the participants in this dialogue take it for granted that whatever may hold for words, pictures, visual images, are natural signs. They are recognisable because they are more or less 'like' the things or the creatures they depict" (LC 11). This assumption is, on the face of it, rather plausible. Socrates spends much of the dialogue subverting Hermogenes' claim that names have no basis other than "convention and agreement."[11] He argues the contrary position, "that names belong to things by nature" (390e; p. 31), using the analogy of images: "a name is an imitation, just as a picture is" (*Cratylus,* 431a; 159). Gombrich is surely right in thinking that this stage of the debate depends on an agreement that images are natural signs. The question at issue is whether names are

11. "No name," argues Hermogenes, "belongs to any particular thing by nature, but only by the habit and custom of those who employ it and who established the usage" (*Cratylus* 384d; 10–11).

like images; the nature of images themselves does not come under direct scrutiny, but is invoked as a basis for comparison. Now it has often been noted that Socrates' argument that words have a natural, mimetic relation to what they name is probably not serious. He concocts fanciful etymologies to show the "natural" connection between name and thing, and once he has persuaded Cratylus of the iconic theory of names he immediately begins to pick it apart. What is not generally noticed is that Socrates also begins to question the iconic theory of icons as well. "The image," Socrates points out, "must not by any means reproduce all the qualities of that which it imitates, if it is to be an image" (432b; 163). If it did "reproduce all the qualities," we would have a "duplicate," not an image. The image, therefore, is necessarily imperfect, representing things both by likeness and unlikeness. But if this is the case, Socrates asks, are not images rather like names in their imperfection, "since both like and unlike letters, by the influence of custom and convention, produce indication? And even if custom is entirely distinct from convention, we should henceforth be obliged to say that custom, not likeness, is the principle of indication, since custom, it appears, indicates both by the like and the unlike" (435a–b; 173).

Socrates' argument that words, like images, have a natural connection of a likeness with what they name finally turns on itself, subverting not only the picture theory of language but the picture theory of pictures. He concludes:

> Then don't you see my friend that we must look for some
> other principle of correctness in images and in names . . .
> and must not insist that they [words] are no longer images
> if anything be wanting or be added? Do you not perceive
> how far images are from possessing the same qualities as the
> originals which they imitate? (432c–d; 165)

What Socrates is leading us toward is a rejection of our cherished notion that truth is a matter of accurate imaging, mirroring, or representing. All signs, whether words or images, work by custom and convention, and all are imperfect, riddled with error. The mistake is to think that we can know the truth about things by knowing the right names, signs, or representations of them.

But the other mistake is to think that we can know anything *without* names, images, or representations. When Plato mounts his famous attack on the illusory knowledge of "mere" images and appearances in Book

VII of *The Republic,* we cannot ignore the fact that he does so by means of an image—the Allegory of the Cave. Plato's allegory is an image in two senses: (1) it involves an elaborate scene or picture that the reader must construct mentally; (2) this scene must be interpreted by a series of likenesses or analogies that compare the scene of the cave to the human condition. When Socrates finishes constructing his "picture" of human life as a cave in which we see nothing but the shadows of images, Glaucon's comment is, "A strange image you speak of."[12] Plato does not, in other words, argue for a straightforward iconoclasm, a banishing of images in favor of direct, unmediated apprehension of "the real thing."[13] The Allegory of the Cave suggests, in fact, that the purpose of the unmediated perception is a return into the world of shadows, a descent back into the cave of images:

> Down you must go then, each in his turn, to the habitation
> of the others and accustom yourselves to the observation of
> obscure things there. For once habituated you will discern
> them infinitely better than the dwellers there, and you will
> know what each of the "idols" is and whereof it is a sem-
> blance, because you have seen the reality of the beautiful, the
> just and the good. (520c; 143)

The apprehension of beauty and goodness is, of course, only possible in an image—what Socrates calls a "provocative," an imperfect picture or likeness that provokes reflection.[14] To claim to have direct knowledge of the ideal, to claim that one possessed the perfect image of nature would be to commit idolatry, to mistake the image for that which it represents.

12. *The Republic* 514b, trans. Paul Shorey (Cambridge: Harvard University Press, 1935); 121. I owe this interpretation to numerous conversations with Joel Snyder.

13. Plato makes the necessity of mediation explicit in his letter to Dion: "For everything that exists there are three classes of objects through which knowledge about it must come; the knowledge itself is a fourth, and we must put as a fifth entity the actual object of knowledge which is the true reality. We have then, first, a name, second, a description, third, an image, and fourth, a knowledge of the object" (Letter VII, trans. L. A. Post, in *The Collected Dialogues of Plato,* ed. Edith Hamilton and Huntington Cairns [New York: Bollingen Foundation, 1961], 1589).

14. Later in the allegory, Socrates distinguishes between "reports of our perception" that "do not provoke thought . . . because the judgment of them by sensation seems adequate, while others always invite the intellect to reflection because the sensation yields nothing that can be trusted" (523b; 153). Socrates prefers, of course, experiences (and perceivers) of "contradictory perception"(523c; 155) which he calls "provocatives." Perhaps the Allegory of the Cave is itself an example of one of these "provocatives."

But since images are all we have to work with, we have to learn to work with them dialectically, acknowledging and identifying their imperfections, using them as a starting point for a dialogue or conversation. For Plato, the knowledge of "nature," the deep truth that lies beyond all appearances or images, is not to be found by a renunciation of the world of custom and convention, nor by a trust in a special class of "natural" signs that eludes convention, but by a dialogue within the world of convention that leads us to its limits.

4

Space and Time
Lessing's *Laocoon*
and the Politics of Genre

Time & Space are Real Beings
Time is a Man Space is a Woman
William Blake, *A Vision of the Last Judgment*

Nothing, I suppose, seems more intuitively obvious than the claim that
literature is an art of time, painting an art of space. When Lessing
attempts to ground the generic boundaries of the arts on "first princi-
ples," he does not turn to the venerable distinction between "natural"
and "arbitrary" signs, nor does he appeal to the commonplace "sensible"
distinction between eye and ear. Instead, Lessing argues:

> If it be true that painting employs wholly different signs or
> means of imitation from poetry,—the one using forms and
> colors in space, the other articulate sounds in time,—and if
> signs must unquestionably stand in convenient relation with
> the thing signified, then signs arranged side by side can rep-
> resent only objects existing side by side, or whose parts so
> exist, while consecutive signs can express only objects which
> succeed each other, or whose parts succeed each other, in
> time.[1]

1. *Laocoon: An Essay upon the Limits of Poetry and Painting* (1766), trans. Ellen Frothing-
ham (1873; rpt., New York: Farrar, Straus, and Giroux, 1969), 91. Unless otherwise
indicated, all English translations of the *Laocoon* will be cited from this text, hereafter
indicated as *L*. References to the German original will be to Lessing's *Werke,* 6 vols.
(Munich: Carl Hanser Verlag, 1974), ed. Herbert G. Gopfert. All subsequent citations will
be given in parentheses, with the Frothingham page number specified first, Gopfert
second.

The fact that Lessing was not the first to make this distinction, that it was a commonplace even among the apologists for the doctrine of *ut pictura poesis* whom he attacked for ignoring it, only increases our sense that it is one of those "self-evident truths" bequeathed to us by the Enlightenment.[2] Lessing's originality was his systematic treatment of the space-time question, his reduction of the generic boundaries of the arts to this fundamental difference. If Newton reduced the physical, objective universe, and Kant the metaphysical, subjective universe to the categories of space and time, Lessing performed the same service for the intermediate world of signs and artistic media.

Although the *Laocoon* has been the subject of controversy since it first appeared in 1766, a few critics have disputed the truth of its basic distinction between the temporal and spatial arts. Even the critical industry founded on Joseph Frank's claim that "spatial form" is a central feature of literary modernism never questions the normative force of Lessing's distinction. "Spatial form," as it is defined in a recent anthology on the subject, "in its simplest sense designates the techniques by which novelists subvert the chronological sequence inherent in narrative"—a definition which suggests that "space" means little more than "atemporal," and which confirms Lessing's claim that chronology is "inherent" in literary art.[3] "Spatial form" in this sense can have no strong theoretical force; it can only be what Frank Kermode calls a "weak figure" for a certain kind of suspended temporality, and there doesn't seem to be any compelling reason for thinking of this phenomenon as "spatial."[4] The best that can be said for this notion of literary space is that it has a limited heuristic value as a vague metaphor for someting that is generally conceded to be marginal, deviant, or exceptional, and that it had a short, rather undistinguished life as a slogan in the polemics of modernism. The fortunes of the corrollary notion—"temporal form" in painting—have been equally modest. Even an apologist for transferences between poetry

2. E. H. Gombrich notes that Joseph Spence and the Comte de Caylus, both of whom Lessing attacked for supposedly ignoring the space-time differentiation of the arts, explicitly honor this familiar distinction. See "Lessing," in *Proceedings of the British Academy for 1957* (London: Oxford University Press, 1958), 139. See also Nikolas Schweizer, *The Ut Pictura Poesis Controversy in 18th Century England and Germany* (Bern: Herbert Lang Verlag, 1972), for a discussion of the numerous precedents for the influence of Lessing's space-time distinction.

3. *Spatial Form in Narrative*, ed. Jeffrey Smitten and Ann Daghistany (Ithaca, N.Y.: Cornell University Press, 1981), 13.

4. See Kermode, "A Reply to Joseph Frank," *Critical Inquiry* 4:3 (Spring, 1978), 582.

and painting like Rensselaer Lee concedes in his classic study, *Ut Pictura Poesis,* that "no one will deny the general rightness of his [Lessing's] contention that the greatest painting, like the greatest poetry, observes the limitations of its medium; or that it is dangerous for a spatial art like painting to attempt the progressive effects of a temporal art like poetry."[5]

The "dangers" in the spatializing of literature have, in the modern era, been understood as specifically political. Frank Kermode and Philip Rahv argue for a connection between the spatial aesthetics of modernism and the rise of fascism, a claim which has been given its most precise formulation by Robert Weimann: "the loss of the temporal dimension means the destruction of the specific narrative effect, namely, the representation of temporal processes" and thus "the ideological negation of self-transforming reality, the negation of the historicity of our world."[6] Literary space, then, for many modern critics, has been a synonym for the denial of history and the escape into irrational reverence for mythic images. The "safe" approach to literary space, on the other hand, has typically proceeded by denying that the notion has any political consequences at all. Joseph Frank argues that the notion of spatial form is a "neutral critical fiction" and that critics like Kermode are "in classic psychoanalytic style . . . project[ing] their own animosity onto others and turn[ing] them into scapegoats."[7] Amid these charges and countercharges, the one thing that unites all the antagonists on the issue of literary space is their common reverence for the principles established in Lessing's *Laocoon.* Those who attack the confusion of genres entailed in a notion of literary space regularly invoke Lessing's authority, and the proponents of spatial form pay him homage by making his categories into their fundamental instruments of analysis.

When a text occupies a central place in the canons of rival traditions, invoked as an oracle by Christian humanists like W. K. Wimsatt and Irving Babbitt on the one hand, and by Trotskyites like Clement Greenberg on the other, it seems worth reopening the question of just what the text says—and said—about the basic issues it is supposed to have

5. *Ut Pictura Poesis: The Humanistic Theory of Painting* (1940; rpt., New York: W. W. Norton, 1967), 21.

6. This passage is quoted by Joseph Frank in *Spatial Form in Narrative,* p. 214, from Weimann's *"New Criticism" und die Entwicklung Burgerliche Literaturwissenschaft* (Halle: M. Niemeyer, 1962). See also Kermode, "A Reply to Joseph Frank," 579–88, and Rahv, "The Myth and the Powerhouse," in Rahv's *Literature and the Sixth Sense* (Boston: Houghton Mifflin, 1969), 202–15.

7. Frank, *Spatial Form in Narrative,* 221.

defined.[8] In the following pages I propose to revisit Lessing's *Laocoon*, raising two sorts of questions, one critical, the other historical: first, how adequate are Lessing's basic distinctions between the temporal and spatial arts as instruments of analysis? Second, what historical conditions prompted Lessing to make these distinctions? I don't expect any of the contending groups to be very happy with the answers to these questions, for I will argue (*contra* Frank and company) that the whole notion of "spatial" and "temporal" arts is misconceived insofar as it is employed to sustain an *essential* differentiation of or within the arts. I will argue (*contra* Kermode, Weimann, and Rahv) that the tendency of artists to breach the supposed boundaries between temporal and spatial arts is not a marginal or exceptional practice, but a fundamental impulse in both the theory and practice of the arts, one which is not confined to any particular genre or period. Indeed, so central is this impulse that it finds expression even in the writings of theorists like Kant and Lessing who establish the tradition of denying it. Finally, I will propose a new way of conceiving of the space-time problem in the arts, as a dialectical struggle in which the opposed terms take on different ideological roles and relationships at different moments in history. This position can be described in a less contentious form by noting that it has points of agreement with both sides of the spatial form debate. That is, I agree with Frank and his followers that literary space is a real phenomenon that deserves study, but I think their formulation of the theory is too tentative, and that literary space ought to be conceived in a strong fashion (not as "atemporality") and applied to all texts, literary or otherwise. On the other hand, I agree with Kermode, Rahv, and Weimann that the categories of space and time are never innocent, that they always carry an ideological freight, and never more so than in that great source of wisdom on this issue, Lessing's *Laocoon*.

Just what does it mean to say that literature is a temporal art, painting a spatial art? Literary critics usually follow Lessing's lead by unpacking this expression with parallel accounts of the reception, medium, and content of literary works. Reading occurs in time; the signs which are read are uttered or inscribed in a temporal sequence; and the events represented or narrated occur in time. There is thus a kind of homology,

8. See W. K. Wimsatt, "Laokoon: An Oracle Reconsulted" (1970), rpt. in *Day of the Leopards* (New Haven: Yale University Press, 1976), 40–46; Babbitt, *The New Laocoon* (Boston: Houghton Mifflin, 1910); Greenberg, "Toward a Newer Laocoon," *Partisan Review* 7 (July-August, 1940), 296–310.

or what Lessing calls a "convenient relation" (*bequemes Verhältnis*) be-
tween medium, message, and the mental process of decoding.[9] A similar
homology operates in accounts of visual art: the medium consists of
forms displayed in space; these forms represent bodies and their rela-
tionships in space; and the perception of both medium and message is
instantaneous, taking no appreciable time.

Exceptions to or violations of these basic rules are often noted by
literary critics and art historians, but they are generally treated as second-
ary, supplemental, or illusory "accidents," in contrast to the essential
primacy of temporal or spatial mode required by the nature of the
medium. Thus, although most literary critics will admit that it makes
some sense to speak of literary space in genres like ekphrastic poetry
(Keats's "Ode on a Grecian Urn" serving as the ritual example) this
admission is generally accompanied by elaborate strategies of denial
which treat this sort of space as illusory, secondary, or "merely figura-
tive." As Wendy Steiner puts it in her recent study of the interartistic
comparison in modern literature, ekphrastic poems "express the idea of
art's overcoming time without themselves overcoming it. They fail
where the visual arts seemingly succeed; what they gain from the topos is
an example of what they can merely aspire to do. . . . the outcome is
lacking in spatial extension and in the coincidence of aesthetic experience
with artifact characteristic of painting. Thus, the literary topos of the still
moment is an admission of failure, or of mere figurative success."[10]
Lessing would entirely approve of this account. It echoes both his
argument for the inherent impossibility of making poetry spatial and the
principle on which that argument is based: Steiner's "coincidence of
aesthetic experience with artifact" is simply a psychological version of the
"convenient relation" between medium, content, and decoding process
Lessing postulates in *Laocoon*.

Similar strategies of denial are produced to counter other sorts of
claims for spatial form in literature. When it is pointed out that a literary
work is spatial insofar as it is *written*, for instance, this feature is dismissed
as a secondary, inessential matter, the true essence of the work being
found in its oral form, or in some ideal version which transcends any

9. In this sense, both literature and the visual arts employ mimetic, iconic, and
"natural" signs for Lessing. See David Wellbery, *Lessing's Laocoon: Semiotics and the Age of
Reason* (Cambridge: Cambridge University Press, 1984), 7.
10. *The Colors of Rhetoric* (Chicago: University of Chicago Press, 1982), 42.

material text or spoken performance.[11] More subtle, indirect claims for literary spatiality—notions of formal, architectonic design, images and symbols which provide semantic or structural totalizations, and spatial memory systems which facilitate oral performance—are dismissed in a variety of ways: they are "merely metaphoric" spaces, and therefore "not real"; they are merely supplementary aids to performance, reading, or interpretation, and not part of "the work itself," which exists in time; or they "totalize" the work in a way that inhibits readerly freedom.[12]

There is a similar tradition of denying temporality in the visual arts. The claim that painting, for instance, must be scanned in some temporal interval, or that a statue must be viewed by moving around it, or that a building can never be seen "all at once" is met with the counterargument that these temporal processes are not determined or constrained by the object itself. We can perform these scannings in any order we wish (more or less), and we know throughout this process that *we* are the ones moving in time, whereas the "object itself" remains stable and static in an unvarying spatial configuration. When the argument is made that some paintings represent temporal events, scenes from a narrative, for instance, or even a sequence of images that suggests movement, one can expect one of the following replies: (1) the temporality implied in a narrative painting is not directly given by its signs, but must be inferred from a single spatialized scene; (2) such temporal inferences, and the clues which suggest them, are not the primary business of painting, whihc is to present forms in sensuous, instantaneous immediacy, and not to aspire to the status of discourse or narrative. The very fact that temporality must be *inferred* in a painting suggests that it cannot be directly represented by the medium in the way that spatial objects can.

All these strategies for explaining away apparent exceptions to the rule of a space-time differentiation of the arts are anticipated in Lessing's *Laocoon*. Indeed, the very chapter in which Lessing lays out his "first principles" goes on to anticipate the most flagrant violations of them. After declaring that "bodies . . . are the peculiar objects of painting," and

11. A good example of this resistance to spatial, material, or visible "incarnations" of literary texts is Roman Ingarden's claim that a literary work is a "purely intentional object" that "is not a substance." *The Literary Work of Art* trans. G. G. Grabowicz (Evanston, Ill.: Northwestern University Press, 1973) 122–23.

12. For a discussion of Earl Miner and Stanley Fish's objections to the notion of literary space, see my essay "Spatial Form in Literature," In *The Language of Images,* ed. W. J. T. Mitchell (Chicago: University of Chicago Press, 1980), 279 and 285.

"actions . . . the peculiar subjects of poetry," Lessing immediately makes a strategic concession:

> All bodies, however, exist not only in space, but also in time. They continue, and, at any moment of their continuance, may assume a different appearance and stand in different relations. Every one of these momentary appearances and groupings was the result of a preceding, may become the cause of a following, and is therefore the centre of a present action. Consequently painting can imitate actions also, but only as they are suggested through forms. (*L*91–2/103)

The spatial art becomes temporal, *aber nur andeutungsweise durch Körper* (but only indirectly, by suggestion, by means of bodies or forms). In a symmetrically similar way,

> Actions, on the other hand, cannot exist independently but must always be joined to certain agents. In so far as those agents are bodies or are regarded as such, poetry describes also bodies, but only indirectly through actions [*schildert die Poesie auch Körper, aber nur andeutungsweise durch Handlungen*]. (*L*92/103)

The distinction between the temporal and spatial arts turns out to operate only at the first level of representation, the level of direct or "convenient relation" (*bequemes Verhältnis*) between sign and signified. At a second level of inference where representation occurs "indirectly" (*andeutungsweise*), the signifieds of painting and poetry become signifiers in their own right, and the boundaries between the temporal and spatial arts dissolve. Painting expresses temporal action indirectly, by means of bodies; poetry represents bodily forms indirectly, by means of actions. Lessing's whole distinction hangs, then, on the slender thread of the difference between primary and secondary representation, direct and indirect expression.

But now we must ask ourselves what can be meant by a "direct" expression or representation, a sign that does not work "indirectly." It certainly cannot mean that the bodies or actions are simply present before us in painting or poetry; that would be to deny that any representation occurs at all. The bodies represented by a painting are not directly presented in any literal sense; they are indirectly presented by

means of shapes and colors—that is, by certain kinds of signs. The distinction between "direct" and "indirect" is therefore not a difference of kind, but one of degree. Painting presents bodies indirectly, through pictorial signs, but it does so less indirectly than its presentation of actions. The representation of bodies is easy or "convenient" for painting. The representation of actions is not impossible, just more difficult or inconvenient. This relation of relative ease or difficulty becomes explicit when Lessing turns to the representation of bodies by poetry:

> The details, which the eye takes in at a glance, he [the poet] enumerates slowly one by one, and it often happens that, by the time he has brought us to the last, we have forgotten the first. Yet from these details we are to form a picture. When we look at an object the various parts are always present to the eye. It can run over them again and again. The ear, however, loses the details it has heard, unless memory retain them. And if they be so retained, what pains and effort [*welche Mühe, welche Anstrengung*] it costs to recall their impressions in the proper order and with even the moderate degree of rapidity necessary to the obtaining of a tolerable idea of the whole. (*L*102–3/110–11)

The propriety of space and time in painting and poetry is at bottom a matter of the economy of signs, the difference between cheap, easy labor, and costly "pains and effort." But if it is only a matter of degree of effort that holds poetry and painting in their proper domains, then it is clear that this distinction cannot be the basis for any rigorous differentiation of *kind*. On the contrary, the argument from economy could quite easily be turned against Lessing's position by a claim that the value of a work of art is proportional to the skill, labor, and difficulty that it "costs." Lessing is perhaps guarding himself against this argument when he ridicules the French playwright Chateaubrun for having introduced a princess into his adaptation of *Philoctetes,* thus turning Sophocles' noble portrayal of manly suffering into a "play of bright eyes." The reviewers, Lessing notes sarcastically, proposed to call this adaptation "La difficulté vaincue" (*L*26/35).

What follows from the abolition of the space-time differential as the basis for the generic distinction between painting and poetry?[13] First, one thing that does *not* follow is the abolition of the difference between texts

13. See Mitchell, "Spatial Form in Literature," 271–99, for a comprehensive discussion.

and images. Nothing I have said here should be taken as a claim that the two arts become indistinguishable, only that the notions of space and time fail to provide a coherent basis for their differentiation. The most immediate positive consequence of calling into question the space-time distinction is that it tends to restore to respectability a great many things that artists do and critics observe in practice. All the discredited strategies for making literature spatial, painting temporal, begin to look more substantial. When we find Rensselaer Lee opining that "it is dangerous for a spatial art like painting to attempt the progressive effects of a temporal art like poetry," we may take this as a challenge to take a certain kind of risk, not a prohibition of its very possibility. When we read Wendy Steiner calling the topos of ekphrasis "an admission of failure, or of mere figurative success," we may ask ourselves what other sort of success poetry might aspire to.

Another practical consequence of abolishing the notion of spatial and temporal genres would be that we could stop saying many things about the arts and that make little or no sense. Our beginning premise would be that works of art, like all other objects of human experience, are structures in space-time, and that the interesting problem is to comprehend a particular spatial-temporal construction, not to label it as temporal *or* spatial. A poem is not literally temporal and figuratively spatial: it is literally a spatial-temporal construction. The terms "space" and "time" only become figurative or improper when they are abstracted from one another as independent, antithetical essences that define the nature of an object. The use of these terms is, strictly speaking, a concealed synecdoche, a reduction of the whole to a part.

The most important consequence of exposing the figurative basis of the spatial and temporal genres is not, however, that it gives us a new way of reading. I suspect that practical interpretation of the arts stumbles along fairly well without worrying about these "first principles." Where these principles do affect practice is in the formation of value judgments, canons of acceptable works, and formulations of the ideological significance of styles, movements, and genres. Since these regulative principles generally advertise themselves as nothing more than natural, necessary, or literal ways of talking about the arts, the disclosure of their figurative basis may help us to reconstruct what Fredric Jameson would call the "political unconscious" that sets them in motion and determines their form.[14]

14. Jameson, *The Political Unconscious* (Ithaca, N.Y.: Cornell University Press, 1981).

In this light, Lessing's choice of space and time as the first principles for generic distinctions of the arts was an especially canny move, for it had the effect of seeming to remove his argument from the realm of desire, and to ground it directly in natural necessities. (The persistent belief that these categories are "neutral critical fictions" testifies to the efficacy of his choice.) Lessing conceals the figurative basis of his distinction under the guise of nature and the "necessary limitations" (*notwendigen Schranken*) that govern physical, mental, and semiotic universes. But the argument from necessity tends to slip unobtrusively into an argument from desire: painting *should not* be temporal because time is not proper to its essential nature. The argument from desire has to be underplayed, of course, because it only makes sense when it is clear that the argument from necessity has failed. There would be no need to say that the genres *should not* be mixed if they *could not* be mixed. Nevertheless, Lessing continually blurs these two kinds of arguments in order to prevent the blurring of two kinds of art:

> In poetry, a fondness for description, and in painting, a fancy for allegory, has arisen from the desire to make the one a speaking picture without really knowing what it can and ought to paint, and the other a dumb poem, without having considered in how far painting can express universal ideas without abandoning its proper sphere and degenerating into an arbitrary method of writing. (*Lx/11*)

What poetry "can and ought to paint" (*was sie malen könne und solle*) Lessing wants to say, ought to be the same thing—actions in time. What it *can* do, unfortunately, is all too obvious in the contemporary cultural scene that Lessing criticizes: it can fall into a "fondness for description" (*Schilderungssucht*) and make itself into a "speaking picture" (*redenden Gemälde*). Painting, in a similar fashion, can abandon its proper sphere for allegory and thus become like writing (*Schriftart*).

The argument from desire, then, has the salutary effect of unmasking the ideological character of the argument from necessity. The case against time in painting, space in literature must now be made, not because these things are illusory or impossible, but because they are all too possible. The "laws of genre," which appeared to be dictated by nature, turn out to be artificial, man-made statutes. We have already noticed Lessing, in an unguarded moment, hinting that these laws are at least partly economic, propriety of genre being associated with "conve-

nient" labor, impropriety with difficult, costly labor. We must now add that the laws are matters of *political* economy, directly related to conceptions of civil society, and beyond that, to a picture of stable international relations. The subtitle of *Laocoon* is generally translated as "An Essay upon the Limits of Painting and Poetry," but the word which is translated as "limits" (*Grenzen*) would be rendered more accurately as "borders," as we see in Lessing's most memorable use of the word:

> Painting and poetry should be like two just and friendly neighbors, neither of whom indeed is allowed to take unseemly liberties in the heart of the other's domain, but who exercise mutual forbearance on the borders, and effect a peaceful settlement for all the petty encroachments which circumstance may compel either to make in haste on the rights of the other. (*L* 110/116)

Lessing's metaphoric borders between the spatial and temporal arts have their literal analogue in the cultural map of Europe he draws in *Laocoon*. The argument is structured, as E. H. Gombrich first noticed, as a "tournament played by a European team. The first round is against Winckelmann, the German, the second against Spence, the Englishman, the third against the Comte de Caylus, the Frenchman."[15] Since Lessing criticizes all three national representatives for failing to observe the borders of the arts, it is tempting to see his position as that of an enlightened internationalist, regulating the contest from an impartial position. But a closer look reveals Lessing's partisanship: it is the French with their "false delicacy," their "difficulté vaincue," and their frigid neoclassicism who blur the genres by making poetry conform to the cold beauties and unities of classical painting and sculpture. Winckelmann's argument that Laocoon does not cry out because of his stoical repression of emotion (rather than, as Lessing will argue, because the "necessities of the medium" dictate restraint) seems dangerous because it looks as if a great German scholar is being infected with French ideas. The English, by contrast, are enlisted as allies against France. Lessing introduces Adam Smith to the argument as "an Englishman, a man therefore, not readily to be suspected of false delicacy," (*L* 26/35), and appeals to the examples of Milton and Shakespeare (borrowed from Burke's *Enquiry*) against the French pictorialist poetic. "We are here watching," Gom-

15. Gombrich, "Lessing," 139.

brich suggests, "the conflation of various traditions: that of the para-
gone, the rivalry of the arts, interweaves with the classic distinction
between the sublime and the beautiful, and these categories in their turn
are seen in terms of political and national traditions, liberty and tyranny,
England and France. Shakespeare is free and sublime poesy, Corneille
rigid if beautiful statuary."[16]

Lessing has nothing against beautiful statuary, of course, as long as it
remains in its place and doesn't try to become a model for poetry. It can
be a rather useful model, on the other hand, for the severe limits that
Lessing wants to impose on all the visual and plastic arts. These limits are
presented, as we might expect, as a law which frees the visual artist from
subjection to alien interests, especially religious ones:

> Among the antiques that have been unburied we should dis-
> criminate and call only those works of art which are the
> handiwork of the artist purely as artist. . . . All the rest, all
> that show an evident religious tendency, are unworthy to be
> called works of art. In them art was not working for her
> own sake, but was simply the tool of Religion, having sym-
> bolic representations forced upon her with more regard to
> their significance than their beauty. (*L* 63/74)

Religion fetters painting by removing it from its proper vocation, the
representation of beautiful bodies in space, and enslaves it to a foreign
concern, the expression of "significance" through "symbolic represen-
tations," concerns that are proper to temporal forms like discourse or
narrative. Lessing's alliance with the English against the French, then, is
religious as well as political—a Protestant "holy alliance" against Roman
Catholic idolatry. We are not surprised, in this light, to find Lessing
approving of the "pious iconoclasts" (*frommen Zerstörer*) for destroying
ancient works of art that carried symbolic attributes (such as the horns of
Bacchus), and for sparing only those works that "had never been dese-
crated by being made an object of worship" (*welches durch keine Anbetung
verunreiniget war*) (*L* 63/74). "Religious painting" is a contradiction in
terms for Lessing; it is a violation of the artist's political liberty, and of
the natural law of the medium, which confines the visual arts to cor-
poreal, spatial beauty and reserves spiritual significance to the temporal
medium of poetry.

16. Gombrich, "Lessing," 142.

The aim of Lessing's laws of genre, then, is clearly not to make the spatial and temporal arts separate but equal, but to segregate them in what he regards as their natural inequality. Poetry had the "wider sphere" because of "the infinite range of our imagination and the intangibility of its images." The "encroachments" of one art upon another are always committed by painting, which tries to break out of its proper sphere and become "an arbitrary method of writing," or, even more sinister, tries to lure poetry into the narrow boundaries of the pictorialist aesthetic. "Poetry has the wider sphere," says Lessing. "Beauties are within her reach which painting can never attain," and therefore "more is allowed to the poet than to the sculptor or the painter." The apparent argument from the mutual respect of borders turns out to be an imperialist design for absorption by the more dominant, expansive art:

> If the smaller cannot contain the greater, it can be con-
> tained in the greater. In other words, if not every trait em-
> ployed by the descriptive poet can produce an equally good
> effect on canvas or in marble, can every trait of the artist be
> equally effective in the work of the poet? Undoubtedly; for
> what pleases us in a work of art pleases not the eye, but the
> imagination through the eye. (L 43/52)

If Lessing were to pursue this line of reasoning to its logical conclusion there would be no need for painting at all. And so he stops short of that conclusion and contradicts himself. Painting is allowed certain kinds of superior power: it "makes a beautiful picture from vivid sensible impressions," while poetry works with "the feeble uncertain representations of arbitrary signs" (L 73/86); it has "that power of illusion which in the presentation of visible objects art possesses above poetry" (L 120/124); and at certain moments when "poetry stammers and eloquence grows dumb," painting may "serve as an interpreter" (L 135/138). Logically, rationally, we should be able to do without painting; poetry comprehends all its effects and more besides, just as, for Kant, the category of space is the basis of our perception of external objects, but the category of time is the basis of all perception of *both* internal and external objects.[17]

17. "Time is the formal *a priori* condition of all appearances whatsoever. Space, as the pure form of all *outer* intuition, is so far limited; it serves as the *a priori* condition only of outer appearances. But since all representations, whether they have for their objects outer things or not, belong, in themselves, as determinations of the mind, to our inner state; and since this inner state stands under the formal condition of inner intuition, and so belongs to

In theory, we should be able to get along without space, without painting, without bodies, in a realm of pure temporal consciousness.

And yet Lessing acknowledges that we cannot: immediacy, vividness, presence, illusion, and a certain interpretive character give images a strange power, a power that threatens to defy natural law and usurp the domain of poetry. Therefore painting must be held in check, as the ancients knew, by "the control of civil law."[18] As usual, Lessing introduces this law by speaking as if it would apply to all the arts, leaving only science exempt, since the pursuit of truth (unlike pleasure) should not be legislated. But when he gets down to cases, the laws only apply to painting—the Greeks' "law against caricature," and "the law of the Thebans commanding [the artist] to make his copies more beautiful than the originals" (L 9/18). Painting, it seems, needs more strict regulation than poetry: "The plastic arts, especially, besides the inevitable influence which they exercise on the character of a nation, have power to work one effect which demands the careful attention of the law (L 10/19). To explain this "one effect," Lessing launches into a remarkable digression. For the Greeks, says Lessing, "beautiful statues fashioned from beautiful men reacted upon their creators, and the state was indebted for its beautiful men to beautiful statues." With us moderns, on the other hand, "the susceptible imagination of the mother seems to express itself only in monsters" (L 11/19). Lessing explains this curious jump from beautiful ancient male creators, creations, and viewers to modern mothers who engender monsters by interpreting a recurrent dream that comes up in legend:

> From this point of view I think I detect a truth in certain
> old stories which have been rejected as fables. The mothers
> of Aristomenes, of Aristodamas, of Alexander the Great,
> Scipio, Augustus, and Galerius, each dreamed during pre-
> gnancy that she was visited by a serpent. The serpent was an
> emblem of divinity. Without it Bacchus, Apollo, Mercury,

time, time is an *a priori* condition of all appearance whatsoever" (*Critique of Pure Reason* II. 6. A34; trans. Norman Kemp Smith [New York: St. Martin's Press, 1929], 77).

18. L10/19: "We laugh when we read that the very arts among the ancients were subject to civil law; but we have no right to laugh. Laws should unquestionably usurp no sway over science, for the object of science is truth. Truth is a necessity of the soul, and to put any restraint upon the gratification of this essential want is tyranny. The object of art, on the contrary, is pleasure, and pleasure is not indispensable. What kind and what degree of pleasure shall be permitted may justly depend on the law-giver."

and Hercules were seldom represented in their beautiful pic-
tures and statues. These honorable women had been feasting
their eyes upon the God during the day, and the bewildering
dream suggested to them the image of the snake. Thus I
vindicate the dream, and show up the explanation given by
the pride of their sons and by unblushing flattery. For there
must have been some reason for the adulterous fancy always
taking the form of a serpent. (*L* 11/19–20)

Indeed there must have been, and Lessing has no need of Freud's
analysis of fetishism and phallicism to see what it is: the dream is
interpreted by the image that gives rise to it. And this dream in turn helps
us to see that "one effect" the visual arts have that "demands the careful
attention of the law." That effect is precisely the irrational, unconscious
power of images, their ability to provoke "adulterous fancy," the imagin-
ing of improper, scandalous conjunctions—the union of human and
divine figured as the copulation of woman and beast.

But the image of the beautiful statue with its emblematic serpent is,
in itself, already an improper conjunction of genres in Lessing's view. It
combines a proper image (a beautiful statue representing a beautiful
body) with an improper, arbitrary, emblematic figure. The serpent does
not represent a serpent: it is an emblem of divinity, an "expression" of
that which cannot be naturally expressed by imagery. And of course just
beneath the surface of this divine emblem is a profane, indecent fetish.
It invites "honorable women" to "feast their eyes" in idolatrous worship
during the day, and to give in to "adulterous fancy" by night. Small
wonder that the pious iconoclasts sensed something obscene in these
statues, and that they spared only those that were confined strictly by the
natural, generic laws of beauty. The adulteration of the arts, of the
genres, is an incitement to the adulteration of every other domestic,
political, and natural distinction, and it is an incitement peculiar to
images, the "one effect" they have that must be constrained by law.

Lessing concludes this extraordinary passage by admitting that he has
been "wandering from [his] purpose, which was simply to prove that
among the ancients beauty was the supreme law of the imitative arts." In
his wandering, however, Lessing has disclosed what is probably the most
fundamental ideological basis for his laws of genre, namely, the laws of
gender. The decorum of the arts at bottom has to do with proper sex
roles. Lessing does not state this explicitly anywhere in *Laocoon*. Only in

the unguarded moment of free association prompted by the contrast between the patrilineal production of ancient sculpture and the monstrous, adulterous maternity of modern art does he allow this figure of the difference to surface. Once we have glimpsed the link between genre and gender, however, it seems to make itself felt throughout all the oppositions that regulate Lessing's discourse, as the following table will show at a glance:

Painting	Poetry
Space	Time
Natural signs	Arbitrary (man-made) signs
Narrow sphere	Infinite range
Imitation	Expression
Body	Mind
External	Internal
Silent	Eloquent
Beauty	Sublimity
Eye	Ear
Feminine	Masculine

Paintings, like women, are ideally silent, beautiful creatures designed for the gratification of the eye, in contrast to the sublime eloquence proper to the manly art of poetry. Paintings are confined to the narrow sphere of external display of their bodies and of the space which they ornament, while poems are free to range over an infinite realm of potential action and expression, the domain of time, discourse, and history.

Lessing's sense of the threatened violation of these natural laws of gender and genre may be seen by setting these generic terms against a table of evaluative terms:

Blurred genres	Distinct genres
Moderns	Ancients
Adultery	Honesty
Monsters	Beautiful bodies
Mothers	Fathers
French "refinement"	English and German "manliness"

Lessing's diatribe against Chateaubrun for tracing Philoctetes' suffering to the loss of a beautiful princess rather than to the loss of his *bow* becomes clear, in this context, as a diatribe against the effeminate French

refinement which turns a sublime, masculine tragedy into a "play of bright eyes."

Lessing did not, of course, invent the connection between genre and gender. He had a powerful and rather explicit precedent in Burke's essay on the sublime and beautiful, which made quite unmistakable the connection between poetry, sublimity, and masculinity on the one hand, and painting, beauty, and femininity on the other. But Lessing never mentions Burke, from whom he borrowed so many ideas and examples, in *Laocoon*.[19] Nor does he mention his own father, who wrote a Latin thesis at Wittenberg entitled *de non commutando sexus habitu*—"on the impropriety, that is, of women wearing men's clothes and men women's."[20] Instead, he grounds everything in what he admits is a "dry chain of conclusions" (*diese trockene Schlusskette*) (*L* 92/104), the abstract categories of space and time. He places himself with Newton and Kant above the realm of ideology and sexuality in a transcendental space where the laws of genre are dictated by the laws of physical nature and the human mind—and there he has remained.

What is the consequence of pulling Lessing down from his imperial position as the Newton of aesthetics? Well, one thing that does *not* follow is any devaluation of his genius. On the contrary, the reading I have proposed is one that I think Lessing deliberately invites when he warns us that the organization of *Laocoon* is "accidental," and that the order of chapters "in their growth" has "rather followed the course of my reading than been systematically developed from general principles. They are, therefore, not so much a book as irregular *collectanea* for one (*L* x/11)." It is Lessing's readers who have turned his irregular, associative argument into a system, converting his embattled, value-laden terms into "neutral critical fictions." This, in spite of Lessing's explicit disavowal that he seeks to make a system: "we Germans suffer from no lack of systematic books. No nation in the world surpasses us in the faculty of deducing from a couple of definitions whatever conclusions we please, in most fair and logical order. . . . If my reasoning be less close . . . my examples will, at least, savor more of the fountain"[21] (*L* x–xi/11).

19. See William Guild Howard, "Burke Among the Forerunners of Lessing." *PMLA* 22 (1907), 608–32.

20. I owe this remarkable fact to Gombrich's "Lessing," 146–47.

21. The reconstruction of the polemical context of Lessing's criticism has become increasingly important in recent scholarship. See, for instance, Dan L. Flory, "Lessing,

Lessing has far more to teach us as a fountain of associations concerning the arts than he does as a builder of systems.[22] One thing he teaches us, almost in spite of his canny rhetorical instincts, is that the relation of genres like poetry and painting is not a purely theoretical matter, but something like a social relationship—thus political and psychological, or (to conflate the terms) ideological. Genres are not technical definitions but acts of exclusion and appropriation which tend to reify some "significant other." The "kind" and its "nature" is inevitably grounded in a contrast with an "unkind" and its propensity for "unnatural" behavior. The relations of the arts are like those of countries, of clans, of neighbors, of members of the same family. They are thus related by sister- and brother-hood, maternity and paternity, marriage, incest, and adultery; thus subject to versions of the laws, taboos, and rituals that regulate social forms of life.

Lessing's attempt to pronounce the rational laws that govern this "family romance" of the genres helps us to understand the work of artists who set out deliberately to violate those laws, artists like William Blake, for instance, who insist on blurring the genres in a mixed art of poetry and painting. It is no accident that Blake's mixed art prophesies a revolution in which "Sexes must vanish & cease to be," along with the "Vanities of Time & Space."[23] Blake, the great personifier of abstractions, saw very clearly what lay beneath Lessing's "first principles": "Time & Space are Real Beings Time is a Man Space is a Woman."[24]

Lessing's wanderings from his first principles into subjects like idolatry and fetishism help us to see, finally, the source of the curious power his text has had over all subsequent attempts to comprehend the difference between poetry and painting. This power does not stem only from the surface rhetoric of reason and necessity, but more deeply from Lessing's cunning exploitation of the iconophobic and iconoclastic rhetoric that pervades the discourse we call "criticism" in Western culture.

Mendelssohn, and *Der nordische Aufsehr:* a Study in Lessing's Critical Procedure," in *Lessing Yearbook VII* (Munich: Max Huber Verlag, 1975), 127–48.

22. See Wallbery, *Lessing's Laocoon,* 7, for an illustration of the persistence of this "systematic" view of Lessing.

23. Blake, *Jerusalem* plate 92, II. 13–14. *The Poetry and Prose of William Blake,* ed. David Erdman (New York: Doubleday, 1965), 250. On the abolition of the "vanities of time and space" see Blake's "A Vision of the Last Judgment," Erdman, 545.

24. "A Vision of the Last Judgment," Erdman, 553.

Lessing rationalizes a fear of imagery that can be found in every major philosopher from Bacon to Kant to Wittgenstein, a fear not just of the "idols" of pagan primitives, or of the vulgar marketplace, but of the idols which insinuate themselves into language and thought, the false models which mystify both perception and representation. By literalizing this iconoclastic rhetoric—by applying it, that is, to painting and sculpture rather than to figurative "idols" or icons—Lessing may help us to expose some of the dangers that lie hidden in our iconophobia. He may help us to measure, for instance, the extent to which we have made a fetish out of our own iconoclastic rhetoric, projecting the very idols we claim to be smashing. An idol, technically speaking, is simply an image which has an unwarranted, irrational power over somebody; it has become an object of worship, a repository of powers which someone has projected into it, but which it in fact does not possess. But iconoclasm typically proceeds by assuming that the power of the image is felt by somebody *else;* what the iconoclast sees is the emptiness, vanity, and impropriety of the idol. The idol, then, tends to be simply an image overvalued (in our opinion) by an *other:* by pagans and primitives; by children or foolish women; by Papists and ideologues (*they* have an ideology; *we* have a political philosophy); by capitalists who worship money while we value "real wealth." The rhetoric of iconoclasm is thus a rhetoric of exclusion and domination, a caricature of the other as one who is involved in irrational, obscene behavior from which (fortunately) we are exempt. The images of the idolaters are typically phallic (recall Lessing's account of the adulterous serpents on ancient statues), and thus they must be emasculated, feminized, have their tongues cut off by denying them the power of expression or eloquence. They must be declared "dumb," "mute," "empty," or "illusory." *Our* god, by contrast—reason, science, criticism, the Logos, the spirit of human language and civilized conversation—is invisible, dynamic, and incapable of being reified in any material, spatial image.

I will not deny that it is very hard to write criticism without lapsing into some verison of this rhetoric, nor that such criticism has great power and value. I will only say that this way of speaking makes it difficult to hear, much less criticize, what either the idol or the idolater is saying. Perhaps we would be better able to listen if we had some other concept of the image to work with besides Lessing's alternatives—the mute, castrated, aesthetic object, or the phallic, loquacious idol.

Coda

This essay should properly end at this point, with a question and an empty space to be filled in by the reader. It is hard to resist, however, the temptation to speculate about what sort of image might fill the blank space our culture creates between aesthetic objects and idols. Anthropology offers us an example of such an image in the notion of the *totem*. Totems are not idols or fetishes, not objects of worship, but "companionable forms" (to use Coleridge's phrase) which the viewer may converse with, cajole, bully, or cast aside. They are, in Sir James Frazer's words, "an imaginary brotherhood established on a footing of perfect equality between a group of people on the one side and a group of things on the other side."[25] The totemism of primitive cultures may, of course, be unrecoverable by an advanced civilization with a deeply ingrained tradition of viewing its own spiritual and intellectual activities in iconoclastic terms. Perhaps we should look closer to home, therefore, with the work of Western artists who struggle with the problem of imagery in a self-conscious way, who make the issues of fetishism, idolatry, and iconoclasm explicit thematic or formal issues in their work. We might reexamine, for instance, those two epochs in the history of western literature and art when the boundaries between the spatial and temporal arts seemed to be especially porous. The first is the eighteenth century, when notions such as *ut pictura poesis,* the sisterhood of the arts, and a psychological criticism grounded in mental imaging tended to blur the boundaries between the arts and reduce them to single principles such as picturing, language, or composite forms of "picture-language." The other notable period is that of modernism, with its stress on an abstract, nonrepresentational notion of the image, and its emphasis on spatial critical paradigms such as formalism and structuralism. Each of these movements tended to violate the traditional proprieties of space and time, generally by elevating spatial or imagistic values over temporal ones, and each was met by a reaction which attempted to reassert the boundaries between space and time, usually by an appeal to the superior status of temporal and historical values. For many nineteenth-century writers (Melville, Dickens, and Conrad, for instance) the iconoclastic

25. Frazer, *Totemism and Exogamy,* 4 vols. (London: Macmillan, 1909), 4:5. I owe this example, and much of the following afterthought on totemism, to David Simpson's *Fetishism and Imagination* (Baltimore: Johns Hopkins University Press, 1982).

reaction could not take the simple form of rejecting imagery or imagination (though it involved plenty of anxiety about both).[26] Instead, the iconoclastic project took the form suggested by Wordsworth in his attempts to discriminate the "living images" of imagination from those dead idols "whose truth is not a motion or a shape/ Instinct with vital functions, but a Block/ Or waxen Image which yourselves have made/ And ye adore."

We see this anxious, iconophobic search for "living images" most literally and concretely in the work of William Blake, who was that strangest of creatures, a Puritan painter, an iconoclastic maker of icons. Blake, as we have noted, saw clearly the sexual and political foundations of the abstractions that define the battle lines between artistic genres. As a religious painter his problem was to come to an understanding of images that would allow for a sense of sacred sublimity and power without creating a new set of idols. He found the terms for the perception of this kind of imagery in something very like the social, familial figures for the arts we have seen in the digressions of Lessing's *Laocoon:*

> If the Spectator could enter into these Images in his Imagination approaching them on the Fiery Chariot of his Contemplative Thought if he could Enter into Noahs Rainbow or into his bosom or could make a Friend & Companion of one of these Images of wonder . . . then would he arise from his Grave then would he meet the Lord in Air & then he would be happy.[27]

This attitude, a sort of Protestant totemism, is of course difficult to distinguish from idolatry, especially from the standpoint of a devout iconoclast. For that very reason it deserves the most careful attention from those who claim to be *critical* iconoclasts, who want to discriminate the vain, obscene idols of the mind or the marketplace from those images that are worthy of being called friends and companions.

26. See Simpson, *Fetishism and Imagination,* for a discussion of these writers in these terms.

27. "A Vision of the Last Judgment," Erdman, 550.

Eye and Ear
Edmund Burke
and the Politics of Sensibility

Man communicates by articulation of sounds, and paramountly by
the memory in the ear; nature by the impression of bounds and
surfaces on the eye. . . .

Coleridge, "On Poesy or Art" (1818)

Mute Poesy and Blind Painting

The most fundamental difference between words and images would
seem to be the physical, "sensible" boundary between the realms of visual
and aural experience. What could be more basic than the brute necessity
for eyesight in the appreciation of painting, and the sense of hearing for
the understanding of language? Even the legendary founder of the *ut
pictura poesis* tradition, Simonides of Ceos, acknowledges that, at best,
"painting is *mute* poesy."[1] It may aspire to the eloquence of words, but it
can only attain the kind of articulateness available to the deaf and mute,
the language of gesture, of visible signs and expressions. Poetry, on the
other hand, may aspire to become a "speaking picture," but it would be
more accurate to describe its actual attainment in Leonardo da Vinci's
words, as a kind of "blind painting." The "images" of poetry may speak,
but we cannot really see them.

I don't wish to dwell on these reductions of the arts to the senses
proper to their apprehension, only to note a few problems that come up
if one tries to found a system on them. The first symptom of difficulty is a

1. For a good discussion of the use of this phrase to the disadvantage of painting, see
Wendy Steiner, *The Colors of Rhetoric* (Chicago: University of Chicago Press, 1982), 5.

certain asymmetry in the relative "necessity" of each sense to its appropriate medium. The ear does not seem to be nearly as necessary to language as the eye is to painting. The eye, in fact, can stand in rather well for the ear in language acquisition. The deaf learn to read, write, and to converse by lip-reading and vocal mimicry learned through touch. Perhaps that is why we don't normally speak of poetry, literature, or language as "aural" arts or media with the same assurance that we do in referring to painting and sculpture as visual arts. If it seems a bit odd to speak of poetry as the "aural art," the designation of painting and the other plastic arts as "visual" seems relatively secure.

How secure is that? It depends, of course, on what one means by "visual." One of the most influential stylistic formulas ever developed in art history treats the visual, not as the universal condition of all painting, but as a characteristic of a particular style that has meaning only by contrast with a particular historical alternative, the "tactile." I allude to Heinrich Wölfflin's famous distinction between classical painting (which is tactile, sculpturesque, symmetrical, and closed) in contrast to the baroque (which is visual, painterly, asymmetrical, and open).[2] Of course Wölfflin was using the terms "visual" and "tactile" as metaphors for differences in things that (we want to say) have to be understood as *literally* visual. We can't apprehend a tactile painting through our sense of touch, and we can't apprehend any painting whatsoever without a sense of sight.

Or can we? What does it mean to "apprehend a painting"? Or perhaps we should ask the question another way: what can the blind know of painting? For someone like Milton, who stocked his memory with the masterpieces of Renaissance art before going blind, the answer is, a great deal. But suppose we took the case of the person blind from birth. The answer, I suggest, is still a great deal. The blind can know anything they want to know about a painting, including what it represents, what it looks like, what sort of color scheme is involved, what sort of compositional arrangements are employed. This information must come to them indirectly, but the question is not how they come to know about a painting, but what they can know. It is entirely conceivable that an intelligent, inquisitive blind observer who knew what questions to ask could "see" a great deal more in a painting than the clearest-sighted dullard. How much of our normal, visual experience of painting is in fact

2. *Principles of Art History,* trans. M. Hottinger (London: 1932).

mediated by one sort of "report" or another, from the things we are taught to see in and say about pictures, the labels we learn to apply and manipulate, to the descriptions, commentaries, and reproductions on which we rely to tell us about pictures.

But surely no matter how complete, detailed, and articulate the conception of a picture might be to a blind person, there is something essential in painting (or in a painting) that is forever closed off from the apprehension of the blind. There is just the sheer experience of seeing the unique particularity of an object, an experience for which there are no substitutes. But that is just the point: there are so many substitutes, so many supplements, crutches, and mediations. And there are never more of them than when we claim to be having "the sheer experience of seeing the unique particularity of an object." This sort of "pure" visual perception, freed from concerns with function, use, and labels, is perhaps the most highly sophisticated sort of seeing that we do; it is not the "natural" thing that the eye does (whatever that would be). The "innocent eye" is a metaphor for a highly experienced and cultivated sort of vision. When this metaphor becomes literalized, when we try to postulate a foundational experience of "pure" vision, a merely mechanical process uncontaminated by imagination, purpose, or desire, we invariably rediscover one of the few maxims on which Gombrich and Nelson Goodman agree: "the innocent eye is blind." The capacity for a purely physical vision that is supposed to be forever inaccessible to the blind turns out to be itself a kind of blindness.

It would be perverse, I suppose, to push this point any further, especially when my only purpose is to apply a bit of pressure to the sense of literalness and necessity that surrounds the notion of painting as a visual art. Let us concede that vision is a "necessary condition" for the apprehension of painting; it is certainly not a sufficient one, and there are many other "necessary conditions"—consciousness, perhaps even self-consciousness, and whatever skills are required for the interpretation of the kind of image in question. At any rate, the point here is simply to call attention to a certain reification or essentializing of the senses in relation to the generic differences between words and images, a reification much like the ones that occur with the categories of space and time, nature and convention. The visual and the aural have the distinct advantage of basing these differences in physiology; the structure of sensation becomes the foundation for a structure of sensibility, aesthetic mode, and even categories of judgment and understanding. As with time and space,

nature and convention, the tendency is to think of the visual/aural structure of symbols as a natural division, one which dictates certain necessary limits to what can (or ought) to be expressed by those symbols. In this case, the natural seems to be the physical, bodily conditions of human sentience. Against this reified "nature" we must set the historicity of the body and the senses, the intuition (first developed by nineteenth-century German art historians like Riegl) that "vision" has a history, and that our ideas of what vision is, what is worth looking at, and why, are all deeply imbedded in social and cultural history.[3] Eye and ear, and their associated structures of sensibility, are in this respect no different from the other figures of difference between words and images: they are categories of power and value, ways of enlisting nature in our causes and crusades.

Leonardo and the Argument of the Senses

The use of the senses as polemical instruments is nowhere better illustrated than in Leonardo da Vinci's *Paragone,* a debate between poetry and painting in which the visual art takes all the prizes just because it is visual. Leonardo musters every traditional sensory prejudice he can think of: the eye is the noblest sense, the window of the soul; it is the most far-reaching and capacious; it is the most useful and scientific, since it naturally constructs a perspectival view "along straight lines that compose a pyramid based in the object and leading to the eye"; it is "less deceived in its functioning than any other sense." By comparison, poetry is only able to raise feeble, short-lived images in the imagination:

> The imagination does not see as well as does the eye, because the eye receives the images or likenesses of objects, transmits them to the impressionable mind, and this in turn sends them to the community of the senses, where they are judged. But imagination does not go beyond the senses, except to refer to memory, and there it stops and dies, if the thing imagined is not of much value. . . . We may say that there is the same relationship between a body and its derivative shadow. There is an even closer relationship, for at least the shadow of such a body achieves sensory perception

3. Gombrich discusses the notion of a "history of seeing" in *Art and Illusion,* 7.

> through the eye, but in the absence of the function of the
> eye the image of that body does not become known to the
> senses, but remains where it originates. What a difference
> there is between imagining a light while the eye is in dark-
> ness and seeing it in actuality without that darkness![4]

The difference between painting and poetry is the difference between
substance and shadow, facts and mere signs of facts: "There is the same
relation between facts and words that there is between painting and
poetry, because facts are subject to the eye and words are subject to the
ear" (Leonardo, 12).

Leonardo's praise of the cognitive superiority of images leads him,
however, into a curious paradox. Painting is not only better at telling the
truth than poetry; it is also better at telling lies. Its very ability to present
"facts" makes it capable of presenting the most convincing illusions, so
convincing that "painting even deceives animals, for I have seen a picture
that deceived a dog because of the likeness to its master; likewise I have
seen dogs bark and try to bite painted dogs, and a monkey that did an
infinite number of foolish things with another painted monkey"
(Leonardo, 20–21). And it is not only animals that do foolish things with
pictures: "men . . . fall in love with a painting that does not represent any
living woman" (Leonardo, 22), they may be "excited to lust and sensual-
ity by the vivid illusion of lewd scenes," and of course, they may be lured
into the worst error of all, the sin of idolatry:

> If you, poet, describe the figure of some deities, the writing
> will not be held in the same veneration as the painted deity,
> because bows and various prayers will continually be made
> to the painting. To it will throng many generations from
> many provinces and from over the eastern seas, and they will
> demand help from the painting and not from what is writ-
> ten. (Leonardo, 22)

Leonardo does not dwell upon these rather sinister powers of painting,
its curious ability to present both the scientific truth about reality and the
most irrational, fantastic illusions, because this point would be inconve-
nient for the defense of painting he wants to mount, and it would directly
contradict his claim that the eye "is less deceived than any other sense."

4. *Treatise on Painting,* ed. A. Philip McMahon (Princeton: Princeton University
Press, 1956), xx. Hereafter cited as Leonardo.

His purpose is simply to make painting look good, and if the "goods" it can be associated with (truth and power) turn out to be in conflict, then the conflict is not to be mentioned.

It is hard to believe that Leonardo was unaware of the conflict. His *Paragone* strikes us as an exaggerated exercise of wit, a kind of parody of the received notions (based in the distinction between mechanical and liberal arts) of poetry as the superior art. The *Paragone* expresses the pure antithesis to the "verbocentric" thesis, appropriating all the values (reason, scientific accuracy, and rhetorical power) that traditionally attached to words. Leonardo's apotheosis of the visual image may not have won the day in the battle of the arts, but it reflects a kind of turning point in the war for the representation of reality. For his notion of the image is precisely the one that governs the picture of the mind constructed by the empiricists, from Hobbes to Locke to Hume—an automatic, necessary, and transparently accurate transcription of reality that forms the basis of ideas and, in turn, the basis of words. The pictorialist aesthetic of European neoclassicism, the claim that a poem is a "speaking picture" in a rather strong and literal sense, is grounded in the notion of the mind as a storehouse of images, and language as a system for retrieving those images. The very possibility of communication is understood as based in the "universal language" of images that underlies the local and limited languages of human speech. The very idea of an "idea" is inseparable from the figure of the picture or engraved imprint, the "eidola" impressed in the imagination by experience, preeminently and paradigmatically by visual experience.

Wit and Judgment: Burke and Locke

The duplicity of this image, however, its capacity for both truth and illusion, leads to a curious ambivalence about its role even among the empirical philosophers who make it central to their models of the mind. We noted earlier that the *paragone,* or contest of painting and poetry, gave infinite occasions for the exercise of wit and judgment in acts of comparison and differentiation. But the connection between these mental acts and the contest of painting and poetry goes even deeper in an image-based theory of the mind: the distinction between wit and judgment is itself conceived as a mental version of the contest between word and image. Locke puts it this way in the *Essay on Human Understanding:*

> Wit lying most in the assemblage of ideas, and putting those together with quickness and variety wherein can be found any resemblance or congruity, thereby to make pleasant pictures and agreeable visions in the fancy; judgment, on the contrary, lies quite on the other side, in separating carefully one from another ideas wherein can be found the least difference, thereby to avoid being misled by similitude and by affinity to take one thing for another.[5]

The appropriate medium for judgment, the faculty which counters and regulates the "pleasant pictures . . . of fancy" will turn out to be language, or at least an idealized version of language in which words have clear, distinct, and consistent relations to the ideas they stand for. In practice, Locke will admit that language falls prey to the allure of resemblance and image-making, and that it is probably as impossible to control the "pictures of fancy" as it is to control—who else?—women: "eloquence, like the fair sex, has too prevailing beauties in it to suffer itself ever to be spoken against."[6] But the role of philosophy is precisely to counteract this tendency of language especially in its primitive forms (the oriental tongues with their profusion of figures) and in poetry and rhetoric. The difference between image and word emerges within the realm of language, then, as a distinction between poetry and prose, ancient and modern, primitive superstition and contemporary analytic clarity, the feminine "agreeableness of the picture and the gaiety of fancy," as opposed to the masculinity of "severe rules of truth and good reason."[7]

Since Locke's theory of the mind rests on a conception of consciousness as a recorder and reflector of images, the distinction must also be turned upon the realm of imagery itself. Images which are regulated by the ideal purposes of language, by the rule of judgment and prosaic difference, will be "clear and distinct." Images of wit and fancy, on the other hand, will be unregulated, confused, and obscure. The complex interplay of these distinctions may be seen in the following table:

Wit	Judgment
Resemblance	Difference
Poetry	Prose

5. *Essay,* bk. II, chap. XI, par. 2.
6. *Essay,* bk. III, chap. X, par. 34.
7. *Essay,* bk. II, chap. XI, par. 2.

Images	Words
Primitive	Modern
Obscure Images	Clear Images

What this table reveals, I suggest, is a curious reversal in the placement of the word-image distinction growing out of the initial ambivalence about the cognitive reliability of imagery: the realm of prose and discursive values turns out to be aligned with clear, distinct ideas or mental pictures, and the realm of poetry and fancy that proliferates these images seems to cancel itself out by producing images that cannot be seen.[8]

This reversal of roles is far from explicit in Locke's writing, but it becomes quite unmistakable in the writing of a theorist such as Edmund Burke who wants to reassert the boundaries between texts and images, and who wants to defy the prevailing Lockean notion of mental images/ideas as the referents of words. Burke introduces his *Enquiry into . . . the Sublime and Beautiful* by echoing Locke's distinctions between wit and judgment:

> The mind of man has naturally a far greater alacrity and satisfaction in tracing resemblances than in searching for differences; because by making resemblances we produce *new images,* we unite, we create, we enlarge our stock; but in making distinctions we offer no food at all to the imagination; the task itself is more severe and irksome, and what pleasure we derive from it is something of a negative and indirect matter. . . . Hence it is, that men are much more naturally inclined to belief than to incredulity. And it is upon this principle that the most ignorant and barbarous nations have frequently excelled in similitudes, comparisons, metaphors, and allegories, who have been weak in distinguishing and sorting their ideas. And it is for a reason of this kind that Homer and the oriental writers, though very fond of similitudes, and though they often strike out such as

8. Locke's alignment of the rational use of words with the notion of pictorial clarity emerges most strikingly in his discussion of names of substances and species, which refer in his view to "complex ideas" or "nominal essences" constructed by the mind. These complex ideas are assembled from two qualities of substances, shape and color, and thus "we commonly take these two obvious qualities, viz., shape and colour, for so presumptive ideas of several species, that in a good picture we readily say, "This is a lion, and that a rose; this is a gold, and that a silver goblet," only by the different figures and colours represented to the eye by the pencil" (*Essay,* bk. III, chap. VI, par. 29).

> are truly admirable, they seldom take care to have them ex-
> act; that is, they are taken with the general resemblance, they
> paint it strongly, and they take no notice of the difference
> which may be found between the things compared.[9]

The oriental, pictorial way of writing lacks, as Locke argued, focus and distinctness: it paints "strongly" but not "exactly." By the end of his *Enquiry,* however, Burke will have carried Locke's argument well beyond this point: the tendency of language to arouse obscure, confused images, or no images at all, will begin to seem normative. Obscurity and other antipictorial features will (at times) become the characteristics of language in general, not just of the poetic or primitive. "Words," Burke will say (still following Locke), produce "three effects . . . in the mind of the hearer. The first is, the *sound;* the second, the *picture,* or representation of the thing signified by the sound; the third is, the *affection* of the soul produced by one or by both of the foregoing" (*Enquiry,* 166). But it will turn out that for Burke the pictorial effect is marginal, dispensable. Only "simple abstracts" such as "blue, green, hot, cold, and the like" are "capable of affecting all three of the purposes of words" (*Enquiry,* 166–67). But "even these" do not in their "general effect" depend upon mental picturing:

> I am of the opinion, that the most general effect . . . of these
> words does not arise from their forming pictures of the
> several things they would represent in the imagination; be-
> cause on a very diligent examination of my own mind, and
> getting others to consider theirs, I do not find that once in
> twenty times any such picture is formed, and when it is,
> there is most commonly a particular effort of the imagina-
> tion for that purpose. (*Enquiry* 167)

All verbal expression, then, but *especially* the witty, picturesque mode, turns out to be nonpictorial: "indeed so little does poetry depend for its effect on the power of raising sensible images, that I am convinced it would lose a very considerable part of its energy if this were the necessary result of all description" (*Enquiry,* 170). Burke sometimes speaks as if this antipictorial quality were a general property of language, but in his more

9. *A Philosophical Enquiry into the Origin of Our Ideas of the Sublime and Beautiful,* ed. James T. Boulton (Notre Dame: University of Notre Dame Press, 1958), 18. Hereafter cited as *Enquiry.*

cautious moments, when he is making judicious discriminations between different verbal practices, he treats it in the Lockean fashion as the special property of "oriental tongues," poetry, and rhetoric. Locke's ideal of a rationally regulated language that would present clear, distinct image-ideas still survives in Burke's scheme, but only as a modern innovation of doubtful value:

> It may be observed that very polished languages, and such as
> are praised for their superior clearness and perspicuity, are
> generally deficient in strength. The French language has that
> perfection, and that defect. Whereas the oriental tongues,
> and in general the languages of most unpolished people,
> have a great force and energy of expression. (*Enquiry,* 176)

If the human mind is a mirror that reflects images of nature, Burke has his doubts about the value of "polishing" it to improve intellectual clarity at the expense of powerful feeling.

Sublime Words and Beautiful Images

The curious turns of the word-image difference are never more convoluted than in their use by Burke as ancillary figures for his distinction between the sublime and the beautiful. The sublime is most appropriately rendered in words; the beautiful belongs to the realm of painting. These aesthetic proprieties are not, however, treated as fundamental postulates in Burke's account of the sublime and the beautiful, but are derived from a more basic set of categories, the sensations of pleasure and pain, and their visual counterparts, clarity and obscurity. For Burke, words are the sublime medium precisely because they cannot provide clear images:

> It is one thing to make an idea clear, and another to make
> it *affecting* to the imagination. If I make a drawing of a
> palace, or a temple, or a landscape, I present a very clear
> idea of those objects: but then . . . my picture can at most
> affect only as the palace, temple, or landscape would have
> affected in the reality. On the other hand, the most lively
> and spirited verbal description I can give, raises a very
> obscure and imperfect *idea* of such objects; but then it is in

> my power to raise a stronger *emotion* by the description than
> I could do by the best painting. (*Enquiry,* 60)

Now there would be nothing to prevent Burke from making room in his scheme for something like "sublime painting." Since he thinks that sublimity does occur in visible nature (in vast, awesome scenes, or displays of overwhelming power), and since "the images in painting are exactly similar to those in nature" (*Enquiry,* 62), it would seem logical to suppose that such scenes could achieve sublime effects in painting. But Burke defies the logic of his own position because he wants to reserve artistic or "artificial" sublimity for poetry and verbal art. When he takes up the notion of sublimity in painting, therefore, he dismisses the very attempt as doomed to failure:

> When painters have attempted to give us clear representa-
> tions of these very fanciful and terrible ideas, they have I
> think almost always failed; insomuch that I have been at a
> loss, in all the pictures I have seen of hell, whether the
> painter did not intend something ludicrous. (*Enquiry,* 63)[10]

Obscurity is sublime, for Burke, precisely because it is a frustration of the power of vision. Physiologically, it induces pain by making us strain to see that which cannot be comprehended.[11] Since painting is by definitions a "clear representation" (and perhaps also because it miniaturizes its subjects) it can only achieve the ridiculous by attempting the sublime. In a similar fashion, language by virtue of its incapacity to present clear and distinct images is naturally suited for sublimity. Burke could, of course, make a case for the beautiful in language on the basis of pleasurable, euphonious sounds, but the momentum of his argument carries him away from this sort of claim. All his literary examples favor the use of language as a medium of sublimity—power, grandeur, terror, and obscurity. There is, in theory, nothing to prevent language from representing clear and distinct images, "but then an act of will is necessary to

10. There are hints that Burke saw the possibility of sublimity in painting in his preference for "unfinished sketches of a drawing"(77), and his suggestion that history paintings should use sad, obscure colors (82).

11. See *Enquiry,* 146, where Burke discusses the mechanical, physiological basis of obscurity as a source of the sublime, by treating the eye as a sort of "sphincter muscle" that strains to let in light, and is frustrated by blackness and darkness.

this" (*Enquiry*, 170), and something in our physical nature makes it difficult, perhaps even unnecessary.[12]

The strangest twist in the dialectic of Burke's *Enquiry* is the conflict between the accounts he gives of the production and consumption of sublime words and beautiful images. We have already noted that the faculty of wit and its power of "tracing resemblances" is the productive power of verbal imagery, but that the very fecundity of this power seems to cancel itself out in its own excess, producing "a croud of great and confused images" which are sublime precisely "because they are great and confused" (*Enquiry*, 62). Judgment, on the other hand, which looks for differences and "offers no food at all to the imagination"(18) ends by being the custodian of clear, distinct images. But notice what happens if we coordinate these productive activities with the principles of pain and pleasure. The perception of resemblance, Burke argues, is invariably associated with pleasure(17–18), while the perception of difference "is more severe and irksome, and what pleasure we derive from it is something of a negative and indirect nature"(18). But this severe, indirect pleasure is exactly the sort of sensation Burke analyzes earlier as "delight," the feeling that accompanies the removal of pain or its contemplation from a safe distance, and which serves as the key term in explaining how pain can become the source of aesthetic pleasure in the sublime. The pleasurable process of noticing resemblances (wit) produces an excess of images, which in their confusion, produce a sense of painful obscurity, the source of the sublime in poetry. The painful, laborious[13] process of noticing differences (judgment) produces clarity, a quality that Burke consistently associates with the beautiful: "Beauty should not be obscure" but "light and delicate"(124); "The beauty of the eye consists, first, in its *clearness*"(118); "A clear idea is . . . another name for a little idea"(63), and Burke will devote a subsection of his *Enquiry* to showing "Beautiful objects small"(113–14).

I have overschematized Burke's distinction between the sublime and the beautiful in its relations with the oppositions of word and image,

12. The similarity between Burke's disparagement of difficult, "willed" mental acts and Lessing's emphasis on "convenient relations" between signs and their referents should be noted here. See chapter 4 above.

13. See *Enquiry*, 135, where Burke associates the work of the "understanding" with physical work: "labour is a surmounting of *difficulties*, an exertion of the contracting power of the muscles, and as such resembles pain. . . ."

pain and pleasure, obscurity and clarity, wit and judgment. A more discriminating view would concede that words do not always line up with sublimity, nor images with beauty, and that wit and judgment have complex relations with both. What this schematization helps us to see, however, are certain tendencies in Burke's argument that are very difficult to grasp unless one actually maps out the movement of his key terms. One of these tendencies is what might be called the principle of dialectical reversal, a process in which oppositions seem to change places. Burke sees this at times as something like a natural law, a *coincidentia oppositorum*. The sublime and the beautiful are as "opposite and contradictory" as "black and white" or "pain and pleasure" (*Enquiry*, 124). There is "an eternal distinction between them, a distinction never to be forgotten by any whose business it is to affect the passions." While the distinction remains eternal, however, "in the infinite variety of natural combinations we must expect to find the qualities of things the most remote imaginable from each other united in the same object"(124). Pleasure and pain can quite easily coexist in the same object, depending on whether it is viewed from the standpoint of consumption or production. There is, moreover, a principle that goes beyond the "combination" of opposites in a single object, and involves the *transformation* of one into the other in the extremes. Thus, although Burke will associate light and darkness with the beautiful and the sublime, he will also point out that "extreme light, by overcoming the organs of sight, obliterates all objects, so as in its effect exactly to resemble darkness"(80). This union of extreme opposites Burke will identify as itself a principle of the sublime: when "two ideas as opposite as can be imagined" are "reconciled in the extremes of both," they "concur in producing the sublime . . . which in all things abhors mediocrity"(81).

It's important to note that Burke's dialectical method, whether we praise it as sublime rhetoric or denounce it as self-contradiction, is grounded in what he regards as the physical structure of the human senses. Our passions, emotions, and aesthetic modes are all derived from a physiological basis, the economy of pleasure and pain, and the receptive capacities of the various sensory organs. Burke rejects the Lockean notion that aesthetic and social values are to be understood as products of "association" and education: "it would be to little purpose . . . to look for the causes of our passions in association, until we fail of it in the natural properties of things" (*Enquiry*, 131). Burke suggests that "an investigation of the natural and mechanical causes of our pas-

sions . . . gives . . . a double strength and lustre to any rules we deliver on such matters"(140). This "double strength" is the confirmation of rules that seem dictated by custom, experience, and common sense by an appeal to a deeper level of natural necessity. These rules are not confined to the realm of sensation, feeling, and aesthetic experience, of course, but permeate every level of social life. The natural structure of human sensibility dictates that certain features of the political order will also be natural, a political aesthetic that will carry Burke well beyond his youthful interest in the theory of art to the theory of political and social revolution.

Politics as Aesthetics: Gender and Race

Burke's most notorious derivation of political values from the mechanics of sensation is his linking of sublimity and beauty with the stereotypes of gender. Sublimity, with its foundations in pain, terror, vigorous exertion, and power, is the masculine aesthetic mode. Beauty, by contrast, is located in qualities such as littleness, smoothness, and delicacy that mechanically induce a sense of pleasure and affectionate superiority (Burke notes the use of "affectionate diminutives," especially by "the French and Italians," to refer to "objects of love") (*Enquiry,* 113). It is not hard to see how these aesthetic and sensory categories line up with those of gender. When Burke refutes the traditional notion of beauty as "fitness" or "usefulness," the sexual example is brought in to clinch his case:

> if beauty in our own species was annexed to use, men would be much more lovely than women; and strength and agility would be considered the only beauties. But to call strength by the name of beauty, to have but one denomination for the qualities of a Venus and Hercules, so totally different in almost all respects, is surely a strange confusion of ideas, or abuse of words. (*Enquiry,* 106)

A similar example is mustered to refute the notion that *"perfection* is the constituent cause of beauty":

> So far is perfection, considered as such, from being the cause of beauty; that this quality, where it is highest in the female

sex, almost always carries with it an idea of weakness and
imperfection. Women are very sensible of this; for which
reason, they learn to lisp, to totter in their walk, to counter-
feit weakness, and even sickness. In all this, they are guided
by nature. (*Enquiry*, 110)

Burke's subsequent elaboration of gender difference makes it clear that
he regards it not just as a matter of sensory or aesthetic decorum but as a
figure for the natural foundations of all political and cosmic order,
the universal structure of domination, mastery and slavery: "The
sublime . . . always dwells on great objects, and terrible; the [beautiful]
on small ones and pleasing; we submit to what we admire, but we love
what submits to us"(113). This natural aesthetics of domination extends
from the family ("the authority of a father . . . hinders us from having
that entire love for him that we have for our mothers")(111), to the state
(fear and admiration are the emotions properly evoked by the leader), to
the terrors of the father-god.

The sensory enforcement of sublimity in these authority figures, it
should be noted, is consistently described by Burke as a strategy of visual
deprivation. The father is remote, the mother intimate and accessible.

Despotic governments, which are founded on the passions
of men, and principally upon the passion of fear, keep their
chief as much as may be from the public eye. The policy has
been the same in many cases of religion. Almost all heathen
temples were dark. Even in the barbarous temples of the
Americans at this day, they keep their idol in a dark part of
the hut, which is consecrated to his worship. (*Enquiry*, 59)

The invisible god of the Judeo-Christian tradition, with all his attendant
prohibitions against visual representations, is simply the abstract perfec-
tion of this theory of sublimity. The word, the indirect verbal report, not
the direct accessibility of the image, is the appropriate medium for this
god, and even the word must be used circumspectly, with the "judicious
obscurity" of a Milton(59). The prohibition against graven images can,
of course, be extended to the word insofar as it is a representation. Thus,
the name of God cannot be spoken or, even more to the point, written
down.

Burke's association of power with darkness is, of course, vulnerable to
one very noticeable and obvious exception, a case in which the power

relations of master and slave directly contradict the sensory, aesthetic relations of light and darkness. In refuting Locke's claim that "darkness is not naturally an idea of terror" but becomes terrible by association with superstitious tales, Burke tells the

> very curious story of a boy, who had been born blind, and continued so until he was thirteen or fourteen years old; he was then couched for a cataract, by which operation he received his sight. Among many remarkable particulars that attended his first perceptions . . . the first time the boy saw a black object, it gave him a great uneasiness; and . . . some time after, upon accidentally seeing a negro woman, he was struck with great horror at the sight. (*Enquiry*, 144)

It is hard to resist the thought that the "great horror" at the black woman (in contrast to the mere "uneasiness" at a black object) is as much owing to the clash of aesthetic and political sensibilities as it is to the mechanics of vision. The doubled figure of slavery, of both sexual and racial servitude, appears in the natural colors of power and sublimity. This sort of incongruous mixture of power and weakness, the confusion of sensory, aesthetic signals and of the "natural" orders of gender, social class, and symbolic modes will become, as we shall see, the basis for Burke's images of the French Revolution.[14]

The French and the Specular Sublime

It has often been noted that there is a kind of discrepancy between Burke's obvious preference for the sublime as an aesthetic mode, and his reaction to the most sublime political event in his lifetime, the French Revolution.[15] The most straightforward way of accounting for this discrepancy is simply to argue that sublimity is one thing in art and

14. Cf. Ronald Paulson, *Representations of Revolution* (New Haven: Yale University Press, 1983), 70, on Burke's notion of the Revolution as a "false sublime."

15. See Paulson's chapter on "The Sublime and the Beautiful," in *Representations of Revolution*, and Isaac Kramnick, *The Rage of Edmund Burke: Portrait of an Ambivalent Conservative* (New York: Basic Books, 1977) for psychological accounts of Burke's "political aesthetic." For a more straightforwardly political account, see Neal Wood's "The Aesthetic Dimension of Edmund Burke's Political Thought," *Journal of British Studies* 4 (1964), 41–64.

nature, quite another in politics. The kind of imaginative fecundity that produces poetic wit becomes a dangerous force in the real world:

> When men have suffered their imaginations to be long affected with any idea, it so wholly engrosses them as to shut out by degrees almost every other, and to break down every partition of the mind which would confine it. Any idea is sufficient for the purpose, as is evident from the infinitive variety of causes which give rise to madness. (*Enquiry,* 41)

This sort of madness is permitted in the realm of aesthetics. Virgil's description of Vulcan's cavern is, according to Burke, "more wild and absurd" in its proliferation of images than "the chimeras of madmen"(171), and so it is "admirably sublime." When the mind is "hurried out of itself by a croud of great and confused images . . . which affect because they are crouded and confused"(62), the effect is sublime as poetic metaphor, merely dangerous when it becomes literalized in mob behavior.

There are two problems with this straightforward account. The first, perhaps trivial, is that it attributes to Burke's *Enquiry* a distinction between a true (aesthetic) and false (political) sublime that only becomes operative forty years later on the occasion of the French Revolution. The second problem, a more serious one, is that such a distinction would fly in the face of Burke's whole stress (in the *Enquiry* and in his later writing) on the continuity of aesthetic and political sensibilities. Fathers, states-men, and deities *should* be sublime; if politics is a question of power and feeling, then there is no way of keeping the aesthetics of the sublime out of it. Is Burke's later reaction to the Revolution an abandonment of the connection between aesthetics and politics? Or is it, as Isaac Kramnick suggests, a shift from one aesthetic category to another as the one "natural" to government—a replacement of "the sublime virtues of Pitt's leadership" for the "beautiful virtues" of party government?[16]

Let us look at the way Burke summarizes the new, dangerous, politi-cal sublime in his *Appeal from the New to the Old Whigs* (1791):

> It is now obvious to the world, that a theory concerning government may become as much a cause of fanaticism as a dogma in religion. There is a boundary to men's passions, when they act from feeling; none when they are under the

16. Kramnick, *The Rage of Edmund Burke,* 114; cited in Paulson, 70.

influence of imagination. Remove a grievance, and, when men act from feeling, you go a great way towards quieting a commotion. But the good or bad conduct of a government, the protection men have enjoyed or the oppression they have suffered under it, are of no sort of moment, when a faction, proceeding upon *speculative* grounds, is thoroughly heated against its form.[17]

It is clear from this passage that Burke is working from the same psychology that accounts for the production of the verbal, rhetorical sublime in the *Enquiry:* the overproduction of visual images by "imagination" is now reemphasized, however, by the addition of the word "speculative," a term that does not play a significant role in the *Enquiry*. And there is another key word in this passage that suggests Burke's sense of having come some distance from a previous position, the word "now." "It is *now* obvious . . . that a theory concerning government may become as much a cause of fanaticism as a dogma in religion." This was not always so obvious; in fact one of Burke's principal claims about the French Revolution was that no one could have predicted it:

> These things history and books of speculation (as I have already said) did not teach men to foresee, and of course to resist. Now that they are no longer a matter of sagacity, but of experience, of recent experience, of our own experience, it would be unjustifiable to go back to the records of other times to instruct us to manage what they never enabled us to foresee. (*On the Policy of the Allies* [1793], 4:470)

What one might have predicted on the basis of Burke's own sagacious speculations on aesthetics was that a nation noted for rationality, blessed with a "polished" language, the sort that is praised for its "superior clearness and perspicuity," at the expense of being "deficient in strength" (*Enquiry,* 176), would have had the good judgment to avoid revolution. The "croud of great and confused images" Burke cites as his example of poetic sublimity included such prophetic items as "a tower, an archangel, the sun rising through mists, or in an eclipse, the ruin of monarchs, and the revolution of kingdoms" (*Enquiry,* 62), and these images are to be

17. *The Works of Edmund Burke,* 12 vols., ed. George Nichols (Boston: Little, Brown, 1865–67), 4:192. Subsequent references to Burke's writings (other than the *Enquiry*) will be to this edition, cited as *Works*.

found, not in the cold beauties of French neoclassical verse, but in the quintessentially English poet, John Milton. One would have expected a revolution from the English, the speakers of a "forceful and energetic tongue" ideally suited for the sublime, or for the blandishments of revolutionary rhetoric. The nation of painters, rationalists, and connoisseurs would seem naturally inappropriate for the fanaticism and energy required for a revolution:

> The abbe du Bos founds a criticism, wherein he gives painting the preference to poetry in the article of moving the passions; principally on account of the greater *clearness* of the ideas it represents. I believe this excellent judge was led into this mistake (if it be a mistake) by his system, to which he found it more conformable than I imagine it will be found to experience. I know several who admire and love painting, and yet who regard the objects of their admiration in that art with coolness enough, in comparison of that warmth with which they are animated by affecting pieces of poetry or rhetoric. Among the common sort of people, I never could perceive that painting had much influence on their passions. It is true that the best sorts of painting, as well as the best sorts of poetry, are not much understood in that sphere. But it is most certain, that their passions are very strongly roused by a fanatic preacher, or by the ballads of Chevy-chase, or the children in the wood, and by other little popular poems and tales that are current in that rank of life. I do not know of any paintings, bad or good, that produce the same effect. So that poetry, with all its obscurity, has a more general as well as a more powerful dominion over the passions than the other art. (*Enquiry*, 61)[18]

This passage captures the whole aesthetic basis of Burke's view of the difference between the French and the English as nations of the eye and the ear, of painting and verbal—especially oral—expression, of system and personal experience, of cool "judgment" and warm "passions." At

18. Kant echoes this view in *The Critique of Judgment*, sec. 29, when he suggests that "images and childish ritual" are tolerated by governments to keep their subjects passive and docile. The "sublime" proscription of graven images, by contrast, is seen by Kant as an impetus to enthusiasm.

the same time, however, it reveals the gulf between Burke's understanding of this difference in the *Enquiry* and his later account of it in the *Reflections on the Revolution*. What Burke has learned between 1757 and 1790 is that the Frenchman, the "excellent judge" whose "system" led him astray in aesthetic questions, could derive an unsuspected warmth, passion, and energy from the clarity of that system. What Burke had not taken into account in 1757 was the possibility of an alliance between the faculties of imagination and reason, an alliance that would manifest itself in a burst of abstract speculation and system-building, the creation of a crowd of great and *clear* images that would derive their power from the authority of science and mathematices. When Burke said that "a clear idea is therefore another name for a little idea" (*Enquiry*, 63), he had not reckoned with the emergence of "ideologie," the sublime of rational revolution.

Indeed, in 1757 it had seemed to him that rational clarity and "mathematical speculations" could excite no passions concerned with either the sublime *or* the beautiful:

> It is from this absolute indifference and tranquillity of mind, that mathematical speculations derive some of their most considerable advantages; because there is nothing to interest the imagination; because the judgment sits free and unbiased to examine the point. (*Enquiry*, 93)

By the 1790s Burke had begun to see mathematics, and indeed all of "experimental philosophy," in a new light, as the agent of a new kind of cold and theoretic passion:

> Their imagination is not fatigued with the contemplation of human suffering through the wild waste of centuries added to centuries of misery and desolation. Their humanity is at their horizon,—and, like the horizon, it always flies before them. The geometricians and the chemists bring, the one from the dry bones of their diagrams, and the other from the soot of their furnaces, dispositions that make them worse than indifferent about those feelings and habitudes which are the supports of the moral world.[19]

For Burke, a "clear idea" is no longer a "little idea." It has, like the

19. *Letter to a Noble Lord* (1796); *Works*, 5:216–17.

rational geometry of the vanishing point on the horizon, produced a sublime indifference to "feelings and habitudes," the "humanity" which the revolutionary speculators want to postpone until the "horizon," the completed revolution, has been attained.

The English and the Verbal Sublime

While Burke may not have anticipated that "a theory of government" with all its clear, systematic ideas could become "as much a cause for fanaticism as a dogma in religion," he was not caught without terms to deal with it. We might even claim that his anatomy of the sublime as originating in imagination predicted something of the sort. And we could also turn back to his essay on the sublime and beautiful for the terms in which he opposed and criticized this imaginative, specular sublime. The opposing terms are *feeling* and *experience*: "There is a boundary to men's passions when they act from feeling; none when they are under the influence of imagination."[20] Against the tendency of images to proliferate endlessly in the process of abstract speculation, he can pit the authority of a judgment that is conceived not as pure rationality but as the product of experience, custom, tradition, and habit. Against the revolutionary fanaticism of clear ideas and ideology, he can pit the "obscure ideas" of English poetry, rhetoric, and tradition. English sublimity, English fanaticism, will be centered on the word, not the image; on religion, not a theory of government; on experience, not speculation. The English fanatic will be a preacher; the English people will be moved by the sound of his voice, or by the popular ballads and tales that move their passions.

Indeed, if we push Burke's anatomy of the sublime far enough in its iconoclastic, antivisual sentiments, we can read in it a claim that the verbal sublime finally has nothing at all to do with images, clear *or* obscure:

> Indeed so little does poetry depend for its effect on the power of raising sensible images, that I am convinced it would lose a very considerable part of its energy, if this were the necessary result of all description. Because that union of

20. *Appeal from the New to the Old Whigs* (1791), *Works,* 4:192.

affecting words which is the most powerful of all poetical in-
struments, would frequently lose its force along with its
propriety and consistency. (*Enquiry,* 170)

Burke illustrates this point with a passage from Virgil which, as we noted
earlier, exemplifies the sublime as wildness and confusion:

> This seems to me admirably sublime; yet if we attend coolly
> to the kind of sensible image which a combination of ideas
> of this sort must form, the chimeras of madmen cannot
> appear more wild and absurd than such a picture. . . . The
> picturesque connection is not demanded; because no real
> picture is formed; nor is the effect of the description at all
> the less upon this account. (*Enquiry,* 171)

Burke's earlier analysis of Milton suggested that the sublime effect was a
product of confused images "which *affect because* they are crouded and
confused" (*Enquiry,* 62; my emphasis). But now Burke seems to want to
shift the emphasis, to deny any need for the picturesque connection. The
signs of his struggle with the Lockean pictorial view of language are
evident: Virgil's description is a "wild and absurd" picture; then it is no
picture at all. A similar equivocation occurs in his claim that "so far is a
clearness of imagery" in verbal expression "from being absolutely neces-
sary to an influence upon the passions, that they may be considerably
operated upon without presenting any image at all." Is it clear images
that are being repudiated here or any image whatsoever, clear or obscure,
organized or confused?

Whatever answer we take, the thrust of Burke's desire is unmistak-
able: he wants to trace the verbal sublime not to the obscurity of verbal
images but to some other positive source. So strong is this desire that he
even becomes uneasy with the notion that words have a connection with
ideas, since an idea, in the theory Burke wants to correct, is invariably
equated with an image. He quotes Milton's description of hell: "Rocks,
caves, lakes, dens, bogs, fens and shades/—of Death":

> This idea or this affection caused by a word, which nothing
> but a word could annex to the others, raises a very great de-
> gree of the sublime; and this sublime is raised yet higher by
> what follows, a *"universe of death."* Here are again two ideas
> not presentable but by language; and an union of them great

and amazing beyond conception; *if they may be properly called ideas which present no distinct image to the mind.* (*Enquiry,* 175)

Burke acknowledges that "it seems to be an odd subject of dispute with any man, whether he has ideas in his mind or not"(168), but this is precisely the case he has to argue: "strange as it may appear, we are often at a loss to know what ideas we have of things, or whether we have any ideas at all upon some subjects"(168). Burke then adduces "two very striking instances of the possibility there is, that a man may hear words without having any idea of the things which they represent, and yet afterwards be capable of returning them to others, combined in a new way." The examples are those of a blind poet and a blind professor of mathematics, the one capable of describing "visual objects with . . . spirit and justness," the other giving "excellent lectures upon light and colours." (168–69)

What then is the other principle that gives language its power to communicate and to affect emotions, if it is not to be found in images, ideas, and imagination? Burke's answer, I suggest, is to be found in his notions of *sympathy* and *substitution.* The "business" of poetry and rhetoric "is to affect rather by sympathy than imitation; to display rather the effect of things on the mind of the speaker, or of others, than to present a clear idea of the things themselves" (*Enquiry,* 172.) Only in dramatic poetry, strictly speaking, where the speeches imitate the things men say (but not the things they talk about) can words be thought of as "imitations." In ordinary speech, and in poetry or rhetoric, however, language "operates chiefly by substitution; by means of sounds which by custom have the effect of realities"(173). Words work their effect by sympathy, substitution, and sound, in contrast to imitation, resemblance, and vision, the mechanisms of image production.

To notice this, however, is also to notice that words are ultimately cut off from what we have previously seen as the source of the verbal sublime—the imagination, which notices "resemblances" and creates new images. In this antipictorial account of language, the effects of words have only an attenuated, indirect connection with the lower parts of human nature; their effect is the product of custom, habit, and acculturation. The primary passion that gives rise to them is sympathy, the first of the social passions, that by which we "enter into the concerns of others" by a process of "substitution." The social bond is also the

semiotic: words are linked to things and feelings by the same force that bonds man to man—an instinct that draws unlike things together.

Burke's disengagement of words from images, his tracing of their power to the effects of custom, habit, and association, tends to move the verbal sublime away from the natural sublime, away from the immediate mechanical response of our nature to terrible, dangerous objects. "Whatever power *words* may have on the passions, they do not derive it from any representation raised in the mind of the things for which they stand" (*Enquiry,* 164). The mechanism of the verbal sublime, of powerful words, is mediated by habit:

> Such words are in reality but mere sounds; but they are sounds, which being used on particular occasions, wherein we receive some good, or suffer some evil, or see others affected with good or evil; or which we hear applied to other interesting things or events; and being applied in such a variety of cases that we know readily by habit to what things they belong, they produce in the mind, whenever they are afterwards mentioned, effects similar to those of their occasions. (165)

The effect of these "mere sounds" is distanced even from the realm of the sublime in natural sounds. The cries of animals, for instance, "are not merely arbitrary," and thus "never fail to make themselves sufficiently understood; this cannot be said of language"(84). Language, precisely because of its arbitrary nature, moderates everything that it mediates, so that it can provide even the most painful, disgusting images of sense with the "distancing" required for delight and sublimity:

> no smells or tastes can produce a grand sensation, except excessive bitters, and intolerable stenches. It is true, that these affections of the smell and taste, when they are in their full force, and lean directly upon the sensory, are simply painful, and accompanied by no sort of delight; but when they are moderated, as in a description or narrative, they become sources of the sublime as genuine as any other, and upon the very same principle of moderated pain. (85)

Burke has to be seen, then, as arguing for two theories of the sublime in the *Enquiry*. One is based on imagination, the mechanics of sensation,

and controlled chiefly by visual and pictorial metaphors—darkness and light, obscurity and clarity. The other, which emerges most clearly in the final section of the *Enquiry,* is resolutely antivisual, antipictorial, and employs the terminology of feeling, sympathy, and customary association or substitution. In modern rhetorical terms, we might say that the first theory is based on metaphor and similitude, the notions of likeness and resemblance; the second is metonymic, grounded in arbitrary, customary linkages. This second sublime is the moderate one because its basis in acculturated, conventional feeling imposes a boundary on the passions, while the visual, speculative, and imaginative sublime has no boundaries, and is the sort of passion that leads to revolution. The difference between the false, speculative French sublime and the true English verbal sublime was, in a sense, lying dormant in the *Enquiry,* awaiting the occasion that would give it application.

English Speech and French Writing

Burke's preference for the moderate verbal sublime is consistently exemplified by an analysis of language as primarily an oral, not a written, medium. It is the "mere sounds" that recall habitual responses, not the written words. Writing, the translation of speech into a "visible language," simply does not figure in the aesthetics of the *Enquiry.* Burke did comment on the different functions of speech and writing, however, in his discussions of the history of "law and institutions," linking "manners" and "customs" to oral tradition, while the notion of "positive law" has to await the arrival of letters:

> If people so barbarous as the Germans have no laws, they
> have yet customs that serve in their room; and these customs
> operate amongst them better than laws, because they be-
> come a sort of Nature both to the governors and the
> governed[21]

In this primitive state (Burke is referring to the ancient Saxons when he talks of "Germans" here)

> authority, great as it was, could never by its very nature be
> stretched to despotism; because any despotic act would have

21. *An Abridgment of English History* (1857), 7:292.

shocked the only principle by which that authority was sup-
ported, by the general good opinion. On the other hand, it
could not have been bounded by any positive laws, because
laws can hardly subsist amongst a people who have not the
use of letters. It was a species of arbitrary power, softened
by the popularity from whence it arose. (*Works,* 7:292).

Burke's praise for the primitive democracy of a society regulated by oral
tradition rather than written law is qualified elsewhere by a recognition
that writing allows for improvement and reform. Oral tradition, un-
leavened by the progressive effects of writing, can keep a people in a
barbarous and wretched condition (Burke cites the "ancient customs" of
the Irish, which "prevent all improvement and . . . perpetuate corrup-
tion" [*Works,* 7:414]). His basic position, as always, is elaborated as a
compromise, but with the balance shifted toward the sway of habit,
manners, and the orally transmitted foundations of social order. The
ancient Saxon customs "operate[d] better than laws," and provided a
structure that remained as the basis for later laws: "thus were delineated
the faint and incorrect outlines of our Constitution, which has since been
so nobly fashioned and highly finished" (*Works,* 7:293). "Letters," which
make possible the encoding of law in a fixed, publicly visible form, are
relegated to the secondary position of "fashioning" and "finishing" what
has been established by the immemorial wisdom of oral tradition.

Given this understanding of the relation of speech and writing, we can
imagine Burke's reaction to Thomas Paine's demand that a constitution
must exist in writing, in "visible form." Paine had insisted that

> a constitution is not a thing in name only, but in fact. It has
> not an ideal, but a real existence; and wherever it cannot be
> produced in visible form, there is none. A constitution is a
> thing *antecedent* to government, and a government is only
> the creature of a constitution.[22]

Quoting this passage from *The Rights of Man* in his *Appeal from the New
to the Old Whigs* (1794) Burke gave Paine's words a contemptuous
dismissal: "such writings," he said, did not "deserve any other than the
refutation of criminal justice"(4:161). Burke declined to answer the

22. *The Rights of Man* (1791–92), with Burke's *Reflections on the Revolution,* (Garden
City, N. Y.: Doubleday, 1961), 309. All references to these texts will be to this edition, cited
as *Rights* and *Reflections.*

charge that the English constitution was invisible, unwritten. His role was to testify to his own sense of the real "constitution" as an organism something like a human body, constituted as a community of senses with distinct powers and privileges, a mixed being of natural and conventional behavior, a creature of biology and habit, pleasure and pain, society and self-preservation. Burke's constitution was thus both political and aesthetic, involved in judgments of morality and taste, and preserved by immemorial customs passed on in the living tradition of a national language. It is no wonder that Burke regarded the *Declaration of the Rights of Man* as "paltry and blurred sheets of paper" (*Reflections,* 100–101); no wonder that he can find nothing to admire in the written constitutions framed by the speculators and geometricians of France, whose imaginations have conquered their feelings. "The constitution on paper is one thing," says Burke, "and in fact and experience is another."[23]

These two constitutions, the one a "visible form," the other invisible and aural, are much like the two sublimes of Burke's *Enquiry.* Ideally, they would combine to make one indissoluble "mixed constitution," an image of the ideal English character and polity. Burke wanted to speak, in both aesthetics and politics, "not like a partisan of one particular member of our Consititution, but as a person strongly, and on principle, attached to them all" (*Works,* 5:99). He knew that, in the community of senses, as of persons, "a constitution made up of *balanced powers* must ever be a delicate thing" (*Works,* 4:98); an abstract consistency could only be achieved by tracing all aesthetic, like all political passions, to one source. His fear that the French disease of "speculation" would overturn this constitution produced a reaction that made this delicate balance impossible to sustain, and led him into a rhetoric that betrayed both the political and aesthetic values on which it was based.

23. *Speech on a Bill for Shortening the Duration of Parliament* (1780); *Works,* 7:77. Burke's association of the French Revolution with "political Men of letters" and "literary cabals" (*Reflections* [124]) become a standard topos both for defenders and critics of the Revolution. William Hazlitt regarded the Revolution as "a remote but inevitable result of the invention of the art of printing" (*The Life of Napoleon,* 1828, 1830; *Collected Works,* ed. P. P. Howe, 21 vols. [London: J.M. Dent & Sons, 1931], 13:38). Thomas Carlyle summed up the revolutionary era as "the age of paper," and made explicit Burke's association of "modern letters" with unbridled "speculation" in politics (paper constitutions) and economics (paper currency). See Carlyle, *The French Revolution* (1837; New York, 1859), 28–29. For more on the issue of Romanticism and the reaction against written language, see my essay, "Visible Language: Blake's Wond'rous Art of Writing," in *Romanticism and Contemporary Criticism,* ed. Morris Eaves and Michael Fischer (Ithaca, N.Y.: Cornell University Press, forthcoming).

"Mr. Burke's Horrid Paintings"
Reflections on the Revolution

Burke's impartial attachment to the different and opposed principles which composed the "mixed constitution" of human nature received its severest test in his reaction to the French Revolution. As a manifesto of political principles *Reflections on the Revolution in France* (1790) remains entirely consistent with the axioms of moderation and respect for tradition that had informed his entire career. At the level of rhetorical and aesthetic effect, however, it is generally acknowledged that his habitual moderation gave way to extremism and excess. His reliance on detailed analysis of the circumstances surrounding any political event gave way to the very sort of imaginative excess he deplored in the French. In particular, his tendency to project and dwell upon "spectacles" of the Revolution without regard to their antecedent causes or historical accuracy produces in his exchanges with the liberals and radicals of the 1790s a fearful and fatal symmetry, a tendency to mimic and parody the rhetoric of the opposition in a way that gives an unsuspected irony to the notion of "reflections."

The most famous of what Paine called "Mr. Burke's horrid paintings" (*Rights*, 287), is his account of "the atrocious spectacle of the sixth of October 1789," when the "swinish multitude" invaded the apartments of Marie Antoinette, forcing "this persecuted woman . . . to fly almost naked" (*Reflections*, 84). Burke follows this titillating spectacle with equally lurid scenes of violence: an "unprovoked, unresisted, promiscuous slaughter" leaves "the most splendid palace in the world . . . swimming in blood, polluted by massacre, and strewed with scattered limbs and mutilated carcasses" (*Reflections*, 84). "The royal captives" are then led from the palace "amidst the horrid yells, and shrilling screams, and frantic dances, and infamous contumelies, and all the unutterable abominations of the furies of hell, in the abused shape of the vilest of women"(85). Burke is especially concerned to stress the sexual, and particularly the feminine character of the violence, alluding perhaps to the popular notion that men in women's clothing participated in the march to Versailles.[24] He thus constructs a spectacle that fulfills all his

24. See Natalie Davis, *Society and Culture in Early Modern France* (Stanford: Stanford University Press, 1975), 147–50, for a discussion of the "female persona" in the revolution, and Paulson, *Representations of Revolution*, 81.

requirements for the specular sublime: it is confused, obscure—a "croud of images"—and filled with violence and danger. But it also contains those inverted signals that, like the blind English boy's first sight of a black woman in the *Enquiry,* produce an especial horror: this is unnatural, feminine violence, a reversal of the natural order of strength and weakness; perhaps even worse, the "abused shape" of a transvestite mob.

What provoked the master of moderation and circumstantial accuracy into this account, which seems exagerrated on the face of it? The best answer seems to be, a previous picture of the same events, offered by Doctor Richard Price at a sermon delivered to the Society for Constitutional Information in November of 1789. Price, like many English liberals, saw the October Days as an augury of peaceful revolution, the reconciliation of Louis XVI with the National Assembly and the French people. Burke describes Price's speech as a spectacular piece of revolutionary theater:

> There must be a great change of scene; there must be a
> magnificent stage effect; there must be a grand spectacle to
> rouze the imagination. . . . The Preacher found them all in
> the French revolution. This inspires a juvenile warmth
> through his whole frame. His enthusiasm kindles as he
> advances; and when he arrives at his peroration, it is in full
> blaze. Then viewing from the Pisgah of this pulpit, the free,
> moral, happy, flourishing, and glorious state of France, as in
> a bird's-eye landscape of a promised land, he breaks out into
> the following rapture.(77–78)

Whereon Burke quotes a "mine eyes have seen thy salvation" setpiece from Price's speech. Price's "Pisgah vision" typologically fuses the triumphal procession of King Louis and the people from Versailles to Paris with Christ's entry into Jerusalem and the entry of the Israelites into the Promised Land. What Price sees as a scene of salvation for both king and people Burke "reflects" back as an obscene, pagan spectacle:

> These Theban and Thracian orgies, acted in France . . . I
> assure you, kindle prophetic enthusiasm in the minds but of
> very few people in this kingdom; although a saint and apos-
> tle who may have revelations of his own, and who has so
> completely vanquished all the mean superstitions of the
> heart, may incline to think it pious and decorous to compare

it with the entrance into the world of the Prince of
Peace.(85)

A picture of pagan orgies or a scene of Christian triumph? Louis XVI as
sacrificial victim or as revolutionary messiah? The rhetoric of rival ideolo-
gical images offers no opening for mediation or negotiation, no way for
one vision to communicate with the other except by inversion and
parody. Burke even seems self-conscious about the way his own "paint-
ing" is carrying away his imagination, though his typical procedure is to
project this activity onto the adversaries, who are seen as themselves
composing the pictures to which he simply responds with "natural
feeling." The rumor that some bishops were involved in counterrevolu-
tionary plots and were in danger of arrest or assassination is expanded by
Burke into a history painting:

> The actual murder of the bishops, though called for by so
> many holy ejaculations, was also wanting. A group of reg-
> icide and sacrilegious slaughter, was indeed boldly sketched,
> but it was only sketched. It unhappily was left unfinished, in
> this great history-piece of the massacre of innocents. What
> hardy pencil of a great master, from the school of the rights
> of men, will finish it, is to be seen hereafter.(86)

Was Burke applying here his observation in the *Enquiry* that the
"unfinished sketches of a drawing . . . pleased me beyond the best
finishing"? (*Enquiry*, 77). Is he aware of his own rhetorical activity when
he confesses that he may "have dwelt too long on the atrocious spectacle
of the sixth of October 1789, or have given too much scope to the
reflections which have arisen in my mind" (93)? If so, he immediately
suppresses his awareness of imaginative excess by arguing that it is only
the corrupting influence of the revolution itself, which has "attempted to
destroy within us every principle of respect" and made him feel "almost
forced to apologize for harbouring the common feelings of men"(93).

Burke's overcoming of his misgivings about the display of his "reflec-
tions" on the revolutionary spectacle leads him directly into a meditation
on the nature of spectacle itself, a meditation that will allow him to
characterize his feelings as the natural impulses of his aesthetic being, the
very sort of impulses he outlined in the *Enquiry,* impulses radically
different from the "unnatural" feelings of Reverend Price and the
French:

> Why do I feel so differently from the Reverend Dr.
> Price . . . ? For this plain reason—because it is *natural* that I
> should; because we are so made as to be affected at such
> spectacles with melancholy sentiments upon the unstable
> condition of mortal prosperity, and the tremendous uncer-
> tainty of human greatness; We are alarmed into
> reflexion; our minds (as it has long since been observed) are
> purified by terror and pity. . . . Some tears might be drawn
> from me, if such a spectacle were exhibited on the stage. I
> should be truly ashamed of finding in myself that superficial,
> theatric sense of painted distress, whilst I could exult over it
> in real life. With such a perverted mind, I could never ven-
> ture to show my face at a tragedy.(94)

"The theatre," Burke will conclude, "is a better school of moral senti-
ments than churches." No poet would "dare to produce such a triumph
as a matter of exultation. . . . They would reject them on the modern, as
they once did on the antient stage. . . . In the theatre, the first intuitive
glance, without any elaborate process of reasoning"(94) would show
what the true, the "natural" response to this sort of spectacle must be.

What Burke forgets, of course, is a certain ambiguity about who the
painter of this spectacle is, whose "reflexions" are on display, who has
composed the tragic scene that he is staging for us. The authorship of
these "horrid paintings" is precisely what Paine would call into question:

> As to the tragic paintings by which Mr. Burke has outraged
> his own imagination, and seeks to work upon that of his
> readers, they are very well calculated for theatrical repre-
> sentations, where facts are manufactured for the sake of
> show, and accommodated to produce, through the weakness
> of sympathy, a weeping effect. But Mr. Burke should recol-
> lect that he is writing history, and not plays. (*Rights*, 286)

Paine's arguments with Burke over political questions—the nature of a
constitution, the legality of the British monarchy—are and were per-
ceived as relatively weak. He was too radical on the question of natural
rights for most of the English liberals, and his grasp of historical and legal
issues seems relatively shallow next to Burke's. But his analysis of Burke's
rhetoric, and particularly Burke's use of theatrical and pictorial effects, is
rather telling. He notes that "it suits [Burke's] purpose to exhibit con-

sequences without their causes. It is one of the arts of the drama to do so. If the crimes of men were exhibited with their sufferings, the stage effect would sometimes be lost" (*Rights*, 297). He accurately diagnoses the compositional techniques in Burke's management of spectacle: "A vast mass of mankind are degradedly thrown into the background of the human picture, to bring forward, with greater glare, the puppet-show of state and aristocracy" (*Rights*, 296). And he captures the nervous, disorganized transitions of Burke's reflections in a marvelous counterimage: "Mr. Burke brings forward his bishops and his lantern, like figures in a magic lantern, and raises his scenes by contrast instead of connection" (*Rights*, 301).

Indeed, Paine has, with his fellow radicals, a whole ensemble of counterimages to the scenes and spectacles of Burke. Sometimes it is an alternate picture of the same event: the October Days as pagan orgy or Christian triumph; the great seal of England as an object sanctified by tradition or "a *metaphor*, shown at the Tower for six-pence or a shilling a-piece" (*Rights*, 315). Sometimes it is a completely different event, figured in a rival iconography. Where Burke focuses on the October Days as an aristocratic tragedy, a Shakespearean spectacle of ruined majesty, Paine presents the fall of the Bastille as a Puritan allegory in the emblematic tradition of the dissenters: "The downfall of it included the idea of the downfall of despotism; and this compounded image was become as figuratively united as Bunyan's Doubting Castle and Giant Despair" (*Rights*, 289).

At the level of rival images it may now be clear why war was inevitable, why only the appearance of discussion could go on. Both parties were caught up in the rhetoric of iconoclasm, the projection of false, mystifying self-images or "reflections," and the imputation of idolatry to the alien antagonist. Paine noticed this in a moment of reflexiveness: "we can all see the absurdity of worshipping Aaron's molten calf, or Nebuchadnezzar's golden image; but why do men continue to practise on themselves the absurdities they despise in others?" (*Rights*, 315). This moment of self-consciousness, like Burke's uneasiness about dwelling on his "spectacles," passes quickly in favor of a frontal assault on the "idols" of church and state in Burke's discourse.[25] The question, however, remains an important one, for it raises in a rather vivid way the relations of

25. For more on this matter, see S. J. Idzerda, "Iconoclasm during the French Revolution," *American Historical Review* 60 (1954).

aesthetic sensibility to the accuracy of historical representations, and beyond that, to the very possibility of producing representations of history that allow for dialogue and communication. The first half of this problem is summarized nicely by Ronald Paulson:

> Because of its apparent uniqueness, the French Revolution is an example of representation that to an unusual degree privileges the historical referent. . . . The referent, the actual French Revolution, was a situation in which historical actions were reported and known and had their effect on the emergent models and metaphors. But we are also dealing with poetic language and images that are self-generating in that they make little or no claim on the real world of what actually happened in the phenomenon called the French Revolution. . . . Once Edmund Burke's "French Revolution" itslef had become a referent, for which the revolutionaries and counterrevolutionaries found their own signifiers and signified, we reach a point where literature and the process of "making" have taken over, only to be "matched" (to use E. H. Gombrich's terms) from time to time against historical events.[26]

This "matching," of course, can never occur directly, but must always employ as its material some other representation. The closest one might come to testing a representation against "history itself," one supposes, is in its application to subsequent events: whose version fits best with the later development of the event in question? Burke's representation clearly won this contest in the short run: it became, as Paulson notes, the referent for other versions. It determined the basic scenes, images, figures, and topoi out of which new representatons could be constructed. It "captured the imagination" of all subsequent reflections on the French Revolution.

It would be a grievous mistake to think of this simply as a problem for historians, as if there were some way of making an end run around the representations of the revolution to the thing itself. For Burke's *Reflections* did not simply play the role of an influential version; it was a historical event in itself, an episode in the revolution's history as well as a reflection on it. One could exaggerate its role by claiming (as some have)

26. Paulson, *Representations of Revolution,* 5.

that it encouraged reactionary hostility to France, led to the suppression of moderate, liberal alternatives, helped to isolate the revolution from the rest of Europe, and so in a sense drove it into the desperate and terrible events of the early 1790s. This would be an exaggeration, but it would be equally false to think of Burke's reflections as a body of images that stands outside of what it represents. Like other publicly influential acts, his reflections had consequences and antecedent causes that do not line up in a simple billiard-ball model of historical causation. Burke produced a poetry that made things happen, both in life and art. His very success may help us to see why there could be a certain attractiveness in a notion of art that would make nothing happen, one that would turn Burke's poetry away from real politics into a politics of sensibility, a revolution in feeling, consciousness, and "all the mighty world/ Of eye and ear." It may also help us understand why such an escape could never succeed, why the senses, the aesthetic modes, and the act of representation itself continue to fall back into the history from which we would like to redeem them.

Part Three
Image and Ideology

If we try to summarize the ways the text-image difference functions in the criticism of art and culture, the first thing we might notice is that all four writers I have discussed converge on a single topic: the image as the site of a special power that must either be contained or exploited; the image, in short, as an idol or fetish. Burke and Lessing treat the image as the sign of the racial, social, and sexual other, an object of both fear and contempt. The contempt springs from the assurance that images are powerless, mute, inferior kinds of signs; the fear stems from the recognition that these signs, and the "others" who believe in them, may be in the process of *taking* power, appropriating a voice. It is not enough, then, for Burke and Lessing to count on the natural laws which govern the power of symbols to keep images in their place; these laws must be continually enforced by generic prescriptions that will keep the arts, and the sensory and aesthetic modes, in their proper places. For Lessing, these laws will insure the "purity" of painting and sculpture and prevent them from usurping the larger sphere of language and expression. For Burke, the threatening "speculative" and "spectacular" images (feminine, barbaric, and French) must be met with counterimages which certify the beauty and sublimity of the native, natural order of things, and which "reflect" the new, threatening images as monstrous, grotesque freaks of nature.

Gombrich also treats images as signs which tap the power of nature—whether the nature of rational, scientific representation, or its darker twin, the nature of primitive, irrational force, and animal instinct. But if Burke and Lessing confront those "natures" with iconophobia, Gombrich's attitude is basically iconophilic: he celebrates the magic of imagery in all its forms (with some notable reservations about modern art)

and reproduces in his rhetoric all the cultural *topoi* that make that magic plausible: the mystique of science, the authority of common sense and tradition, and the power of cultural "others" (sexual, racial, and historical) to define our cultural "selves." Gombrich's text takes on added power, it must be noted, by his lavish display and discussion of illustrative images drawn from every sort of realm—advertising, children's art, ornamental design, optical illusions, classical painting, scientific illustration, etc. His great contribution has been to rekindle our sense of wonder at the "ordinary language" of images, and to lay open for analysis the sources of that wonder.

The other great iconologists in the modern era have, of course, been Rudolph Arnheim and Erwin Panofsky. Arnheim's application of Gestalt psychology to problems in pictorial perception naturalizes the image from a formal standpoint, in contrast to Gombrich's emphasis on natural illusion and representation.[1] A really full account of modern image theory would probably situate these two theorists in the Kantian tradition, Gombrich (following Panofsky and neo-Kantians like Cassirer) in adapting the Kantian "schematism" to a historicist program, Arnheim following the ahistorical line of Kant's thought toward a universalist and a priori harmonizing of mind and world in the act of perception and representation.[2]

Nelson Goodman, in contrast to the iconophilia of Gombrich and Arnheim, labels himself explicitly (though without historical self-consciousness) as an iconoclast. He carries the philosopher's battle against iconicity to its logical extreme, banishing imitation, resemblance, copying, likeness, and all their relatives from their position as foundational notions in aesthetics and epistemology, and replacing them with a thoroughly formal and conventionalist account based on reference and denotation. The only versions of iconicity that survive Goodman's critique are (1) the concession that resemblance might be a *product* of certain pictorial practices (the world can begin to look like the pictures we make of it); (2) the admission of metaphor to full philosophical

1. Since Arnheim's "nature" is purely formal, basing itself in innate tendencies to seek visual patterning in whatever data strikes the eye, it displays few of the ethnocentric features we find in Gombrich's emphasis on the teleology of illusion and scientific representation. Arnheim thus has few problems with abstract modernism, and with primitive or children's art. See his *Art and Visual Perception* (Berkeley: University of California Press, 1954).

2. See Michael Podro, *The Critical Historians of Art* (New Haven: Yale University Press, 1982), for a reconstruction of this tradition.

respectability as a "way of world-making." Metaphor, in Goodman's account, would of course not be grounded in resemblance or in "mental images" in the empiricist sense, but in the novel application of labels. Not that Goodman utterly banishes the magic of images. One could argue that his categories of density and repleteness reinstate the basic values of modern formalism by treating these emphases on the signifier as "symptoms of the aesthetic." Autographic objects, in which considerations of density and repleteness are coupled with a stress on origins and history of production, are the paradigmatic objects of "aesthetic" attention: every difference makes a difference, and aesthetic excellence is linked with cognitive subtlety, complexity, and inexhaustibility on the one hand, and formal economy, rightness, and elegance on the other.

Goodman's list of "symptoms of the aesthetic," when coupled with his account of expression as the application of metaphorical predicates to art objects, is surprisingly close to Walter Benjamin's notion of "aura," the mystique that surrounds artistic and ritual objects like a semivisible halo.[3] What Goodman provides is a system for describing the "routes of reference" (from predicates to art object; from art object to other objects or predicates; from art object to semantic or syntactic fields of compliance) that produce our sense of aura. What he does not even attempt to provide (and what Benjamin is most interested in) is an account of the "*roots* of reference," the origins, genealogies, histories, the social forces that give rise to "auratic" or aesthetic symptoms.[4] For Goodman, history does not exist, except as a formal necessity in works whose uniqueness and origins are inseparable from their meaning. Realistic images in general, and photographic images in particular, have no special status in Goodman's theory. They are simply local conventions of representation that enjoyed a certain kind of novelty at one time, and have a rather widespread familiarity at the present time. They have no special status as "privileged representations," and Goodman regards any such status as simply a conceptual mistake that his iconoclasm will help to correct.

I have suggested that Goodman's ahistorical, formalistic conventionalism serves, paradoxically, to open up a new perspective on the history of symbolic theory and practice. The more obvious use of his work would be as a system for the neutral technical description of

3. See my discussion of Benjamin's notion of aura in chapter 6, pp. 180–185 below.
4. See Goodman's essay, "Routes of Reference," *Critical Inquiry* 8:1 (Autumn, 1981), 121–32.

symbolic practices. It seems likely, however, that as long as the terms of modern semiotics and the traditional distinctions of symbol theory maintain their currency, that something would be lost by simply replacing them with Goodman's terminology. That "something" is precisely the charge of value, power, and interest that is carried by culturally loaded terms like nature and convention, space and time, the visual and the aural, the iconic and the symbolic. While these terms may seem "mistaken" from Goodman's point of view, as long as they continue to be the operative vocabulary for the expression of artistic intention and critical intuition, there is no gainsaying their discursive force. Goodman's demystification of these terms is primarily useful, in my view, not for a value-free analysis (symbol theory has no "metalanguage" in that sense) but for an analysis which confronts head-on the values and interests they enforce and screen off.

This double role of enforcement and screening is what I have tried to elucidate in the foregoing discussions of Lessing and Burke, both writers employing distinctions screened by the authority of metaphysical and physiological necessity (space and time, the visual and the aural) in order to enforce specific cultural and social values. The same sort of critique could be made of Goodman's commitment to a modernist aesthetic and a liberal pluralist ideology, or of Gombrich's use of the image to ratify the inevitability of Hobbesian "nature" and possessive, acquisitive individualism.

Such a critique can lead us in several directions. The most obvious would be more of the same—more study, that is, of critics, aestheticians, and other theorists who have tried to legislate the boundaries between the arts, and especially the war-torn border between image and text. A second alternative would be to study artistic practice in relation to the embattled boundary between texts and images. How is this struggle manifested in the formal characteristics of texts and images that are designed to confirm or violate the boundaries between space and time, nature and convention, the eye and ear, the iconic and the symbolic? To what extent is the battle of text and image a consciously articulated theme in literature, the visual arts, and the various "composite arts" (film, drama, cartoons, narrative cycles, book illustrations) that combine symbolic modes? These questions take us beyond the boundaries of this book, away from "what people say" about images toward the things they do with images in practice. It will probably be evident, however, that many of my claims about the possibility of violating the image-text

boundary are based on a conviction that this is something that occurs all the time in practice (I hereby promise a companion volume on this topic). My own work with British painting and poetry in the Romantic era, and the very considerable body of scholarship that studies the relations of verbal and visual art in everything from medieval illumination to modern poetry convinces me of two things: first, that this sort of study is not only possible but necessary if we are to understand anything like the full complexity of either verbal *or* visual art (transgressions of text-image boundaries being, in my view, the rule rather than the exception); second, that this sort of study can stand some self-criticism, especially at the level of general principles. Since there is, at present, no real "field" in the humanities that studies the relations of verbal and visual art, no "iconology" that studies the problem of perceptual, conceptual, verbal, and graphic images in a unified way, it may be worth saying something about the way the principles of this book might affect these fragmented practices.

This sort of study is already well advanced in literary criticism, of course, and sometimes it even announces itself under the name of "iconology."[5] Literary iconology has its "literal" basis in certain specialized forms: graphic, concrete and shaped poetry, in which the physical presentation of the text is charged with "density" and figural, iconic features; ekphrastic poetry, where the text attempts to represent a work of visual or graphic art. But literary iconology also invites us to pay special attention to the presence of visual, spatial, and pictorial motifs in all literary texts: architecture as a metaphor for literary form; painting, film, and the theater as metaphors for literary representation; emblematic images as encapsulations of literary meaning; scenes (depicted or described) as symbolic settings for action and projections of mental states; portraits and mirrors as "agents" of action and projections of selves; and characters as "picture-makers" in the narrow sense (Austen's Emma, Charlotte Brontë's Jane Eyre, Virginia Woolf's Lily Briscoe) or as "seeing subjects" in the broad sense (Henry James's visually acute narrators; the Ruskinian "beholder"; the steady Wordsworthian "eye").

5. See, for instance, George P. Landow's *Images of Crisis: Literary Iconology, 1750 to the Present* (Boston: Routledge & Kegan Paul, 1982), and Theodore Ziolkowski's *Disenchanted Images: A Literary Iconology* (Princeton: Princeton University Press, 1977). Both of these studies would be more appropriately titled "iconographies," since their main concern is not with the theory of imagery, but with specific motifs and symbols: magic mirrors, haunted portraits, and talking statues (Ziolkowski), and scenes of shipwreck, deluge, and catastrophe (Landow).

Obviously this sort of literary iconology has its counterpart in the visual arts, where the representation of writers and readers, speakers and listeners, and the incorporation of textual elements (narrative, temporality, "differentiated" signs, "readable" sequences) is an ever-present possibility to be exploited or avoided. To the extent that "iconology" has its roots in art history rather than in literary criticism, and in a highly literate form of art history that insists on seeing images in relation to philosophical, historical, and literary texts, it would seem almost superfluous to have to make a case for an interest in language and literature in the study of visual art. The fact is, however, that there is considerable resistance among art historians, some of it no doubt justified, to "incursions" by the proponents of textuality. Insofar as semiotics, for instance, treats every graphic image as a text, a coded, intentional, and conventional sign, it threatens to blur the uniqueness of graphic images, and make them part of the seamless web of interpretable objects. It is not surprising that the authority of Lessing (who was, in a very precise sense, no friend of the visual arts) is often invoked to defend the turf of art history.

The resistance to the interartistic comparison, to the study of the "sister arts," runs deeper, however, than mere professional insularity. What I am suggesting here is that the comparative study of verbal and visual art would be leavened considerably by making this resistance one of its principal objects of study, instead of treating it as an annoyance to be overcome. Such a shift in perspective might help us define more clearly just what is at stake in the incorporation of one medium by another, what values are being served by transgressions or observances of text-image boundaries. How does respect or disregard for formal laws manifest itself in various kinds of artistic practices, both familiar and experimental? The movies, for instance, which seem so self-evidently to combine textual and imagistic values, clearly do not have any single formula for these combinations, despite the best attempts of film theorists to identify the "essential" character of the medium in textual (narrative and dramatic) or imagistic values. And these "theoretical" controversies (over the superiority of the silent film versus the "talkies," for instance) have a way of insinuating themselves into the concrete practices of filmmaking.[6] The theater itself, as the example of Ben Jonson and

6. Erwin Panofsky's classic essay, "Style and Medium in The Motion Pictures," transfers the space/time categories of Lessing and Kant into film criticism in ways that reproduce

Inigo Jones suggests, is a kind of battleground between the values associated with verbal and visual codes. The presentation of imagistic elements in texts, textual elements in images is, in other words, a familiar practice which might be "defamiliarized" by understanding it as a transgression, an act of (sometimes ritual) violence involving an incorporation of the symbolic Other into the generic Self.

How would this application of ideological analysis to iconological problems change the way we think about the relations of text and image? One implication would be that the considerable amount of practical, historical criticism now being done "between the arts" of image and text need not wait for some super-structuralist theory of the relations between the arts to legitimate its work. The major stumbling block in the way of this sort of study has always been, in fact, the hope for some master trope, some structural model, that would allow a kind of scientific, comparative formalism to proceed under the umbrella of a "true theory" of the relation between image and text. The familiar excesses of comparative criticism of texts and images—formal analogies between cupolas and couplets, cathedrals and epics, all certified by the *zeitgeist* or a transcendental notion of "style"—are best understood as displaced expressions of this desire for a master theory to unite the arts.[7] But if we were to understand the text-image relation as a social and historical one, characterized by all the complexities and conflicts that plague the relations of individuals, groups, nations, classses, genders, and cultures, our study might be freed from this craving for unity, analogy, harmony, and universality, and might, in the process, be in a better position to move toward some sort of coherence.

The third direction our study might take at this point would be an examination of the foundations of our own inquiry. I have argued in the preceding pages that the *theory* of imagery is deeply bound up with a

their ideological force. And a number of feminist film critics have noted the connection between gender and the tension between the "mute" film image and the *auteur*. See, for instance, Laura Mulvey, "Visual Pleasure and Narrative Cinema," in *Screen* 16:3 (1975), and Judith Mayne, "Female Narration, Women's Cinema," in *New German Critique*, nos. 24–25 (Fall–Winter, 1981–82), 155–71. See also my discussion of semiotic and sexual conflict in Billy Wilder's *Sunset Boulevard*, in "Going Too Far with the Sister Arts," *Image and Text*, ed. James Heffernan and Barbara Lynes (New York: Cambridge University Press, forthcoming).

7. For a good survey of the "history of analogical insight—and disappointment—that characterizes the painting-literature comparison," see Wendy Steiner, *The Colors of Rhetoric* (Chicago: University of Chicago Press, 1982), chap. 1.

fear of imagery, that iconology cannot be thought apart from a confrontation with iconoclasm and its antagonists—idolatry, fetishism, and iconophilia. These confrontations, as we have seen in the Burke-Paine debate, tend to destroy the possibility of mediating terms, of images that are neither true nor false, neither worshipped nor despised. The usual candidate for the function of mediating image (especially in post-Kantian aesthetics) is the aesthetic object. But these objects have a tendency, as we have seen in Lessing's account of imagery, to cloister themselves in the enclave of aesthetic "purity," and to distinguish themselves from impure, idolatrous images. What distinguishes the iconologist from the art historian, the aesthetician, and the literary critic, however, is the willingness to contemplate the "impure" image in all its forms—from the figures, analogies, and models that disrupt the purity of philosophical discourse, to the "ordinary language" of images that Gombrich finds in mass culture, to the ritual objects the anthropologist might find in "pre-aesthetic" cultures. We have seen hints of this sort of mediating image in the preceding pages: the notion of a "totem" or "companionable form" as a medium between Lessing's idol and the aesthetic object; the Platonic notion of a "provocative" or "dialectical image" that elides the distinction between natural and conventional signification. Nelson Goodman's dissolving of the ontological divide between image and text suggests, in a similar way, a merging of the aesthetic and the cognitive, with the possibility of interplay between philosophy and metaphor, science and art.

Concrete instances of these dialectical images are a familiar feature of iconological discussion. They include the canonical examples (Plato's cave, Aristotle's wax tablet, Locke's dark room) that come up whenever the nature of images becomes a subject for philosophical reflection, whenever the nature of images becomes linked with an account of the nature of man. And they have their analogues in the realm of graphic images: Wittgenstein's duck-rabbit, Foucault's *Las Meninas,* Lessing's Laocoön (the image, not the text), all serve, like the philosophers' images, as what I have called "hypericons," figures of figuration, pictures that reflect on the nature of images. These hypericons have a tendency, however, to lose their dialectical character; their very status as canonical examples changes them from "provocatives" or objects of dialogue and totemic play into reified signs, objects that (like idols) always say the same thing. One of the principal goals of iconology, then, is to restore the provocative, dialogic power of these dead images, to breathe new life

into dead metaphors, particularly the metaphors the inform its own discourse.

I have attempted to revivify the critical figures of iconology by subjecting them to ideological analysis, scrutinizing the "political unconscious" that informs our understanding of imagery and its difference from language, and suggesting that behind every theory of imagery is some form of the fear of imagery. But what about the mode of ideological analysis itself? Does it not also have constitutive figures and images, hypericons that control its picture of its own activities? What sort of status does it have in relation to the discursive practices it analyzes? Is it a kind of master theory or meta-language that stands above all these benighted theories of imagery, revealing their blind spots from its own enlightened perspective? Or is it involved in the very practice it seeks to explain? In order to answer these questions, we need to turn the tables on our inquiry and make the notion of ideology itself the subject of an iconological analysis.

6

The Rhetoric of Iconoclasm
Marxism, Ideology, and
Fetishism

> If in all ideology men and their relations appear upside-down as in
> a *camera obscura,* this phenomenon arises just as much from their
> historical life-process as the inversion of objects on the retina does
> from their physical life-process.
>
> Karl Marx, *The German Ideology* (1845–47)

The theory of ideology has been the subject of both the liveliest disputes
and the most refined elaboration in modern Marxist criticism of culture.
The purpose of this essay is not to settle those disputes or to further that
elaboration but to perform a historical analysis on some features of the
figurative language it employs—what Wittgenstein would call the "sym-
bolism" or "model" that allows the theory to "be taken in at a glance and
easily held in the mind."[1] In doing this sort of analysis I am following
what I take to be Marx's own hints about the correct method for
analyzing concepts, namely, the method of making concepts "concrete"
by turning them into images. Any "mental fact" or "conceptual totality,"
Marx notes, "is by no means a product of the idea which evolves
spontaneously and whose thinking proceeds outside and above percep-
tion and imagination, but is the result of the assimilation and transforma-
tion of perceptions and images into concepts."[2] The proper method for
analyzing concepts, then, is one which retraces the steps from the ab-
stract concept back to its concrete origin:

1. *The Blue and Brown Books* (New York: Harper & Row, 1958), 6.
2. *A Contribution to the Critique of Political Economy* (1859), 207. Reference here and
throughout will be to the Maurice Dobb edition, trans. S. W. Ryazanskaya (New York:
International Publishers, 1970), cited as *CPE.*

> The concrete concept is concrete because it is a synthesis of
> many definitions, thus representing the unity of diverse
> aspects. It appears therefore in reasoning as a summing up, a
> result, and not as the starting point, although it is the real
> point of origin, and thus also the point of origin of percep-
> tion and imagination. The first procedure attenuates
> meaningful images to abstract definitions, the second leads
> from abstract definitions by way of reasoning to the repro-
> duction of the concrete situation.[3]

It is this second procedure that Marx calls "the correct scientific method,"
a method whose goal is the recovery of its own origins, a "reproduction
of the concrete situation" that it was devised to explain.

The two concrete concepts that I will be concerned with here are the
notions of ideology and of the commodity. These two terms provide the
mind-body axis, as it were, on which Marx's dialectic revolves. Ideology
is the crucial term in Marx's analysis of mind and consciousness, and
commodities are his central physical objects in the real world. Ideology is
the earlier term, employed chiefly in the writings of the 1840s when Marx
was exorcising the influence of idealist philosophy. Its status is somewhat
doubtful in the thought of the mature Marx, and the key text for the
elaboration of the notion, *The German Ideology,* was not even published
in Marx's lifetime. Nevertheless, it has provided the foundation, as
Raymond Williams notes, "in almost all Marxist thinking about culture,
and especially about literature and ideas."[4] Commodities, on the other
hand, play an unquestionably crucial role in Marx's major work. *Capital*
opens with a lengthy exposition of the commodity as the foundational
concept in Marx's entire economic theory, and yet I think it is fair to say
that this notion has played a relatively minor role in the study of culture,
the arts, or ideas. The attempt to see these "superstructural" phenomena
in such close proximity to the economic "base" of society has generally
been regarded as a kind of vulgar Marxism, and the study of culture has
relied on "softer," more diaphanous terms like "hegemony" and
"ideology."[5]

3. *CPE,* 206.
4. *Marxism and Literature* (Oxford: Oxford University Press, 1977), 55.
5. There are notable exceptions to this rule, such as Jean Baudrillard's *For a Critique of the Political Economy of the Sign* (St. Louis: Telos Press, 1981), which I will discuss later in this essay. Hereafter cited as *CPS.*

Marx makes the concepts of ideology and commodity concrete the way poets and rhetoricians always have, by making metaphors. The metaphor for ideology, or as Marx would say, the image behind the concept, is the *camera obscura,* literally a "dark room" or box in which images are projected. The image behind the concept of commodity, on the other hand, is the fetish or idol, an object of superstition, fantasy, and obsessive behavior. When these concepts are seen in their concrete form, their relationship becomes clearer. Both are "hyper-icons" or images in a double sense, like Plato's cave or Locke's tabula rasa, in that they are themselves "scenes" or sites of graphic image-production, as well as verbal or rhetorical images (metaphors, analogies, likenesses). When we speak of them as "images," then, it is important to keep in mind that we are using the term to refer (1) to the use of these objects as concrete vehicles in the metaphoric treatment of abstractions, and (2) as objects which themselves are graphic images or producers of images. The *camera obscura* is a machine for producing a very specific kind of image, and a fetish is a very particular sort of image—not, however, the kind we see in a camera obscura. On the contrary, there is a kind of dissonance between the two: the camera obscura is thought to produce highly realistic images, exact replicas of the visible world. It is constructed in accordance with a scientific understanding of optics. The fetish, on the other hand, is the antithesis of the scientific image, epitomizing irrationality in both its crudity of representational means and its use in superstitious rituals. It is a "producer" of images, not by means of mechnical reproduction, but by an organic "breeding" of its own likeness.

But this striking contrast between the two images is not the whole story. They also have a rather precise complementarity in form and function: in the one, the images are shadows, insubstantial "phantoms" projected in darkness; in the other, the images are material objects carved, stamped, or imprinted as tangible, permanent forms. Each implies and generates the other in a dialectical fashion: ideology is the mental activity that projects and imprints itself on the material world of commodities, and commodities are in turn the imprinted material objects that imprint themselves on consciousness. Most important, they are related by the whole conceptual scheme that brings them into play: both are emblems of capitalism in action, one at the level of consciousness, the other in the world of objects and social relations. Thus, both are false images or what Francis Bacon called "idols": the camera obscura of

ideology produces "idols of the mind" and the commodity fetish func-
tions as an "idol of the marketplace." In the dialectic between them a
whole world emerges. If we think of the camera obscura as a figurative
descendant of Plato's Cave with its shadows projected on the wall, the
fetishes are like the objects that cast the shadows, "human images and
shapes of animals as well, wrought in stone and wood and every
material."[6] The standard interpretation of the allegory of the Cave might
easily be applied to Marx as well: "The artificial objects correspond to the
things of sense and opinion . . . and the shadows to the world of reflec-
tions, *eikones*." In the interplay of these "things" and "reflections" arises
a dialectic—an idealist one in Plato's case, a materialist one in Marx's.

In the following pages I will analyze the figures of the camera obscura
and the fetish as concrete concepts in Marx's thought. My aim is partly
exegetical: I simply want to show how richly evocative these metaphors
are, by exhibiting the "unity of diverse aspects" or "synthesis of many
definitions" they contain. But I also have a critical aim, which is to show
how these concrete concepts have to a certain extent crippled Marxist
thought even as they have enabled it. This disabling, I will argue, arises
from a neglect of the concreteness—and particularly the historical spe-
cificity—of ideology and fetishism, a tendency to treat them as reified and
separable abstractions instead of dialectical images. One might put this
most simply by saying that ideology and fetishism have taken a sort of
revenge on Marxist criticism, insofar as it has made a fetish out of the
concept of fetishism, and treated "ideology" as an occasion for the
elaboration of a new idealism.[7]

I should stress that this argument in its general form is not terribly
original, nor is it especially hostile to the tradition of Marxist criticism.
As Raymond Williams has observed, Marxist criticism is passing
through "a time of radical change" when it is no longer "possible to
assume that [it] is a settled body of theory or doctrine."[8] Many of its
fundamental concepts are undergoing revision and radical scrutiny, and
a number of Marxist theorists have puzzled over the problem of how to
prevent the reification of basic terms like "ideology" and "fetishism." If
there is any originality in what follows, it is perhaps in the treatment of

6. *Republic* VII.514b; Loeb edition, 121.
7. See E. P. Thompson, *The Poverty of Theory and Other Essays* (New York: Monthly
Review Press, 1978), for a vigorous critique of this idealism in the work of Althusser.
8. *Marxism and Literature*, 1.

Marx's text and the writing he inspires as something like a literary tradition (as opposed, say, to a body of scientific thought to be proved or disproved); and more specifically, in the focus on the problematic of images in Marx's writing—the status of figures, icons, and graphic symbols—and the rhetoric of iconoclasm that gives them life.

Ideology as Idolatry

> The idols and false notions which are now in possession of the human understanding, and have taken deep root therein, not only so beset men's minds that truth can hardly find entrance, but even after entrance is obtained, they will again in the very instauration of the sciences meet and trouble us, unless men being forewarned of the danger fortify themselves as far as may be against their assaults.
>
> Francis Bacon, *The New Organon* (1620)

Before we turn to Marx's use of the camera obscura as a model for ideology, it might be helpful to look at the historical connections of this term with models of image production. The concept of ideology is grounded, as the word suggests, in the notion of mental entities or "ideas" that provide the materials of thought. Insofar as these ideas are understood as images—as pictorial, graphic signs imprinted or projected on the medium of consciousness—then ideology, the science of ideas, is really an iconology, a theory of imagery. It isn't necessary, of course, to think of ideas as images, but it is extremely tempting to do so, and most theories of mind at some point or other find themselves either giving in to this temptation or rejecting it as a kind of pyschological idolatry—what might be called "eidolatry" or "ideolatry." Most try to have it both ways, repudiating the "idols of the mind" worshiped by some competing model of consciousness, and embracing some new sort of image that contains guarantees against mystification and idolatry. Thus, for Plato the false images are those of sensory appearance, and the true images (which of course are not really images) are the abstract, ideal forms of mathematics. For Locke, the false images are the "innate ideas" of scholastic philosophy, and the true images are the direct impressions of sensory experience. For Kant and the German idealists of the nineteenth

century, the false images are the sensory impressions of empiricism, and the true ones are the abstract schemata of a priori categories.[9]

The iconoclastic rhetoric in each of these philosophical revolutions has a ritual familiarity: the repudiated image is stigmatized by notions such as artifice, illusion, vulgarity, irrationality; and the new image (which is often declared not to be an image at all) is honored by the titles of nature, reason, and enlightenment. In this scenario of intellectual history, the worship of graven images in the dark groves and caves of heathen superstition has given way to a superstitious belief in the power of graven mental images that reside in the dark cave of the skull. And the urge to enlighten the savage idolater gives way to the project of enlightening all the benighted worshipers of "idols of the mind."

The notion of ideology has its historical origins in just such a project of enlightenment. The term was first used by intellectuals during the French Revolution to designate an iconoclastic "science of ideas" that would reduce social issues to the certainty of materialist and empirical science. Ideology was to be a method for separating true ideas from false ones by determining which ideas had a true connection with external reality. As George Lichtheim notes:

> The antecedents of this faith are Baconian and Cartesian. To Condillac, who preceded the ideologues and the Revolution, it had already seemed plain that Bacon's criticism of the "idols" must be the starting point of that reformation of consciousness which was the principal aim of the Enlightenment. Bacon's *idolum* becomes Condillac's *prejuge*, a key term also in the writings of Holbach and Helvetius. The idols are "prejudices" contrary to "reason." To remove them by the relentless application of critical reasoning is to restore the "unprejudiced" understanding of nature.[10]

This "unprejudiced" understanding is, as we might expect, based in a counterimage to the illusory idols of prejudice. For Destutt de Tracy, the coiner of the word "ideology," the correct reasoning process worked like an "extensible telescope" that would be capable of looking back to the

9. Coleridge's distinction between "allegory" (a "mere picture-language") and "symbols," and Hegel's distinction between "picture-thoughts" and "notions" betray the same structural contrast of high and low images.

10. Lichtheim, "The Concept of Ideology," *History and Theory* 4 (1965), 164–95.

origin of any idea in a material sensation.[11] Given the paradigmatic role of vision and optical instruments in empirical accounts of sensation, it is hardly surprising that deTracy thought his treatise, the *Elements d'idéologie*, would provide "mirrors in which objects are painted clearly and in their proper perspectives . . . from the true point of view."[12]

The reaction against the rule of this science of rationalized mental images had begun even before it was given the name of "ideology." As we have seen, Burke's aesthetics of the sublime questioned the whole pictorial model of mind that dominated the empirical tradition. His defense of "just prejudice" is a vindication of English "idolatry" against French iconoclasm, and his "prismatic" model of human rights is a direct reply to the telescope and the mirror, the optical metaphors of rational "transparence" in Enlightenment political theory:

> These metaphysic rights entering into common life, like rays of light which pierce into a dense medium are, by the laws of nature, refracted from their straight line. Indeed in the gross and complicated mass of human passions and concerns, the primitive rights of men undergo such a variety of refractions and reflections, that it becomes absurd to talk of them as if they continued in the simplicity of their original direction.[13]

For Burke, the clear, perspicuous mirror of ideology was a producer, not of true images, but of falsely reductive images that could only lead to political tyranny. Coleridge, following Burke's logic, turned the accusation of idolatry back against the French: the "idolism of the French" for Coleridge consists in their tendency to think that the "conceivable, must be imageable, and the imageable must be tangible."[14] Any "idea" worthy of the name, in Coleridge's view, is distinguished precisely by its inability

11. See Emmet Kennedy, *A Philosophe in the Age of Revolution: Destutt de Tracy and the Origins of Ideology* (Philadelphia: American Philosophical Society, 1978), 225. Kennedy notes that de Tracy so far "exceeded the claims of Locke and Condillac as to the accuracy of sense impressions" that he regarded them as the universal basis of knowledge. It is interesting to note that de Tracy criticized hieroglyphics as "inadequate for communication" precisely because they did not represent direct sensory experience the way pictures do. See Kennedy, 108.

12. Quoted in Kennedy, 206.

13. *Reflections on the Revolution in France* (1790) (New York: Doubleday, 1961), 74.

14. *The Friend*, in *Complete Works*, 16 vols. (Princeton: Princeton University Press, 1969), vol. 4. (in 2 vols.), ed. Barbara E. Rooke, i:422.

to be rendered in pictorial or material form: it is a "living educt" of the imagination, a "power" that can be rendered only by the translucence of a symbolic form, never by a "mere" image.

Ideology, then, which begins historically as an iconoclastic "science of ideas" designed to overturn "idols of the mind," winds up being characterized as itself a new form of idolatry—an ideolatry.[15] This ironic turnabout takes its most complex form in Marx's adoption of this negative sense of the term as a weapon against those very persons who transformed its meaning: for Marx, "ideology" is primarily the false consciousness of those Romantic idealist reactionaries who had turned the word against the ideologues of the French Revolution; more specifically, it is the "German" ideology of the Young Hegelians who thought that revolution could occur at the level of consciousness, ideas, and philosophy without a material revolution in social life. But Marx was not just settling scores with reactionaries, for it is clear that he regarded the original "ideologists," the intellectuals of the Enlightenment and the French Revolution, as equally benighted, equally victimized by ideology as false consciousness. That is why Marx is capable, when he is criticizing the French bourgeois intellectuals, of sounding just like Edmund Burke denouncing a nation of shopkeepers, moneylenders, and lawyers. In a characteristically synthetic and critical move, Marx repudiated both the positive science of ideology elaborated by the French Enlightenment, and the simple negation of this science as idolatrous illusion by the English and German reactionaries, and developed in their place the notion of ideology as the key term in a new sort of science, a negative, interpretive science of historical and dialectical materialism. This science of the future, however, had to work with the poetry of the past in elaborating its central concept of ideology. Insofar as the critique of ideology would make cognitive claims about "false consciousness" and distorted representations of the world, it had to work through the picture theory of the mind that dominated the empirical, materialist

15. This characterization comes not only from English reactionaries like Burke and Coleridge, but from within the heart of the Revolution. Napoleon's expulsion of the ideologues from the leadership of the Revolution is well known; but perhaps less familiar is the psychological theory on which it was based: "there are some," Napoleon is reported to have said, "who, from some physical or moral peculiarity of character, form a picture (tableau) of everthing. No matter what knowledge, intellect, courage, or good qualities they may have, these men are unfit to command." Quoted in Paul Shorey's notes to Plato's *Republic*, 196, from Pear, *Remembering and Forgetting*, p. 57.

tradition, a theory that employed as its "concrete concept" the figure of the camera obscura.

The Camera Obscura of Ideology

Perhaps the most noticeable thing about Marx's use of the camera obscura as a metaphor for ideology is the curious incompatibility of this usage with the status of this mechanism as a literal fact in the popular imagination of the 1840s.[16] Marx employs the figure as a polemical device to ridicule the illusions of idealist philosophy at the very moment that it was being hailed as the producer of "a perfect image of nature" that could at last be preserved in the medium of the daguerreotype.[17] The camera obscura had been synonymous with empiricism, with rational observation, and with the direct reproduction of natural vision ever since Locke employed it as a metaphor for understanding:

> I pretend not to teach but to inquire; and therefore cannot but confess here again, that external and internal sensation are the only passages that I can find of knowledge to the understanding. These alone, as far as I can discover, are the windows by which light is let into this dark room. For methinks the understanding is not much unlike a closet wholly shut from light, with only some little opening left to let in external visible resemblances or ideas of things with- out: would the pictures coming into such a dark room but stay there, and lie so orderly as to be found upon occasion, it would very much resemble the understanding of a man in reference to all objects of sight, and the ideas of them.[18]

The invention of photography provided a mechanism for doing exactly what Locke describes as the activity of "human understanding" itself. And this is a model, we should note, that is rather close to Marx's own

16. After I had completed this essay, Sarah Kofman's *Camera Obscura de l'Idéologie* (Paris: Editions Galilee, 1983), came to my attention. Kofman analyzes the role of this figure in Marx, Freud, and Nietzsche.

17. This was Louis Daguerre's own characterization of his invention. See "Daguer- reotype," (1839), reprinted in *Classic Essays in Photography,* ed. Alan Trachtenberg (New Haven, Conn.: Leete's Island Books, 1980), 12. Hereafter cited as Trachtenberg.

18. *An Essay Concerning Human Understanding* (1689), bk. II, chap. XI. sec. 17 (New York: Dutton, n.d.), 107.

account of the "concrete concept" originating in a concrete image. Locke's "external and internal sensation" are functionally equivalent to Marx's "perception and imagination" in the formation of ideas. In comparing ideology to a camera obscura, Marx seems to be undercutting his own model for empirical, materialist cognition by treating it as nothing but a mechanism for illusion, the "phantoms," "chimeras," and "shadows of reality" that he attributes to the German ideologists. Marx's use of the camera obscura as a polemical device for ridiculing the illusions of idealist philosophy beings to look even more ungainly when we recall that Locke had also used it as a polemical device—in exactly the opposite way. For Locke, the camera obscura is the model which helps us to see how ideas originate in the objective, material world, and it is presented as a positive figure in opposition to the idealist notion that ideas are "innate" or self-generated by the mind. Marx's use of it to caricature the Young Hegelian idealists would seem about as appropriate as a characterization of Kant that attributed to him a *tabula rasa* model of the mind.

Why would Marx use a metaphor for ideology that seems both rhetorically ineffective and potentially damaging to his own reliance on empirical premises? One answer is that it is a youthful error which, in the words of one commentator, "is a source of confusion" that "not only shows the lack of integration of some of Marx's statements, but also contributes to obscure Marx's own solution."[19] Fredric Jameson says "the figure is paradoxical to the degree to which in it a socially conditioned and historically determined mystification is described in terms of a permanent natural process," and speculates that Marx has "at this stage" not yet differentiated a "natural tendency" toward "idealism" from "class ideology."[20] Raymond Williams suggests that the analogies of the camera obscura "are no more than incidental, but they probably relate to (though in fact, as examples, they work against) an underlying criterion of 'direct positive knowledge'."[21] Williams feels that "the emphasis is clear" in Marx's metaphor, "but the analogy is difficult" and it leads to "the language of 'reflexes', 'echoes', 'phantoms', and 'sub-

19. Jorge Larrain, *The Concept of Ideology* (Athens, Ga.: University of Georgia Press, 1979), 38. Another way to explain "lack of integration" in *The German Ideology* whould be to look at it as the product of shared authorship. Perhaps the camera obscura was Engels' image.

20. *Marxism and Form* (Princeton: Princeton University Press, 1971), 369. I shall argue in what follows that the confusion of nature and historical artifice is quite deliberate.

21. Williams, *Marxism and Literature* (Oxford: Oxford University Press, 1977), 59.

'sublimates'" which is "simplistic" in its "naive dualism" and "disastrous" in repetition by later Marxist critics.

One might see much of the controversy of modern theories of ideology as attempts to complicate or refine the optical metaphor that Marx uses in *The German Ideology*. Almost every sophisticated Marxist theorist at some point denies the charge that Marx was naive positivist or empiricist, and attempts to refine the metaphor of the camera obscura with some complex mechanism. Terry Eagleton says that "ideology . . . so produces and constructs the real as to cast the shadow of its absence over the perception of its presence," a metaphor that preserves Marx's shadow-box image, but doubles the "shadowing" process by removing any positive, present object to cast the shadow.[22] Eagleton's point is to suggest that "the real is by necessity empirically imperceptible" in "the capitalist mode of production." Althusser replaces the camera obscura with a complicated system of "specular duality," a reflection and counterreflection of a single image in a "dual mirror" structure (perhaps we should call this the "barbershop" image of ideology).[23] The point of these refinements is, on the one hand, to make ideology something more complicated than a simple inversion of the world, and, on the other, to refute the vulgar Marxist notion that Marx offers a direct, positivist alternative to the illusions of ideology.

The odd thing about these corrections of Marx's "youthful error" is the way they remain under the spell of the optical symbolism of the theory of ideology, even as they try to correct it.[24] The claim that the camera obscura metaphor for ideology is "incidental" is continually belied by the obsession of Marxist theorists with the imagery of shadows, reflections, inversions, and representational media of all sorts. The centrality of photography and cinema in Marxist criticism is simply the most conspicuous symptom of this obsession. If the figure of the camera obscura is a youthful error, it is one that haunts the entire Marxist theory of ideology.

Suppose we were to take the metaphor of the camera obscura, not as a mistake, but as the "concrete concept" that underlies Marx's notion of

22. *Criticism and Ideology* (London: Verso, 1978), 69.

23. See Althusser's essay, "Ideology and Ideological State Apparatuses," in his *Lenin and Philosophy* (New York: Monthly Review Press, 1971), 178. Althusser elaborates his optical model of ideology, it is interesting to note, by analogy with the *imago dei*.

24. For a good summary of debates over the optical model, see Raymond Williams's chapter, "From Reflection to Mediation" in his *Marxism and Literature*.

ideology, an image whose full synthetic power he never got around to developing. Suppose he meant what he said. What sort of rhetorical and logical force would have attached to this figure in the 1840s, aside from the shock value of attributing an empiricist model of cognition to the Young Hegelians? One thing Marx might well have noticed was that the camera obscura and its photographic offspring were not being celebrated only because they seemed to incarnate the most natural, scientific, and realistic representations of the visible world. He might have noticed that the camera obscura had always had a double reputation as both a scientific instrument and as a "magic lantern" for the production of optical illusions.[25] He also might have read Louis Daguerre's remarks on the uses of the daguerreotype:

> Everyone, with the aid of the DAGUERREOTYPE, will make a view of his castle or country-house: people will form collections of all kinds, which will be the more precious because art cannot imitate their accuracy and perfection of detail. . . . The leisured class will find it a most attractive occupation, although the result is obtained by chemical means, the little work it entails will greatly please ladies.[26]

He might also have read, in the very year he was writing *The German Ideology,* William Henry Talbot's description of the images in the camera obscura as "fairy pictures, creations of a moment, and destined to fade away,"[27] and gone on to read Talbot's account of the way he came upon the idea of fixing these images on sensitive paper: "such was the idea that came into my mind. Whether it had ever occured to me before amid floating philosophical visions, I know not, though I rather think it must have done so."

Whether or not Marx had read these particular passages is beside the point. The point is that he would have seen the camera obscura and the

25. See Svetlana Alpers, *The Art of Describing: Dutch Art in the Seventeenth Century* (Chicago: University of Chicago Press, 1983), for a good discussion of the camera obscura. Alpers notes that "we are so accustomed by now to associating the image cast by the camera obscura with the real look of Dutch painting (and after that with photography) that we tend to forget that this was only one face of the device. It could be put to quite different uses" including "a magic lantern show" that involved instantaneous transformations of a human figure from beggar to king and back again (see 13, and chap. 1).

26. Quoted in Trachtenberg, 12–13.

27. Talbot, "A Brief Historical Sketch of the Invention of the Art," introduction to *The Pencil of Nature* (London, 1844–46), quoted in Trachtenberg, 29.

invention of photography with a jaundiced eye, as another false, bourgeois "revolution." All the claims about scientific accuracy would have left him cold next to the plain fact that the camera was a leisure-class toy, a machine for producing new "collector's items," portraits of well-to-do burghers, views of country houses, lady's amusements, and that it was being produced by and for leisured gentlemen who could afford the luxury of "floating philosophical visions." The idea that such toys could provide a serious model for human understanding must have struck him as ludicrous. It was appropriate only as a model of false understanding, that is, for ideology. Yet that is just the paradox of ideology: it is not just nonsense or error, but "false understanding," a coherent, logical, rule-governed system of errors. This is the point Marx captures in his stress on ideology as a kind of optical inversion. In one sense, the inversion makes no difference at all; the illusion is perfect. Everything is in the proper relation to everything else. But from a contrary point of view the world is upside down, in chaos, revolution, mad with self-destructive contradictions. The question is: what does one do with or to the inverted images of ideology? How does one imagine an iconoclastic strategy that is likely to have force as a means of dispelling or criticizing the illusion, getting outside it so as to struggle against it?

Three Iconoclastic Strategies

The first strategy, as we might expect, is a refusal to traffic in images at all; we are to trust no representations, Marx argues, but only pay attention to things themselves, things as they are, without mediation.

> That is to say, we do not set out from what men say, imagine, conceive, nor from men as narrated, thought of, imagined, conceived, in order to arrive at men in the flesh. We set out from real, active men, and on the basis of their real life-process we demonstrate the development of the ideological reflexes and echoes of this life-process. The phantoms formed in the human brain are also, necessarily, sublimates of their material life-process, which is empirically verifiable and bound to material premises.[28]

28. *The German Ideology*, ed. C. J. Arthur (New York: International Publishers, 1970), 47. All quotations from *The German Ideology* will be from this edition, hereafter indicated by *GI*.

This invocation of direct, positive knowledge based in "empirically verifiable" observations is riddled with problems, not the least of which is the fact that Marx has just parodied the central model of empirical observation (Locke's dark room) as the producer of ideology, not of true understanding. Marx will go on to criticize idealists and "contemplative materialists" like Feuerbach for supposing that "the sensuous world around him is . . . a thing given direct "(*GI* 62), and will argue that "consciousness is . . . from the beginning a social product" (*GI* 51), a claim that works against the notion of pure, unmediated, or direct knowledge of "men and their circumstances." If the intention of the camera obscura metaphor is clear, then, its application and meaning are fraught with difficulty, for it is not immediately evident how one is to circumvent the camera obscura and gain access to true versions or representations of the world, any more than it is clear how one can see without using one's eyes.

The usual answer of vulgar Marxists to this problem is the postulation of a countermechanism to the camera obscura, some device that will illustrate the claim of direct, positive knowledge. The standard hand-book, *Fundamentals of Marxism-Leninism,* puts it this way:

> The Marxist theory of knowledge is a *theory of reflection*. This means that it regards cognition as the reflection of objective reality in the human mind. . . . It is not the things them-selves or their properties and relations, that exist in man's consciousness, but mental *images* or reflections of them. . . .[29]

It should be clear why this appeal to the model of "mind-as-mirror" only postpones the problem. If "the mind" in fact does work like a mirror, then it is not clear why ideology, the production of distorted mental images, should ever occur. The untarnished mirror of direct reflection could apply only to man's mind in a state of nature, outside the "histori-cal life-process" which, like the "physical life-process," creates systematic distortions in our understanding. Marx's own use of the terms "reflexes and echoes" to describe ideological representations suggests that, what-ever escape route there may be from ideology, it is not through the metaphor of reflection.

If there is no detour around ideology to a direct, positive view of men and their circumstances, the obvious alternative is to work through ideology by means of a process of interpretation, a "hermeneutics of

29. (Moscow: Foreign Languages Publishing House, 1963), 95–96.

suspicion" that distrusts the manifest, surface content of representations, but can only get to the deep, hidden meaning by working its way through this surface. If we cannot circumvent the inverted images of the camera obscura, then we can rectify them in an act of reinterpretation. The only problem with this alternative is that it sounds just like the iconoclasm of the Young Hegelians, the very idealists mocked by Marx in the Preface to *The German Ideology*:

> Hitherto men have constantly made up for themselves false conceptions about themselves, about what they are and what they ought to be. The have arranged their relationships according to their ideas of God, of normal man, etc. The phantoms of their brains have got out of their hands. They, the creators, have bowed down before their creations. Let us liberate them from the chimeras, the ideas, dogmas, imaginary beings under the yoke of which they are pining away. Let us revolt against this rule of thoughts. Let us teach men, says one, how to exchange these imaginations for thoughts which correspond to the essence of man; says the second, to take up a critical attitude to them; says the third, how to knock them out of their heads; and—existing reality will collapse. (23)

If all we have to work with are the images of ideology, if there is no counterimage or unmediated vision, no science beyond ideology, then we are no better off than the Romantic idealists, and have to settle for more idealizations ("the essence of man"), or skeptical interpretation ("a critical attitude") in order to get men's idols "out of their heads." Marx seems caught between the equally distasteful alternatives of a positive empiricism that stands outside the historical life process, and a negative idealism that can only play with the shadows, phantoms, and chimeras.

The usual answer to this dilemma is to declare that the empiricist alternative is the less distasteful. The fact that *The German Ideology* is mainly directed against the idealists makes this choice fairly easy to sustain: Marx regularly appeals to "empirical premises" as the basis of a critique of ideology. But this solution does not capture the difficult synthesis Marx was trying to achieve, and which he so brilliantly illustrates in the metaphor of the camera obscura. We have been speaking of this metaphor so far as if the optical device, the "dark room," were simply

analogous to the human eye and the physiology of natural vision. But this comparison also involves a contrast between nature and artifice, between the realm of organic production of images and the mechanical reproduction of them by a human invention, a device that is produced at a certain moment in human history. When we stress the ultimate analogy of the physical eye, we naturalize this machine and treat it as a scientific invention that simply mirrors the timeless, natural facts about vision.[30] But suppose we reversed the stress, and thought of the eye as modeled on the machine? Then vision itself would have to be understood not as a simple, natural function to be understood by neutral, empirical laws of optics but as a mechanism subject to historical change. Vision would comprise not just the physiology of lenses and retinas but a whole field of ideological attentiveness—a preselected, preprogrammed grid of features and structures of perception.

The third option, then, that avoids the dilemma of the idealist with his shadows, the empiricist with his direct and natural view, is the historical materialist with his sense of both the shadows and the direct vision as historical productions. The inverted images, whether in the eye or the camera obscura, are inverted, not by a simple physical mechanism of light, but by a "historical life process," and they can be rectified only by a reconstruction of that process—that is, by a recounting of the material history of production and exchange that gives rise to them. "As soon as this active life-process is described," says Marx, "history ceases to be a collection of dead facts as it is with the empiricists . . . , or an imagined activity of imagined subjects, as with the idealists" (GI, 48). The problem with the facts and mental images of the empiricists is not so much that they are false but that they are static and dead. If the rectification of the inverted images of idealist German ideology involves reconnecting them with material conditions and practical life, the rectification of the empiricist image is accomplished by temporalizing it, seeing it as a product of a "historical life-process" and not as a simple datum presented to the senses.

This temporalizing of ideological images can be achieved, however, only by consulting the sorts of evidence that Marx has ruled out of

30. This is the emphasis that leads to Jameson's reading of the camera obscura as a "paradox." See *Marxism and Form*, 369 and n. 20 above.

court—namely, "what men say, imagine, conceive . . . men as narrated, thought of, imagined" (*GI*, 47). The activities of "real, active men" whom we encounter "in the flesh" can have no meaning, will simply be dead facts, for the empiricist who sees them as objects of direct, positive knowledge.[31] The meaning of their activities emerges only when they are seen as parts of a process, agents in a historical development, or figures in a narrative. In one sense, however, Marx would surely stick by his claim that we must ignore the narratives and thoughts of men in order to get at the truth about them: for Marx, the stories men tell *about themselves*— their myths and legends, and even their histories—are irrelevant except insofar as they fit with the story of material, social development that he wants to tell. "History," as Terry Eagleton notes, "is the ultimate signifier of literature" and "of any signifying practice" whatsoever.[32]

It is from the standpoint of this history, not from any positive empirical science, that Marx criticizes the "phantoms," "reflexes," and inverted images of ideology. It is within this historical process that false consciousness arises with all its idols of the mind. Marx does not see himself standing outside the historical process, occupying a transcendental perspective. He is within history, but as a self-conscious agent of its laws, and of a particular class. In one very precise sense, Marx himself is an "ideologist," if by this term we mean an intellectual who represents the interests of a particular class as if they were the general interests of all mankind.[33] (Lenin's later adoption of the positive term, "Marxist ideology," is an acknowledgment of this possibility.)[34] The difference between Marx and the bourgeois intellectuals he opposes is that he represents a different class (the proletariat), this class is not in a position of dominance, and (Marx can argue) he is not self-deceived about the relation between his general or "universal" ideas and the particular commitments that lie behind them: "theoretical communists," notes Marx, "the only

31. Raymond Williams (*Marxism and Literature*, 60) notes that Marx's rejection of "what men say," etc., would if taken literally lead to "an objectivist fantasy: that the whole 'real life-process' can be known independently of language ('what men say') and of its records ('men as narrated').

32. *Criticism and Ideology*, 72.

33. "Active, conceptive ideologists . . . make the perfecting of the illusion of the class about itself their chief source of livelihood." They must "represent its interest as the common interest of all the members of society" (*GI*, 65–66).

34. See *What Is to Be Done?* in *The Lenin Anthology*, ed. R. Tucker (New York: Norton, 1975), and the chapter on "Ideology in the Positive Sense" in Raymond Geuss, *The Idea of a Critical Theory* (Cambridge: Cambridge University Press, 1981).

ones who have time to devote to the study of history, are distinguished precisely because they alone have *discovered* that throughout history the 'general interest' is created by individuals who are defined as 'private persons'" (*GI*, 105). The theoretical communist, like any other intellectual, participates in "the division of mental and material labour" which makes possible the emergence of "active, conceptive ideologists, who make the perfecting of the illusion of the class about itself their chief source of livelihood" (*GI*, 65). The "illusion" that Marx propagates is that the interests of the proletariat are the general interests of mankind: "The class making a revolution *appears* [emphasis mine] from the very start, if only because it is opposed to a *class*, not as a class but as the representative of the whole of society" (*GI*, 66). Marx believed that the interest of the proletariat would become the universal interest of mankind in the future, but he never pretended that this was the case in his own time.[35]

The notion that Marx claims (at least in 1848) to criticize "ideology" as a general phenomenon from an objective, scientific viewpoint, then, needs to be severely qualified. Ideologies are never "general" phenomena, any more than are the societies or intellectuals that produce them: there is "German ideology" and "French ideology" and "English ideology,"[36] but no such thing as ideology apart from particular social and historical conditions (the notion of "bourgeois ideology," much less "a thoery of ideology *in general*," like the one Althusser proposes is from this standpoint virtually meaningless).[37] The critique of ideology is possible precisely because of this localization and particularity:

> the fact that under favourable circumstances some individuals are able to rid themselves of their local narrow-mindedness is not at all because the individuals by their reflection imagine that they have got rid of, or intend to get rid of, this local narrow-mindedness, but because they, in

35. I rely here on Raymond Geuss's excellent analysis of the concept of "interests" in Marx and in the work of the Frankfurt school. See *The Idea of a Critical Theory*, 45–54.

36. See Jerome McGann's *The Romantic Ideology* (Chicago: University of Chicago Press, 1983), for a helpful discussion of nationalism and ideology.

37. See Althusser, *Lenin and Philosophy*, 159, for the promise of a general theory of ideology. Insofar as Marx sometimes regarded "theory" itself as synonymous with ideology, it is not hard to guess what he would have thought of a "general theory of ideology." It would be a "theory of theories," i.e., a metaphysics. The general notion of "bourgeois ideology," on the other hand, seems securely implanted in his thought. But the notion is tempered by his continual insistence that the bourgeoisie in different nations—for instance, Germany and England—is in a quite different stage of development.

> their empirical reality, and owing to empirical needs, have
> been able to bring about world intercourse. (*GI*, 106)

This "empirical reality" is, I would suggest, simply the local and particular fact of alienation, the condition of being in a place and time whose contradictions impel us to take some critical distance from it. That is why Marx, the German Protestant-Jewish intellectual, reserves his severest criticism for those closest to his material and intellectual home: the German bourgeoisie, the Jews as paradigmatic capitalists, and the Young Hegelians whose "Universal History" of the world spirit is the mirror image of Marx's own "ultimate signified."

I want to postpone for the moment the question of whether this radical historicism simply replaces the empiricist and idealist idols of the mind with a new idol called "History," and return to the figuration of history in the camera obscura. The "historical process," we should recall, is that which Marx sees as causing the camera's "inversions," just as the "physical life-process" inverts images on the retina. But inversion is also a feature of ideology itself, the turning of values, priorities, and real relationships upside down. The camera obscura plays a deeply equivocal role, then, as a figure for both the illusions of ideology and for the "historical life-process" that generates those illusions and provides a basis for dispelling them. In this light, the camera obscura is both the producer and the cure for the illusions of ideology. Its mechanism of inversion, like the optical vortex of Romantic art and literature, is a figure for the formal pattern of revolution and counterrevolution.[38] This thought is not explicit in Marx's writing, of course. It is only a kind of potential in the figurative language he employs. But the thought takes on a real force in later Marxist writing, especially the sort that moves from the camera obscura as a metaphoric device to the direct and literal analysis of its offspring, the camera and the technical process of photography.

Benjamin and the Political Economy of the Photograph

> Each wondrous work of thine excites Surprize;
> And, as at Court some fall, when others rise;
> So, if thy magick Pow'r thou deign to shew;

38. See my essay, "Metamorphoses of the Vortex," in *Articulate Images: The Sister Arts from Hogarth to Tennyson,* ed. Richard Wendorf (Minneapolis: University of Minnesota Press, 1983), 125–68, for a discussion of the various nineteenth-century revolutions embodied in this formal image.

The High are humbled, and advanc'd the Low;

.

Instructive Glass! here human Pride may trace,
Diminish'd Grandeur, and inverted Place.

Anonymous, *Verses Occasion'd by the Sight of a*
Chamera Obscura (1747)[39]

I mentioned earlier a curious asymmetry in Marxist writing about pho-
tography. In spite of the fact that photography was *the* revolutionary
medium of the nineteenth century, invented during the years when Marx
produced his major writings, he never mentions it except as another kind
of "industry."[40] It is not hard to see, nevertheless, why photography
would take on a special status for later Marxist criticism. The assumption
that photography is an inherently realistic medium is very congenial with
Marx's own expressed preference for realism in literature and painting.
Marx and Engels resisted the notion that literature and art should be
merely didactic instruments of socialist propaganda, preferring the real-
ism of a nostalgic royalist like Balzac to the *Tendenzroman*.[41] And in the
visual arts, Engels suggested that the leaders of the revolution should not
be glorified but should

> be finally depicted in strong Rembrandtian colors, in all
> their living qualities. Hitherto these people have never been
> pictured in their real form; they have been presented as of-
> ficial personalities, wearing buskins and with aureoles around
> their heads. In these apotheoses of Raphaelite beauty all
> pictorial truth is lost.[42]

"Rembrandtian" was, as it happens, one of the terms applied to the
daguerreotype; Samuel Morse called the new images "Rembrandt per-

39. These verses were printed for the noted optician, John Cuff, who probably wrote
them. See Heinrich Schwarz, "An Eighteenth Century English Poem on the Camera
Obscura," in *One Hundred Years of Photographic History: Essays in Honor of Beaumont
Newhall,* ed. Van Deren Coke (Albuquerque, University of New Mexico Press, 1975),
128–35. I am grateful to Joel Snyder for leading me to this text.

40. *Capital* (1867), ed. Frederick Engels, trans. from the third German edition (1883) by
Samuel Moore and Edward Aveling, 3 vols. (New York: International Publishers, 1967),
1:445. All references to *Capital* will be from this edition, hereafter indicated by *C*.

41. See Marx and Engels, *Literature and Art* (New York: International Publishers,
1947), 42. A strong argument for placing Marx's aesthetic theory with the Saint-Simonist
avant garde is made by Margaret A. Rose in *Marx's Lost Aesthetic* (New York: Cambridge
University Press, 1984).

42. *Literature and Art,* 40.

fected" in 1839.[43] The "realism" celebrated here is not, however, an optical, scientific reconstruction of vision—Vermeer would have been the right analogy for that sort of realism. And it is not "historical" in the sense of traditional history painting ("apotheoses of Raphaelite beauty"), but an image of *real* history, of flesh-and-blood creatures in their material circumstances. This image replaces the traditional "aureole" around the figure with a new sort of aura—the "living qualities" of the subject.

These "living qualities" are what, notoriously, the camera captures under the right conditions, so that it seems to come equipped with a historical, documentary claim built in to its mechanism: this really happened, and it really looked this way, at this time. This is more than the claim to merely optical fidelity, a correct transcription of visual appearances; it is a claim to have captured a piece of the "historical life-process" as well as the "physical life-process." Perhaps we can now see some of the reasons for the Marxist fascination with photography and cinema, and also understand its ambivalence. The camera duplicates the ambiguous status of the camera obscura and raises it to a new power, for its images, in their permanence, can become material objects of exchange, and its overcoming of the transience of the "fairy images" of the camera obscura means that it really can capture the historical process in a way that was only figuratively possible for the camera obscura.

Walter Benjamin's essays on photography provide the most fully developed expression of the Marxist ambivalence about the camera. Benjamin treats the camera as a kind of two-handed engine wielded at the gateway to the revolutionary millennium. The camera is, on the one hand, the epitome of the destructive, consumptive political economy of capitalism; it dispels the "aura" of things by reproducing them in a leveling, automatic, statistically rationalized form: "that which withers in the age of mechanical reproduction is the aura of the work of art. . . . To pry an object from its shell, to destroy its aura, is the mark of a perception whose 'sense of the universal equality of things' has increased to such a degree that it extracts it even from a unique object by means of reproduction."[44] Benjamin's camera does to the visible world what Marx

43. *One Hundred Years of Photographic History*, 23.

44. "The Work of Art in the Age of Mechanical Reproduction," first published in *Zeitschrift für Socialforschung* V, I (1936). Reference here and throughout is to the translation in *Illuminations*, ed. Hannah Arendt (New York: Shocken, 1969), 221, 223, hereafter cited as "Work of Art."

said (in the *Communist Manifesto*) that capitalism was doing to social life
in general: capitalism, like the pitiless eye of the camera, "strips of its halo
every occupation," and replaces all the traditional forms of life "veiled by
religious and political illusions" with "naked, shameless, direct, brutal
exploitation."[45] On the other hand, Benjamin also echoes Marx's faith in
the dialectical inversion and redemption of these evils by the cunning of
historical development: capitalism must run its course, unveil its contra-
dictions, and produce a new class that will be so nakedly dispossessed
that a complete social revolution will be inevitable. In a similar fashion,
Benjamin hails the invention of photography as "the first truly revolu-
tionary means of production" ("Work of Art," 224), a medium that was
invented "simultaneously with the rise of socialism" and that is capable of
revolutionizing the whole function of art, and of the human senses as
well. If Marx thought of ideology as a camera obscura, Benjamin re-
garded the camera as both the material incarnation of ideology and as a
symbol of the "historical life-process" that would bring an end to
ideology.

Benjamin was not the only one to express ambivalence about the
camera, of course. The endless battles over the artistic status of photogra-
phy and the larger question of whether the photographic image has a
special "ontology" reflect similar contradictory feelings. Is photography
a fine art or a mere industry? Is it "Rembrandt perfected," as Samuel
Morse thought, or a new distraction for the "idolatrous multitude," as
Baudelaire characterized it? ("An avenging God has heard the prayers of
this multitude; Daguerre was his messiah.")[46] Does the camera provide a
material incarnation of objective, scientific representation by mechaniz-
ing the system of perspective, as Gombrich argues? Or is it an instrument
of "contemplative materialism," "a purely ideological apparatus" whose
"monocular" vision ratifies "the metaphysical centering on the subject"
in bourgeois humanism, as Marcel Pleynet contends?[47]

Benjamin finesses all these kinds of disputes by treating them as
"contradictions" in the Marxist-Hegelian sense: they are symptoms of

45. See 1:397, for capitalism as a leveler; the "halo" and "veil" images occur in *The Communist Manifesto* (1848), ed. Samuel H. Beer (Arlington Heights, Ill.: Harlan David-son, 1955), 12.

46. Trachtenberg, 86.

47. See chapter 3 above for a discussion of Gombrich on the scientific status of photography; Pleynet is quoted in Bernard Edelman, *The Ownership of the Image* (London: Routledge & Kegan Paul, 1979), 63–64.

contradictions within capitalism that find their resolution in a historical narrative that foresees a synthesis in the future. Thus, Benjamin can mimic both sides of these debates while criticizing them. He can echo Baudelaire's distaste for the leveling effect of photography as an idol of mass culture, and yet see this leveling as an omen of the classless society. He can absorb the dispute between the "scientific" and "ideological" views of the photograph in the same way that Marx absorbed the debate between idealism and empiricism in the metaphor of the camera obscura, by treating them as equally partial, equally deluded options in the dialectic of history. He can rise above the argument over the artistic status of photography by dismissing it as a "futile" debate that ignores the "primary question—whether the very invention of photography had not transformed the entire nature of art" ("Work of Art," 227). The argument that photography is a fine art is denounced as reactionary idolatry:

> Here, with all the weight of its dullness, enters the philis-
> tine's concept of *art,* to which any technical development is
> totally foreign, which with the provocative challenge of the
> new technology, feels its own end nearing. Nevertheless it
> was this fetishistic, fundamentally anti-technological concept
> of art with which the theoreticians of photography sought
> for almost a hundred years, naturally without coming to the
> slightest result.[48]

On the other hand, the dismissal of photography as mere technology is, in Benjamin's view, equally involved in fetishism and idolatry, the sort that tries to exclude the photographic image from the circle of sacred (i.e., artistic) objects. Benjamin quotes the Leipzig *City Advertiser* to illustrate this sort of reaction:

> "To fix fleeting reflections," it was written there, "is not only
> impossible, as has been shown by thoroughgoing German
> research, but to wish to do it is blasphemy. Man is created
> in the image of God and God's image cannot be held fast by
> a human machine. At the most the pious artist—enraptured
> by heavenly inspiration—may at the higher command of his

48. Benjamin, "A Short History of Photography," originally published in *Literarische Welt* (1931); reprinted from *Artforum* (February, 1977), Phil Patton, trans., in Trachtenberg, 201. Hereafter cited as "Short History."

genius dare to reproduce those divine/human features in an
instant of highest dedication, without mechanical help"
("Short History," 200).

Photography, for Benjamin, is neither art nor nonart (mere technol-
ogy): it is a new form of production that transforms the whole nature of
art. To hold on to the view of photography as *either* art or as nonart in the
traditional sense of the word is to fall into some sort of fetishism, a charge
which Benjamin can substantiate simply by quoting the antagonists
against one another. One thing Benjamin does not really try to explain,
however, is why one version of this fetishism won out. Why did assimila-
tion of the machine-made image into the fine arts by the "philistine"
(recall here that the legendary Philistines were not simply idolaters but
also the legendary thieves who stole the Ark of the Covenant from the
Israelites; see 1 Samuel 5:1) overcome the reactionary pieties about man-
made images? One answer is that there were certain historical excep-
tions: early photographs, with their predominance of shadows and oval
images have about them the "aura" or "halo" that Benjamin sees photo-
graphy as ultimately destroying ("Short History," 207). In these early
"pre-industrial" photographs, the "photographer was on the highest
level of his instrument" ("Short History," 205), and thus occupies, in
Benjamin's view, a kind of prophetic or patriarchal status in the history of
the medium: "there seems to have been a sort of Biblical blessing on
those first photographers: Nadar, Stelzner, Pierson, Bayard all lived to
ninety or a hundred" ("Short History," 205). Another answer is that
there are two ways to dispel the aura around object in the photographic
process: one is the merely technical, vulgar clarity that comes with mass
production and improved lighting: "The conquest of darkness by in-
creased illumination . . . eliminated the aura from the picture as thor-
oughly as the increasing alienation of the imperialist bourgeoisie had
eliminated it from reality" ("Short History," 208). The other is the
"liberation of the object from the aura" that one sees first in Atget, and
which prefigures the "healthy alienation" Benjamin sees in surrealist
photography ("Short History," 208–10).

Neither of these examples, however, really answers the question about
the absorption of photography by traditional notions of fine art. When
Benjamin praises the production of aura in Nadar, and the destruction of
aura in Atget, he is praising them as moments in the formation of a new,
revolutionary conception of art that bypasses all the philistine twaddle

about creative genius and beauty. And yet it is precisely these traditional notions of aesthetics, with all their attendant claims about craftsmanship, formal subtlety, and semantic complexity, that have sustained the case for the artistic status of photography. Some photographs just happen to be beautiful, by some criterion or other; some have a lot to say, or they present novel, moving, or otherwise interesting subject-matter. If the photograph really has the revolutionary character that Benjamin ascribes to it, one would expect more resistance to its appropriation by traditional aesthetic norms, more inertia in its status as a mere industry, and more unequivocal evidence of its tendency to transform all the other arts—to shift our attention, as it were, from "photography as a form of art" to "art as a form of photography" ("Short History," 211).

The Marxist tradition has an answer to the question of why photography was assimilated to the fine arts, but it does not fit very well with Benjamin's idealization of it as a revolutionary art. Bernard Edelman suggests that the aesthetic idealization of photography is purely an economic and legal matter. The photographer had to gain recognition as a creative artist in order for the law to find grounds for ownership of photographic images. Before the invention of photography, Edelman argues,

> the law recognised only "manual" art—the paintbrush, the chisel—or "abstract" art—writing. The irruption of modern techniques of the (re)production of the real—photographic apparatuses, cameras—surprises the law in the quietude of its categories. . . . Photographer and film maker must become creators, or the industry will lose the benefit of legal protection.[49]

Edelman suggests, like Benjamin, that the "pre-industrial" phase of photography is somehow a special moment: "The photographer of 1860 is the *proletarian of creation;* he and his tool form one body."[50] But this preindustrial phase is also preaesthetic, and Edelman musters a large number of legal opinions to suggest that the rise of the aesthetic justification—the "creative subjectivity" of the photographer in particular—is a legal fiction devised to secure property rights.

Edelman is completely silent about Benjamin, an astonishing omission in a Marxist analysis of photography and cinema. But the reason

49. *The Ownership of the Image,* 44.
50. Ibid., 45.

may not be so difficult to see. There is no suggestion in Edelman's account that some photography (except perhaps the earliest) escapes the political economy of capitalism. Edelman presents no sensitive analyses of Atget or the surrealists, no discoveries of the revolutionary destruction of aura and "healthy alienation" as Benjamin does. In fact he never discusses a single photograph. He is interested only in photography as a "legal fiction" and in the photographer as a "subject in law" under capitalist jurisprudence. In his way, Edelman's version of photography is as idealized as Benjamin's; the difference is that he has some empirical evidence to suggest that his particular idealizaton (for which he has nothing but contempt) has had the force of law. Benjamin's, we might say, has the force of desire: he wants photography to transform the arts into a revolutionary force; he wants the question of photography as a fine art (or perhaps as just another technique of picture-making) to be bypassed by history. The one place where these two accounts converge is in their agreement that the aestheticizing of photography is a kind of fetishism. For Benjamin, it is the quasi-religious fetishism that tries to reproduce the "aura" in photography by tricking it up or imitating painterly styles; for Edelman, it is the fetishism of the commodity, the photograph as something that has exchange value. The "idols of the mind" that Marx saw projected in the camera obscura take their material, incarnate form in the legal and aesthetic status of the photograph as a capitalist fetish. This conclusion fulfills the logic of Marx's thought, but it also produces certain problems for the application of that thought to photography, and to art in general, problems which are centered in the figure of the fetish.

From Phantom to Fetish

Considered in its relation to the Fine Arts, the general action of Fetishism upon the human intellect is certainly not nearly so oppressive as it is in a scientific point of view. It is indeed, evident that a philosophy which animated directly the whole of nature must have tended to favour the spontaneous impulse of the imagination, at that time necessarily having a mental preponderance. The earliest attempts in all the fine arts, not excepting poetry, are to be traced to the age of Fetishism.

G. H. Lewes, *Comte's Philosophy of the Sciences* (1853)[51]

51. Quoted from Burton Feldman and Robert Richardson, *Modern Mythology* (Bloomington: Indiana University Press, 1972), 169–70.

> Let us suppose that we had carried out production as human
> beings. . . . Our products would be so many mirrors in which we
> saw reflected our essential nature.
>
> Marx, "Comments on James Mill" (1844)[52]

It is easy enough to see the general logic in Marx's turn from ideology to fetishism as the key notion in his iconoclastic polemic. The shift preserves the general indictment of idolatry in capitalist society, but moves it from the realm of ideals and theories into the sphere of material objects and concrete practices. This move is accompanied by an increasing confidence and self-consciousness in Marx's deployment if figurative language to construct the concrete concept of commodity. If Marx seems uncertain or casual about the camera obscura and its "phantoms" of optical projection, he has no hesitation in deploying the fetish as a polemical and analytic weapon in his later writing. He devotes an entire section of the opening chapter of *Capital* to the elaboration of this metaphor, and continues to depend on it in subsequent chapters. It is clear, moreover, that Marx was very interested in the vehicle of the "commodity fetish" metaphor as a specific subject of investigation in its own right. His silence about the revolutionary medium of photography contrasts sharply with the abundant evidence of his interest in eighteenth- and nineteenth-century anthropology, particularly the study of primitive religion. As early as 1842 he had read Charles de Brosses' classic, *Du Culte des Dieux fétiches,* and he continued to take voluminous notes on ethnology and the history of religion throughout his life.[53]

Marx's interest in fetishism raises a number of questions for anyone concerned with the application of his thought to problems in the history of the arts and culture. Why, given Marx's extensive researches in fetishism, does this concept play so small a role in Marxist cultural criticism and aesthetics? Why is "ideology," with its shadows, projections, and reflections, the crucial notion in Marxist criticism of literature and art, while fetishes, which in at least one sense literally are works of art, generally have a minor and problematic function in Marxist aesthetics?[54]

52. *Collected Works*, (New York: International Publishers, 1975), 3:227–28.

53. See *The Ethnological Notebooks of Karl Marx*, ed. Lawrence Krader (Assen, Netherlands: Van Gorcum, 1972). Marx's reading of de Brosses is discussed on 89 and 396. I am greatly indebted in the following to discussions with David Simpson, and to his book, *Fetishism and Imagination* (Baltimore: Johns Hopkins University Press, 1982).

54. For an exemplary account of the Marxist uneasiness with notion of art as commodity, see the introduction to *Marxism and Art,* ed. Berel Lang and Forrest Williams (New

A short answer to this question suggests itself immediately: fetishism is a vulgar, superstitious, degraded form of behavior. Marx employs the notion of fetishism chiefly as a polemical weapon to make capitalism an object of disgust. To apply this concept in discussions of poems, novels, and paintings would be to lapse into the most vulgar sort of Marxism, the kind that condemns all prerevolutionary, capitalist art as a mere reflection of bourgeois self-deception, and seeks to replace Shakespeare with socialist realism, Balzac with the *tendenzroman*. Since we have good reason to think that Marx preferred Shakespeare to socialist realism, Balzac to Zola, the reduction of art to mere commodity (let alone a fetish) would be a violation of the spirit of his thought. Ideology, with its stress on "ideas," consciousness, indrect mediation, and superstructural distance from the material economic base where commodity fetishism reigns, is ideally suited to the understanding of works of art.

This answer may help us to see why Western Marxist aesthetics and cultural criticism have drawn their inspiration mainly from the young Marx, the humanistic philosopher, and not from the mature economist and materialist historian. And yet it is hard not to be uneasy about this splitting of an idealist and materialist Marx, especially when we consider the common structure that unites them: ideology and fetishism are both varieties of idolatry, one mental, the other material, and both emerge from an iconoclastic critique.[55] The difference between the two Marxes, then, may be something as important—or as trivial—as the difference between two different sorts of images that attract superstitious devotion, the shadowy optical projections in the camera obscura and the rude "stocks and stones" worshipped by primitive savages. If we could clarify the relation of these two sorts of idols, we might be in a position to better understand the continuity and development of Marx's thought, and to understand why Marxist criticism so often finds itself in a position of mutual embarrassment vis-à-vis the arts.

Some of the embarrassment over the suggestion that works of art are

York: Longman, 1972), 7–8. Lang and Williams criticize the notion that "works of art are merely . . . commodities, bearing all the obvious marks of the business enterprise." They suggest that this view leads to vulgar didacticsm, state censorship, and mechanical determinism, and praise, by contrast, Lucien Goldmann's emphasis on "implicit ideology" in works of art.

55. It is interesting to note that Raymond Williams's critique of the dualism entailed in the Marxist notion of base and superstructure is not accompanied by any reconsideration of fetishism as an aesthetic category. See his *Marxism and Literature*, (Oxford: Oxford University Press, 1977), 75–82.

"mere commodities" might be alleviated if we reminded ourselves of what Marx actually says about commodites. Far from being a trivial, simply determined, or reductive phenomenon, they are described by Marx as "transcendent" beings, endowed with a "mystical," "enigmatical" character (C, 1:71). They are "social hieroglyphics," that are "just as much a social product as language," and they ask to be deciphered for both their "meaning" and their "historical character" (C, 1:74–75). Now it is true that I am taking these epithets out of a context in which many of them (especially "transcendent" and "mystical") reek with irony. But it is also true that much of Marx's rhetorical energy is directed against the superficial notion of commodities, against the fact that "a commodity appears at first sight, a very trivial thing."[56] The counterclaim is that a commodity "is, in reality, a very queer thing, abounding in metaphysical subtleties and theological niceties." The terms that Marx uses to characterize the commodity are drawn from the lexicon of Romantic aesthetics and hermeneutics. As commodity is a figurative, allegorical entity, possessed of a mysterious life and aura, an object which, if properly interpreted, would reveal the secret of human history. Before we dismiss the "vulgar" notion of art as a commodity, therefore, we need to contemplate the refinements of Marx's claim that a commodity is something very like a work of art.

What is it that makes a commodity, "at first sight, a very trivial thing, and easily understood" (C, 1:71), into an object of "magic and necromancy"? (76). One answer is, Marx's own rhetorical strategies, his insistence on transforming what seems to be utterly ordinary and natural into something mysterious and complex. But Marx would of course deny that he is tricking us into seeing commodities as mysterious entities. He would insist that he is simply describing a process that has concealed itself under a "mist" of familiarity, and that his analysis "dissipates the mist through which the social character of labor appears to us to be an objective character of the products themselves"(74). This analysis must therefore proceed in two steps: first, a revelation that "the stability of natural, self-understood forms of social life" is actually a mystery to be deciphered; and second, the actual work of carrying out that decipherment. The commodity hides its true nature under a twofold veil, the

56. Jerrold Seigel suggests that this view of the commodity as a mysterious hieroglyph requiring interpretation is a departure from Marx's earlier conviction that the "surface anarchy" of bourgeois production is sufficiently self-explanatory. See his *Marx's Fate: The Shape of a Life* (Princeton: Princeton University Press, 1978), 318.

outer one a mask of naturalness and familiarity, the inner one an explicit fantasy, full of grotesque and perverted imagery.

Here is Marx's fullest account of this process:

> A commodity is therefore a mysterious thing, simply because in it the social character of men's labour appears to them as an objective character stamped upon the product of that labour; . . . This is the reason why the products of labour become commodities, social things whose qualities are at the same time perceptible and imperciptible by the senses. In the same way the light from an object is perceived by us not as the subjective excitation of our optic nerve, but as the objective form of something outside the eye itself. But, in the act of seeing, there is at all events, an actual passage of light from one thing to another, from the external object the eye. There is a physical relation between physical things. But it is different with commodities. There, the existence of things *qua* commodities, and the value-relation between the products of labour which *stamps* them as commodities, have absolutely no connexion with their physical properties and with the material relations arising therefrom. There it is a definite social relation between men, that assumes, in their eyes, the fantastic form of a relation between things. In order, therefore, to find an analogy, we must have recourse to the mist-enveloped regions of the religious world. In that world the productions of the human brain appear as independent beings endowed with life, and entering into relation both with one another and the human race. So it is in the world of commodities with the products of men's hands. This I call the Fetishism which attaches itself to the products of labour, so soon as they are produced as commodities, and which is therefore inseparable from the production of commodities.
> (C, 1:72)

The first thing we might notice about this account of the commodity is the way its figures overlap with those of the camera obscura and the optical process as a metaphor for ideology. The commodity is a "fantastic" form—literally, a form produced by projected light; these forms, like the "ideas" of ideology, are both there and not there—both "perceptible and imperceptible by the senses." The difference from the images pro-

jected by the camera obscura is that the fantastic forms of the commodity are "objective character[s]" in the sense that they are projected outward, "stamped upon the product of . . . labour." The evanescent, subjective projections of ideology are imprinted and fixed the way a printing press (or photographic process) stamps the "characters" of typographic or graphic imagery. Marx puns on the term *Charaktere* to suggest, first, the ambiguous typographic-pictorial-hieroglyphic nature of the imprints, and second, their figurative status as personifications, inanimate objects that have been endowed with life and expressive "character." (Marx turns these figurative personifications into literal persons a few pages later when he allows them to speak; see p. 83.) The synthetic figure that unites all these aspects is the fetish, the material idol of primitive religion, now understood as an ideological projection. Ideology and commodity, the "fantastic forms" of the camera obscura and the "objective characters" of fetishism, are not separable abstractions, but mutually sustaining aspects of a single dialectical process.

Ancient and Modern Fetishism

Marx was not alone in his interest in the literal fact of primitive fetishism and its metaphorical application to modern life. Fetishism had been a central concept of the emerging science of anthropology since the eighteenth century, and most of Marx's ideas about it are derivative. His claim that the commodity fetish is a "hieroglyphic," for instance, is no doubt borrowed from de Brosses' claim that Egyptian hieroglyphics were the signs of a fetishistic religion.[57] His account of commodities as objects that have been personified by an act of projected consciousness follows almost exactly the model provided in accounts of idolatry. The "horror" of fetishism was not just that it involved an illusory, figurative act of treating material objects as if they were people, but that this transfer of consciousness to "stocks and stones" seemed to drain the humanity out of the idolater. As the stocks and stones come alive, the idolater is seen as falling into a kind of living death, "a state of brutal stupidity" (de Brosses, 172) in which the idol is more alive than the idolater. Marx's claim that commodity fetishism is a kind of perverse "exchange," producing "material relations between persons and social relations between things"(C, 1:73), employs precisely the same logic.

57. See de Brosses' in Feldman and Richardson, *Modern Mythology,* 174.

Probably the most important feature of the anthropological literature for Marx's purposes was the distinction between idolatry and fetishism. De Brosses thought that Fetishism was "more ancient than idolatry properly so called"(172), regarding it as the most "savage and coarse" form of primitive religion in its worship of plants, animals, and inanimate objects. "Less senseless peoples worshipped the sun and stars" (what de Brosses calls "Sabeism") or human heroes(171–72). F. Max Müller's *Lectures on the Origin and Growth of Religion* (1878) drew the standard distinction between the fetish and the idol in a different way, on what we might call "semiotic" grounds: "A fetish, properly so called, is itself regarded as something supernatural; the idol, on the contrary, was originally meant as an image only, a similitude or symbol of something else."[58] This distinction clarifies some of the specific force in Marx's choice of "fetishism" as his concrete concept for commodities. Part of this force is rhetorical: the figure of "commodity fetishism" (*der Fetischcharakter der Ware*) is a kind of catachresis, a violent yoking of the most primitive, exotic, irrational, degraded objects of human value with the most modern, ordinary, rational, and civilized.[59] In calling commodities fetishes, Marx is telling the nineteenth-century reader that the material basis of modern, civilized, rational political economy is structurally equivalent to that which is most inimical to modern consciousness. The shadowy *eidola* and mental "idols" in the camera obscura of ideology look rather harmless and even refined by comparison. We begin to see why the accusation of ideology (i.e., mental idolatry) is so much less threatening than the charge of fetishism, and why the ideological critique is the preferred approach to aesthetic forms.

But the fetish/idol distinction plays an analytic as well as a rhetorical role in *Capital*, in Marx's account of the semiotics of money. Marx regards money, not as an "imaginary" symbol of exchange-value, but as "the direct incarnation of all human labor," the "embodiment" of value: "the fact that money can, in certain functions, be replaced by symbols of itself gave rise to that . . . mistaken notion that it is itself a mere sym-

58. Quoted in Simpson, *Fetishism and Imagination*, 13.

59. The translation of *Ware* by the term "commodities" loses some of the connotations of commonness and ordinariness one senses in the German. But the etymology of "commodity," with its associations of fitness, proportion, and rational convenience (cf. "commodious") sustains the violence of Marx's figure, as does the obvious tension between the sacred and the secular. The origin of the word "fetish," on the other hand (literally, a "made object") tends to sustain the propriety of the comparison, insofar as both commodities and fetishes are products of human labor.

bol"(*C*, 1:90). Of course, from a standpoint *outside* capitalism, money is a mere symbol, but one which has, in the *internal* logic of capitalism, ceased to be recognized as a symbol, and has become a fetish, the thing itself. Thus the error of capitalist economists in thinking of money as a symbol is for Marx "a presentiment that the money-form of an object is not an inseparable part of that object, but is simply the form under which certain social relations manifest themselves. In this sense, every commodity is a symbol, since, in so far as it is value, it is only the material envelope of the human labour spent upon it." But the capitalists cannot follow up the prophetic logic of this "error" in their own analysis:

> If it be declared that the social characters assumed by objects, or the material forms assumed by the social qualities of labour under the regime of a definite mode of production, are mere symbols, it is in the same breath also declared that these characteristics are arbitrary fictions sanctioned by the so-called universal consent of mankind. This suited the mode of explanation in favour during the 18th century. Unable to account for the origin of the puzzling forms assumed by social relations between man and man, people sought to denude them of their strange appearance by ascribing to them a conventional origin.(*C*, 1:91)

"Convention" in this account is, of course, synonymous with "nature" (recall Burke's "second nature" of habit, custom, and tradition), in its universal, immutable character. Marx wants to prevent the fetishist from "denuding" the "strange appearance" of his behavior with paradoxes like "universal convention," that produce "mere arbitrary symbols" that just happen to be natural. He wants to force the fetish-worshiper to put on his motley garments in all their strangeness, to admit that he is a fetishist, not a mere "idolater" who worships something "symbolized" by commodities. Commodities, like "stocks and stones," are *really* (i.e., from the point of view of the iconoclast) nothing but symbols; but from within capitalism, as from within primitive life, they are magical objects that contain within themselves the principle of their value.

Marx's insistence on the magical character of commodities involves, of course, a recognition that there will be considerable resistance to this claim, and that this resistance is precisely what distinguishes modern fetishism from ancient. To tell a West African worshiper of fetishes that his talismans and amulets are, to him, magical objects that contain a

supernatural presence is only to tell him what he already believes. To tell the capitalist that gold is his "holy grail," by contrast, is to utter a slander that he will deny with all his heart. Marx makes this point by extending the notion of "forgetting" found in anthropological accounts of fetishism. The magic of the fetish depends on the projection of consciousness into the object, and then a forgetting of that act of projection. More specifically, de Brosses argued, the fetish-worshipers are to be understood as peoples in whom "the memory of Divine Revelation" is "entirely extinguished"(172). Commodity fetishism can be understood, then, as a kind of double forgetting: first the capitalist forgets that it is he and his tribe who have projected life and value into commodities in the ritual of exchange. "Exchange-value" comes to seem an attribute of commodities even though "no chemist has ever discovered exchange-value either in a pearl or a diamond"(C, 1:83). But then, a second phase of amnesia sets in that is quite unknown to primitive fetishism. The commodity veils itself in familiarity and triviality, in the rationality of purely quantitative relations and "natural, self-understood forms of social life"(75). The deepest magic of the commodity fetish is its denial that there is anything magical about it: "the intermediate steps of the process vanish in the result and leave no trace behind"(92). Like hieroglyphics, like language itself, commodities become a timeless, eternal code: "man seeks to decipher, not their historical character, for in his eyes they are immutable, but their meaning"(75). Capitalist economics is thus an ahistorical hermeneutics seeking the "meaning" of money and commodities in "human nature" or "universal conventions"; it has forgotten, not "divine revelation" (like the primitive fetishists), but the historical character of its own mode of production.

One of the most popular "universal meanings" for fetishism in eighteenth- and nineteenth-century literature was, of course, its sexual significance, a theme that would later become central for Freud. James Fergusson's *Tree and Serpent Worship* (1868), which Marx read,[60] hinted about certain "unhallowed rites," and Marx would not have had to look very far to find these hints elaborated. Richard Payne Knight's *An Inquiry into the Symbolical Language of Ancient Art and Mythology* (1818) carried the notion of sexual symbolism to its extreme, finding emblems of the male and female sexual organs in everything from the explicit imagery of Priapus, to the "spires and pinnacles" of Christian religious

60. See *Ethnological Notebooks*, 348.

architecture. The attitude of commentators toward the lascivious im-
plications of fetishism and idolatry ranged from Knight's scarcely con-
cealed delight in scandal, to the genial urbanity of Joseph Spence (whose
collection of gems and medals Knight studied) to the outrage of aesthetic
Puritans like Lessing (who denounced the "intolerable taste" of Spence's
Polymetis [*Lacoon,* 51]).

The notion of the fetish as a displaced phallus could take two basic
forms: either the symbolic object could encourage lascivious fantasy (as
it does in Lessing's account of ancient idolatry), or it could produce
impotence. The projection of the worshiper's "life" into the fetish takes
on the specific form of a projection of masculinity, a projection whch
results in the symbolic castration or feminization of the fetishist. David
Simpson's study of fetishism in nineteenth-century literature notes this
pattern cropping up in iconoclastic denunciations of all sorts of figura-
tive "idolatry." The condemnation of luxury, of theatricality, shows, and
"sensationalism," of ornaments, trinkets, cosmetics, and figurative lan-
guage, of printed "visible" language, and of the visual arts (especially
photography) routinely employs an iconoclastic rhetoric that depicts the
idolater as infantile, feminine, and narcissistic—in a word, as "unmanly."
Godwin gave the clearest political expression to this rhetoric in his claim
that the "the idol that monarchy worships, in lieu of the divinity of
truth," causes the individual's "grandeur and independence [to] be
emasculated."[61]

Marx's descriptions of monetary and commodity fetishism echo many
of these commonplaces, as do modern Marxist denunciations of bour-
geois "impotence."[62] The capitalist's greed is regularly figured as a dis-
placed sexual passion, an "unsatiable desire"(*C,* 1,133) that actually frus-
trates the expression of real, physical sexuality. "His imaginary boundless
thirst for enjoyment causes him to renounce all enjoyment," and turns
him into "a martyr to exchange-value, a holy ascetic seated at the top of a
golden column"(*CPE,* 134; cf. Payne Knight's "pinnacles"). "The
hoarder" must continually defer the gratifications of real use-value, and
thus "makes a sacrifice of the lusts of the flesh to his gold fetish"(133).
Marx even finds a prefiguration of economic, religious, and sexual fetish-
ism in the religion of ancient Greece: "ancient temples," he suggests,

61. Quoted in Simpson, *Fetishism and Imagination,* 75.
62. See Eagleton's remarks on "the impotent idealist conscience" of capitalism in
Criticism and Ideology, 14.

served a triple role as churches, banks, and whorehouses—"dwellings of the gods of commodities"(132n) where "virgins, who at the feast of the Goddess of Love, gave themselves up to strangers" only to "offer to the goddess the piece of money they received." Money is not only a "pimp" and "universal whore" for the capitalist, it is, like the ancient fetish, an ostensible "symbol" of fertility that actually renders its worshiper impotent and sterile by taking all fertility into itself. Capital acquires "the occult quality of being able to add value to itself. It brings forth living offspring, or, at the least, lays golden eggs"(154).[63] The goal of exchange-value is an endless cycle of breeding in which "Money begets money"(155), and the capitalist becomes "capital personified"(152), nothing but the "conscious representative" of the movement of surplus value.

Marx departs from the sexual interpretation of fetishism, however, in one crucial way. For Marx, sexuality is not (as it was for Freud), a universal drive that is mediated by various symbols; it is rather a social relation that is historically modified by changes in the organization of labor. It is not perverse sexuality, then, that expresses itself in commodity fetishism, but commodity fetishism that renders sexuality, along with every other human relationship, perverse. That is why the societies that produce traditional fetishes—primitives, savages, Asians, Africans, or (closer to home) medieval Catholic Europeans—are treated by Marx as relatively lesser perversions of human possibility. These traditional, pre-capitalist societies are regarded, rather, as "idyllic" and relatively humane forms of life. The products of their labor bear a "specific social imprint" (*CPE,* 33), but it is not the imprint of abstract, alienated, homogeneous "labour-time"—the mark stamped on the commodity fetish. It is rather "the distinct labour of the individual," the mark of the craftsman or guild, the imprint of men and women's work, or the mark of the traditional fetish, the special religious object as such. In sexual terms, the traditional fetish is completely explicit about its sexual origins: the medals and jewels Spence collected left little doubt about what they represented. The commodity fetish, and its "crystallised" forms in gold and coinage, efface all qualitative differences of this sort.[64] Capital levels

63. Marx would no doubt want us to extrapolate the Aesopian allusion: if capital is the goose that lays the golden eggs, the capitalist is the owner whose greed will inevitably destroy the source of his wealth. His fertility is ultimately sterile.

64. It is interesting to note that Freud's view of fetishism saw it as a form of anxiety aroused by the mistaken view of the mother as a castrated man. Freud's fetishism thus also involves a kind of refusal to admit sexual difference, though for quite different reasons.

all the distinctions of sex, age, and skill into quantities of universal labor time in both the exchange and factory. It even levels, as Lukács noted, the space-time distinction that Lessing regarded as fundamental to discrimination of genres:

> Time sheds its qualitative, variable, flowing nature; it freezes into an exactly delimited, quantifiable continuum filled with quantifiable "things" (the reified, mechanically objectified "performance" of the worker, wholly separated from his total human personality): in short, it becomes space.[65]

Fetishes in the traditional sense are, for this reason, absolutely anathema in a modern economy of commodity fetishism. The primitive, communal, feudal, or patriarchal economies that are replaced by capitalism are idolatrous and fetishistic precisely because they have not yet developed the modern form of fetishism. This modern form is both a repetition and inversion of traditional "pagan" religious materialism. It repeats the structural elements of transference and forgetting, but it introduces a new dimension of rationalization: the modern fetish, like the image in the camera obscura, is an icon of rational space-time. It is thus declared to be natural magic, a universal convention, in theory "only a symbol" (thus not a fetish), in practice "the thing itself" (thus a fetish). Most important, the modern fetishism of commodities defines itself as an iconoclasm, and sets itself the task of destroying traditional fetishes. Implicit in Marx's critique of fetishism, then, is a critique of its dialectical counterpart, the phenomenon of iconoclasm, to which we now turn.

The Dialectic of Iconoclasm

The Christian religion was able to contribute to an objective understanding of earlier mythologies only when its self-criticism was to a certain extent prepared, as it were potentially. Similarly, only when the self-criticism of bourgeois society had begun, was bourgeois political economy able to understand the feudal, ancient, and oriental economies. In so far as bourgeois political economy did not simply identify itself with the past in a mythological manner, its criticism of earlier economies—especially of the feudal system

65. *History and Class Consciousness* (1968), trans. Rodney Livingstone (Cambridge, Mass.: MIT Press, 1971), 90.

against which it still had to wage a direct struggle—resembled the
criticism that Christianity directed against heathenism, or which
Protestantism directed against Catholicism. (*CPE*, 211–12)

The criticism that Christianity directed against heathenism, and Protes-
tantism against Catholicism, was, of course, the charge of fetishism or
idolatry. Indeed, to a devout Puritan, the difference between heathen
fetishism and Catholic idolatry was not terribly significant. Willem Bos-
man, whose *Discription of Guinea* provided de Brosses with much of his
material, remarked that "if it was possible to convert the *Negroes* to the
Christian Religion, the *Roman*-Catholics would succeed better than we
should, because they already agree in several particulars, especially in
their ridiculous ceremonies."[66] This sort of "agreement" between
varieties of idolatry suggests that there is a similarity, not just among
different sorts of image worship, but among different kinds of hostility
towards image worship—that is, among different varieties of icono-
clasm. The typical features of iconoclasm should now be familiar. It
involves a twofold accusation of folly and vice, epistemological error and
moral depravity. The idolater is naive and deluded, the victim of false
religion. But the illusion is never simply innocent or harmless; from the
iconoclastic point of view it is always a dangerous, vicious mistake that
not only destroys the idolater and his tribe, but threatens to destroy the
iconoclast as well.

There is a curious ambivalence, then, in the rhetoric of iconoclasm.
Insofar as the stress is on the folly of the idolater, he is an object of pity
who requires education and therapeutic conversion "for his own good."
The idolater has "forgotten" something—his own act of projection—
and thus he must be cured by memory and historical consciousness.[67] The
iconoclast sees himself at a historical distance from the idolater, working
from a more "advanced" or "developed" stage in human evolution,
therefore in a position to provide a euhemeristic, historicizing inter-
pretation of myths taken literally by the idolater.

Insofar as the stress is on depravity, on the other hand, the idolater is
the object of a wrathful judgment that is in principle without limits. The
unlimited severity of the judgment follows logically from the peculiar

66. *Modern Mythology*, 46.
67. The analogy with Freud's theory of fetishism and the therapeutic process will be
evident here. I have deliberately avoided bringing Freud into this discussion for obvious
historical reasons, but his presence should be felt throughout.

character of idolatry, which is not just a moral failure among others but a renunciation of one's own humanity, a projection of that humanity into objects. The idolater is, by definition, subhuman and until it is shown that he can be educated into full humanity, he is a fit object for religious persecution, exile from the community of believers, enslavement, or liquidation.

Iconoclasm has a history at least as old as idolatry. Although it always tends to appear as a relatively recent, revolutionary breakthrough, overturning some previous established cult of image-worship (the Protestant Reformation breaking with Roman Catholicism, the iconoclasts of the Byzantine Empire opposing the patriarch, the Israelites escaping Egypt), it regularly presents itself as the most ancient form of religion—a return to primitive Christianity, or to the religon of the first human creatures, before a "fall" which is always understood as a fall into idolatry.[68] Indeed, one might argue that iconoclasm is simply the obverse of idolatry, that it is nothing more than idolatry turned outward toward the image of a rival, threatening tribe. The iconoclast prefers to think that he worships no images of any sort, but when pressed, he is generally content with the rather different claim that his images are purer or truer than those of mere idolaters.

A version of this understanding of the relation of iconoclasm and idolatry (which we might call "anthropological") was familiar to Marx from the writings of Feuerbach. All religious images, from the crudest fetishes to the most refined versions of the *imago dei*, were treated "anthropologically" by Feuerbach, as projections of the human imagination. From Feuerbach Marx also learned to think of Judaism as the prototype of iconoclastic self-deception. "The Hebrews," said Feuerbach, "raised themselves from the worship of idols to the worship of God."[69] But this "raising" is, for Feuerbach, actually a degradation. Heathen idolatry "is simply man's primitive contemplation of nature"(116), an activity of the "aesthetic" and "theoretic" sense that finds

68. Milton's treatment of Eve's narcissism and Adam's excessive fascination with Eve's beauty is perhaps the most subtly developed version of the traditional notion of the fall as a consequence of idolatry. See *Paradise Lost*, XI, 508–25, in which Michael explains to Adam how the true image of God in man is displaced by the fall into idolatry: "Their Maker's image . . . then/Forsook them, when themselves they vilified/ To serve ungoverned appetite and took/ His image whom they served, a brutish vice,/ Inductive mainly to the sin of Eve."

69. *The Essence of Christianity* (1841), trans. George Eliot (1854). Reference here is to the Harper Torchbook reprint of Eliot's translation (1957), 116.

its most refined forms in Greek religion and philosophy: "polytheism is the frank, open, unenvying sense of all that is beautiful without distinction"(114). By contrast, Judaism wants to dominate nature, so it makes an "idol of the egoistic will" in the person of Jehovah as creator, and in the practical life of the Jew as a mere consumer. (Feuerbach claims that "eating is the most solemn act . . . of the Jewish religion" while "contemplation" is the characteristic activity of the heathen).[70]

Marx's anti-Semitism is expressed in cruder, more direct economic terms: the Jew is the arch-iconoclast who wants to smash all the traditional fetishes and replace them with commodities. "Money is the jealous god of Israel before whom no other god may exist. Money degrades all the gods of mankind—and converts them into commodities."[71] This sort of rhetoric is sometimes excused by claiming that it is only figurative: Marx's editors tell us that his "essential animus was against the dehumanizing alienation of civil society" (YM 216); and Marx himself tells us that the Jew, literally and historically understood, "is only the special manifestation of civil society's Judaism" (YM 245). But it is clear that Marx wanted to express both a literal and figurative animus against Judaism, and that he saw the Jew's figurative hegemony as the end result of an actual, material transformation. Marx's history of political economy moves from a time when the Jew was marginal, a nomadic trader "in the pores" of societies that had not yet internalized the commodity-form, to the modern world in which this form is central, and where, for all practical purposes, "the Christians have become Jews" (YM, 244; cf. C, 1:79).

Marx's way of stressing the identity of Jews and Christians in bourgeois society is to shift the burden of his polemic onto the Protestants, especially the Puritans, the Christian iconoclasts who smash the political economy of feudal Catholicism, employing the Old Testament poetry of Habbakuk and the New Jerusalem. Modern political economy, for Marx, is rationalized by this Jewish-Christianity with its liberal

70. For an argument that iconoclasm is essentially a religious pretext for the centralization of political, social, and economic power, see Joseph Gutmann, *No Graven Images* (New York: Ktav, 1971), xxiv–xxv. Gutmann suggests that Egyptian, Jewish, Byzantine, and Christian iconoclasm is linked by the common theme of political centralization, and that polytheistic idolatry tends to be diversified, pluralistic, and decentralized in local cults and their deities.

71. "The Jewish Question," in *Writings of the Young Marx on Philosophy and Society,* ed. Loyd Easton and Kurt Guddat (Garden City, N.Y.: Doubleday, 1967), 245. Hereafter cited as YM.

philo-Semitism and its programs for "emancipation" of the Jews. If Adam Smith is a Moses (*CPE*, 37), he is also a Martin Luther.[72] Monotheism is the religious reflex of an abstract, uniform standard of value: for a society that reduces "individual private labour to the standard of homogeneous human labour . . . Christianity with its *cultus* of abstract man, more especially in its bourgeois developments, Protestantism, Deism, &c., is the most fitting form of religion" (*C* 1:79). Puritanism, more specifically, with its Hebraism and ethics of hard work and thrift, comes closest to providing the synthetic figure of the modern Christian/ Jew that Marx requires: "in so far as the hoarder of money combines asceticism with assiduous diligence he is intrinsically a Protestant by religion and still more a Puritan"(*CPE*, 130).

The synthesis produced in these figures is not just between Judaism and Christianity but between iconoclasm and idolatry. The modern Christian iconoclast *is* the idolater; commodity fetishism *is* an iconoclastic monotheism that destroys all other gods.[73] To find an appropriate emblem for this paradoxical "iconoclastic fetishism," Marx turns to the image that had become synonymous with rise of modern aesthetics as a "purification" of superstitious, religious elements in art. That image is, not surprisingly, the Laocoön. Marx suggests that the Puritan may be imaged as a perversion or inversion of the iconography of Laocoön: "the pious and politically free inhabitant of New England is a kind of *Laocoon* who does not make the slightest effort to free himself from the serpents strangling him. *Mammon* is his idol to whom he prays not only with his lips but with all the power of his body and soul"(YM 244). Lessing, we recall, thought the serpents on ancient statues were emblems of divinity that detracted from their pure beauty, and turned them into idols that fed the fantasies of women, but he never applied this analysis to the actual iconography of Laocoön's struggle with the serpents. Marx seems to have applied Lessing's critique of idolatry to the statue of Laocoön itself, interpreting the struggle of the priest and his sons as an image of the fight against idolatry. For Laocoön to stand passively embraced by the serpents would be to give into Mammon, to become an idolater in Marx's terms, an idol in Lessing's.[74]

72. See Engels, *Outlines of a Critique of Political Economy* (1844), in *Economic and Philosophical Manuscripts of 1844,* ed. Dirk J. Struik (New York: International Publishers, 1964), 202.

73. See Gutmann, *No Graven Images,* for a discussion of iconoclasm and monotheism.

74. Marx mentions Lessing's *Laocoon* first in a list of books from which he copied

There is more than a little irony in Marx's invocation of the Laocoön as an image of the iconoclast becoming idolater. It is as if Marx were turning Laocoön into an emblem of Lessing's attempt to free art from superstition, a meaning that Lessing never explicitly embraces, but which is latent in his discussion of primitive religious art, and the specific symbolism of the serpent as an ambiguous fetish.[75] As long as Laocoön strives against the serpents, he symbolizes the iconoclastic struggle against fetishism, the values of Enlightenment aesthetics against primitive superstition. But the Laocoön also symbolizes, in that very struggle, a new fetishism, the bourgeois cult of "aesthetic purity" which defines itself in opposition to traditional religious art—the sort of art in which men do not struggle against the generative, natural forces represented by the serpents but embrace them as equals. In order to make his use of the Laocoön, Marx has to dehistoricize it, remove it from its exemplary status in Enlightenment aesthetics, and forget for the moment that if ever there was a "Jewish-Christian" who questioned German anti-Semitism, it was Lessing, the Christian philo-Semite who wrote *Nathan the Wise* and defended Moses Mendelssohn, the pioneer of secular aesthetics.[76] If Marx had ever thought to combine his critique of the Jewish question with a critique of art under capitalism, he would no doubt have seen "aesthetics" as another Jewish subterfuge, a mystification of the commodity under the veils of "purity," "beauty," and "spiritual expressiveness." His characterization of the commodity in terms that vacillate between idealization (the "metaphysical," "transcendent" aura of art) and degradation (the fetish as the object of a coarse, vulgar, obscene cult) makes it an apt emblem for the ambivalence of all subsequent marxist thinking about art. This vacillation is dramatized in Walter Benjamin's ambiguous treatment of artistic aura as both "outmoded" and deeply attractive, and Theodore Adorno's objection to Benjamin's later criti-

excerpts while a student in Berlin. See his "Letter to (father) Heinrich Marx," November 10, 1837, *The Letters of Karl Marx,* ed. Saul K. Padover (Englewood Cliffs, N.J.: Prentice-Hall, 1979), 8.

75. See chapter 4 above.

76. Mendelsohn thought that "the deism of the Enlightenment, which he had developed into a universal religion of reason, was in fact identical with Judaism." See Giorgio Tonelli, "Mendelssohn," in *The Encyclopedia of Philosophy,* 5:277. Marx's sensitivity to these intellectual alliances is suggested by his contemptuous comparison of the Young Hegelians who "treat Hegel in [the] same way as the brave Moses Mendelssohn in Lessing's time treated Spinoza." See the "Afterword to the Second German Edition" of *Capital,* 19.

cism as simultaneously vulgar and idealistic, "at the crossroads of magic and positivism."[77]

Perhaps a simpler way of saying all this is just to note that aesthetics is Marx's blind spot, the one major philosophical topic that remained relatively undeveloped in his writing, the one topic on which his opinions tend to be conventional and derivative. Lessing, Diderot, Goethe, and Hegel were his aesthetic mentors, and however much he might quarrel with their idealism in the sphere of political economy, his fragmentary opinions on the arts reflect basic agreement with the Enlightenment idealization of art. That is why aesthetics and the Marxist tradition have always confronted each other in a state of mutual embarrassment.[78] Marxism is embarrassed because, if it follows the logic of Marx's economic thought, it seems inevitably to fall into a vulgar reduction of the arts to mere commodities , or to mechanical "reflexions" in the camera obscura of ideology. If it follows the idealism of Marx's actual opinions about the arts, sustained by the humanism of his early writings, then "Marxist aesthetics" seems to become soft, neo-Hegelian, and un-Marxian.

Aesthetics, on the other hand, finds itself equally embarrassed by the Marxist challenge. Its notions of purity, autonomy, and timeless significance seem remarkably vulnerable to historical deconstruction. One need not be a vulgar Marxist to see some force in the claim that "aesthetics" is an elitist rationalization, a mystification of cult objects that (especially in the visual arts) have an "aura" about them that smells like money. Indeed, not only the arts, but all the means of communication in the modern political economy—television, print journalism, film, radio—seem to share in a global network of what might be called "mediolatry" or "semiotic fetishism." "Image-making" in advertising, propaganda, communications, and the arts has replaced the production of hard commodities in the vanguard of advanced capitalist economies, and it is hard to see how any telling criticism of these new idols can be sustained without some recourse to the Marxist rhetoric of iconoclasm. And yet it is hard also to see how this rhetoric can avoid consuming itself in the sort

77. Letter from Adorno to Benjamin, August 2, 1935, in *Aesthetics and Politics,* ed. Perry Anderson et al. (New York: New Left Books, 1977), 126. For a good analysis of this dispute, see Eugene Lunn, *Marxism and Modernism* (Berkeley: University of California Press, 1982), 166–67.

78. On this problem, see Hans Robert Jauss, "The Idealist Embarrassment: Observations on Marxist Aesthetics," *New Literary History* 7:1 (Autumn, 1975), 191–208.

of desperately alienated iconoclasm one finds in an ultraleftist like Jean Baudrillard, who concludes that the arts and the media are so utterly co-opted by capitalism that not only is "reform" impossible but also all efforts at dialectical conversion to progressive, liberating purposes. Baudrillard ridicules the notion that the art museum, for instance, might return works of art

> to a sort of collective ownership and so to their "authentic" aesthetic function. In fact, the museum acts as a *guarantee* for the aristocratic exchange. . . . just as a gold bank . . . is necessary in order that the circulation of capital and private speculation be organized, so the the fixed reserve of the museum is necessary for the functioning of the sign exchange of paintings.(*CPS,* 121)

The possibility that the fetishes of capitalist aesthetics, objects experienced and understood as "beautiful," "expressive," etc., might have *both* an authentic and inauthentic function for their users is exactly the possibility that the radical iconoclast cannot countenance.

In a similar vein, Baudrillard denounces the mass media as modes of production that are in themselves inimical to true human communication:

> It is not as vehicles of content, but in their very form and very operation, that media induce a social relation; . . . The media are not co-efficients, but *effectors* of ideology. . . . The mass media are anti-mediatory and intransitive. They fabricate non-communication.(*CPS,* 169)

The only answer, in Baudrillard's view, is "an upheaval in the entire existing structure of the media. No other theory or strategy is possible. All vague impulses to democratize content, subvert it, restore the "transparency of the code," control the information process, contrive a reversibility of circuits, or take power over media are hopeless—unless the monopoly of speech is broken"(170). Baudrillard concludes that the only "authentic" revolutionary communication in the student uprisings of the late sixties were to be found in symbolic acts that bypassed the media and the official circuits of the arts—personal conversations, graffiti, and "witticisms" that produced a "transgressive reversal of discourse" (see *CPS,* 170, 176, 183–84). The radicals of Paris in 1968 should not have

occupied the radio stations to broadcast revolutionary messages; they should have smashed the transmitters!

I cite this sort of ultraleftist view of aesthetics and semiotics to show how Marx's iconoclasm might be logically applied to the arts and media, and to suggest how un-Marxian the results finally are in their rejection of modern modes of production and their sentimental appeals to less developed models of communication. Baudrillard seems continually to forget his own best insight, that fetishism is part of an iconoclastic rhetoric that turns against its users. Yet is is hard to deny that there is some truth to his caricature of the museum as a bank, the media as fabricators of "non-communication." The question is, how can these truths be brought into some coherent relationship with the fact that the museum is (sometimes) the site of authentic aesthetic experience, the media (sometimes) the vehicle of real communication and enlightenment? How can the rhetoric of iconoclasm serve as an instrument of cultural criticism without becoming a rhetoric of exaggerated alienation that imitates the intellectual despotism it most despises?

At its best moments, in the writing of Benjamin, Althusser, Williams, Lukács, Adorno, and others, this rhetoric has produced a mutual embarrassment between Marxism and aesthetics that has been dialectical and fruitful. At its worst moments, in the writings of these same figures, it has degenerated into dogmatic iconoclasm, with its familiar litany of accusation. If the rhetoric of iconoclasm is to do its proper dialectical work, however, it must begin, as Marx thought it should, in self-criticism and its obverse, an act of historically sympathetic imagination. The notions of fetishism and ideology, in particular, cannot simply be appropriated as theoretical instruments for a surgical operation on the bourgeois "other." Their proper use depends on an understanding of them as "concrete concepts," historically situated *figures* that carry a political unconscious along with them. They are based in what Adorno and the Frankfurt school have called "dialectical images," "crystallizations of the historical process," or "objective constellations in which the social condition represents itself." The problem with the Frankfurt school's notion of the dialectical image is that it depends, as Raymond Wiliams notes, "on a distinction between the 'real social process' and the various fixed forms, in 'ideology' or 'social products', which merely appear to represent or express it."[79] This distinction simply reinstates the iconoclastic schism:

79. *Marxism and Literature*, 103.

"dialectical images" are authentic, genuine, and true, in opposition to the false, reified images of ideology and fetishism. They have the same utopian status as those transparent, nonfetishistic images, the products of postrevolutionary labor that Marx thought "would be so many mirrors in which we saw reflected our essential nature."[80] What we need to realize is that the concrete concepts of fetishism and photographic "ideolatry" are themselves dialectical images—"social hieroglyphs," ambiguous syntheses whose "authentic" and "inauthentic" aspects cannot be disentangled by a question-begging invocation of the "real social process" or our "essential nature." The essence of the dialectical image is its polyvalence—as object in the world, as representation, as analytic tool, as rhetorical device, as figure—most of all as a Janus-faced emblem of our predicament, a mirror of history, and a window beyond it.

Marx adopted fetishism as a metaphor for commodities at the moment when Western Europe (and particularly England) was changing its view of the "undeveloped" world from an unknown, blank space, a source of slave-labor, to a place of darkness to be illuminated, a frontier for imperialist expansion and wage-slavery. "Fetishism" was a key word in the vocabularies of nineteenth-century missionaries and anthropologists who went out to convert the natives to the privileges of enlightened Christian capitalism. Abolition had completed its work, and was being replaced by an evangelism that brought Puritan iconoclasm face to face with "the horror" of its own antithesis.[81]

Marx's turning of the rhetoric of iconoclasm on its principal users was a brilliant tactical maneuver; given nineteenth-century Europe's obsession with the primitive, oriental, "fetishistic" cultures that were the prime object of imperialist expansion, one can hardly imagine a more effective rhetorical move. On the other hand, the history of the use of this particular weapon suggests that it comes back to haunt those who forget that history, who abstract it from historical criticism in the service of theory. The notion of fetishism, as Jean Baudrillard suggests, "almost has a life of its own. Instead of functioning as a metalanguage for the magical thinking of others, it turns against those who use it"(CPS, 90). This sort of self-subversion is, I suggest, what we see at work in Benjamin's reification of photography, in Althusser's infinite hall of ideological

80. "Comments on James Mill," Works, 3:228.
81. See Patrick Brantlinger, "Victorians and Africans," Critical Inquiry, 12:1 (September, 1985).

mirrors, and in Marx's own fall into anti-Semitism. None of us can avoid such lapses, but none of us can afford to avoid acknowledging them either, nor to suppose that acknowledgement is enough.

The obvious way to cultivate this sort of acknowledgment within the Marxist tradition would be to recall Marx's description of traditional religious iconoclasm (Christian versus pagan, Protestant versus Catholic) as historical movements that engaged in *self-criticism* before they turned themselves outward: "The Christian religion was able to contribute to an objective understanding of earlier mythologies only when its self-criticism was to a certain extent prepared, as it were potentially"(*CPE*, 211). Similarly, the Marxist rhetoric of iconoclasm must interrogate its own premises, its own claims to authority. It should be clear from the preceding discussion that this is precisely the step that tends to be bypassed in Marxist criticism, at the price of a certain repetition of the sins of the iconoclastic fathers. Althusser describes this bypassing as the moment when ideology is produced: "those who are in ideology believe themselves by definition outside ideology: one of the effects of ideology is the practical *denegation* of the ideological character of ideology by ideology: ideology never says, 'I am ideological.'" More precisely, Althusser might have said that this is the sort of Cretan paradox that "self-criticism" can fall into when it becomes a theoretical exercise, with all options predetermined. Althusser seems to acknowledge the alienating, despotic character of the ideological critique ("As is well known, the accusation of being in ideology only applies to others, never to oneself") but then takes it all back in a crucial parenthesis—"(unless one is really a Spinozist or Marxist, which, in this matter, is to be exactly the same thing)."[82] If self-criticism is, as Althusser claims, "the golden rule of Marxism," it is one he violates the moment he begs the question of what it is "to be a Marxist" who (along with the enlightened Spinozists) has the exclusive privilege of self-critical insight.

Marxism plays the role in modern Western intellectual life of a kind of secular Puritan/Judaism, a prophetic iconoclasm that challenges the polytheistic pluralism of bourgeois society. It tries to replace this polytheism with a monotheism in which the historical process plays the role of messiah, and the capitalist idols of the mind and marketplace are reduced to demonic fetishes. The liberal pluralist complaint against the

82. *Lenin and Philosophy*, 175.

intolerance of its iconoclastic rhetoric is likely to be met by a Marxist dismissal of petit-bourgeois "tolerance" as the luxury of a privileged minority. When it comes to real politics—issues of war, peace, economics, and state power—Marxism and liberalism don't have much to say to each other. Each refuses to enter the metaphysics of the other. The one place in which they can engage in dialogue—especially in American intellectual life—is the historical criticism of culture where, in a sense, the stakes are less immediate, and a long tradition of agreement about the meaning and value of canonical texts is in place. In this sphere the mutual embarrassment of Marxism and aesthetics, Marism and the liberal idealism of the Enlightenment, Marxism and Jewish-Protestant iconoclasm has at least a chance to be dialectical. In this context a Western intellectual can say, as Jerrold Seigel does, "my relationship to Marxism is frankly ambivalent; although morally and intellectually drawn to Marx's vision, I remain unable to accept his social theory, or identify with his politics."[83] And a Marxist like Raymond Williams, committed to an open, liberalized Marxism that recognizes the plurality and historicity of its traditions, can respond without the reflexive "dismissal of all other kinds of thinking as non-Marxist, revisionist, neo-Hegelian, or bourgeois."[84]

This, at any rate, is one scenario for a liberalism that would accept the difficult questions that Marxism puts to it, and for a Marxism that might be willing to listen to liberalism's answers. It is the sort of scenario that I have tried to play out in this book in studying the complex relations between iconophobia and iconophilia, between love and fear of images, between the "soft" and the "hard" view of ideological criticism. If this methodical ambivalence deserves a name, I suppose it would be what I have elsewhere described as "dialectical pluralism,"[85] and it can best be illustrated by recalling the two models of dialogue Blake provides in *The Marriage of Heaven and Hell*. The first insists on the structural necessity of "contraries" that can never be reconciled, and whose conflict is necessary to the "progression" of human existence: "these two classes of men are always upon earth, & they should be enemies; whoever tries to reconcile them seeks to destroy existence." The second model is one of

83. *Marx's Fate*, 9.
84. *Marxism and Literature*, 3.
85. "*Critical Inquiry* and the Ideology of Pluralism," *Critical Inquiry* 8:4 (Summer, 1982), 609–18.

conversion, in which the angel becomes a devil, and agrees to read the Bible "in its infernal or diabolical sense." This book attempts to use the second model of conversion and reconciliation as a perspective from which to study the first: to make both our love and hatred of "mere images" contraries in the dialectic of iconology.

Bibliography

The following bibliography contains six kinds of items: (1) scholarship that deals with the theory of imagery in visual communication and graphic art; (2) studies of imagery in perception, cognition, and memory; (3) comparative studies of visual and verbal art, including work on the "sister arts" comparison and the tradition of *ut pictura poesis;* (4) studies of textuality and temporality in pictorial representation, and of iconicity and spatiality in verbal forms; (5) work in aesthetics, symbol theory, and the philosophy of art that focuses on imagery; (6) studies of iconoclasm, idolatry, and fetishism. The bibliography contains a considerable number of references that are not cited in this book, and leaves out a number of titles that appear in the footnotes. My purpose is to suggest the main types of scholarship that have been useful to me in the development of an interdisciplinary approach to the study of imagery. No single field of image study (art history, "sister arts" scholarship, psychology, optics, epistemology, literary criticism, aesthetics, theology) is covered in anything approaching comprehensiveness; most are represented only by minimal suggestions.

Abel, Elizabeth. "Redefining the Sister Arts: Baudelaire's Response to the Art of Delacroix." In *The Language of Images,* ed. W. J. T. Mitchell. Chicago: University of Chicago Press, 1980.

Abrams, M. H. *The Mirror and the Lamp: Romantic Theory and the Critical Tradition.* 1953; rpt. New York: Norton, 1958.

Aghiorgoussis, Maximos. "Applications of the Theme 'Eikon Theou' (Image of God) According to St. Basil the Great." *Greek Theological Review* 21 (1976), 265–88.

Aldrich, Virgil. "Mirrors, Pictures, Words, Perceptions." *Philosophy* 55 (1980), 39–56.

Alpers, Svetlana and Paul. "Ut Pictura Noesis? Criticism in Literary Studies and Art History." *New Literary History* 3:3 (Spring 1972), 437–58.

Argan, Giulio Carlo. "Ideology and Iconology." In *The Language of Images,* ed. Mitchell (1980).

Arnheim, Rudolf. *Art and Visual Perception.* Berkeley: University of California Press, 1954.

"The Arts and Their Interrelations." *Bucknell Review* 24:2 (Fall 1968).

Bachelard, Gaston. *The Poetics of Space* (1958). Trans. Maria Jolas, Boston: Beacon Press, 1969.

Barthes, Roland. *Image/Music/Text.* Trans. Stephen Heath. New York: Hill & Wang, 1977.

Baudrillard, Jean. *For a Critique of the Political Economy of the Sign* (1972). Trans. Charles Levin. St. Louis: Telos Press, 1981.

Bender, John. *Spenser and Literary Pictorialism.* Princeton: Princeton University Press, 1972.

Benjamin, Walter. "The Work of Art in the Age of Mechanical Reproduction." Trans. Harry Zohn. In *Illuminations,* ed. Hannah Arendt. New York: Schocken Books, 1969.

Berger, John. *Ways of Seeing.* London: Pelican, 1972.

Binyon, Laurence. "English Poetry in Its Relation to Painting and the Other Arts." *Proceedings of the British Academy* 8 (1917–18): 381–402.

Bishop, John Peale. "Poetry and Painting." *Sewanee Review* 53 (Spring 1945), 247–58.

Blanchot, Maurice. *The Space of Literature* (1955). Trans. Ann Smock. Lincoln: University of Nebraska Press, 1982.

Block, Ned, ed. *Imagery.* Cambridge, Mass.: MIT Press, 1981.

Boas, George. "The Classification of the Arts and Criticism." *Journal of Aesthetics and Art Criticism* 5 (June 1947), 268–72.

Boorstin, Daniel J. *The Image: A Guide to Pseudo-Events in America.* New York: Atheneum, 1961.

Boulding, Kenneth. *The Image.* 1956; reprint, Ann Arbor: University of Michigan Press, 1961.

Brown, Peter. "A Dark Age Crisis: Aspects of the Iconoclastic Controversy." *English Historical Review* 88 (1973).

Brown, Roger, and Richard J. Herrnstein, "Icons and Images." In *Imagery,* ed. Block (1981).

Bryson, Norman. *Word and Image: French Painting of the Ancien Régime.*
Cambridge: Cambridge University Press, 1981.

Burke, Edmund. *A Philosophical Enquiry into the Origin of Our Ideas of the
Sublime and Beautiful* (1757). Ed. James T. Boulton. South Bend, Ind.:
Notre Dame University Press, 1968.

Casey, Edward S. *Imagining: A Phenomenological Study.* Bloomington:
Indiana University Press, 1976.

Caws, Mary Ann. *The Eye in the Text: Essays on Perception, Mannerist to
Modern.* Princeton: Princeton University Press, 1981.

"A Checklist of Modern Scholarship on the Sister Arts." in *Articulate
Images: The Sister Arts from Hogarth to Tennyson,* ed. Richard Wen-
dorf. Minneapolis: University of Minnesota Press, 1983, 251–62.

Comparative Criticism: A Yearbook. Ed. E. S. Shaffer. Cambridge:
Cambridge University Press, 1982. Part I: "The Languages of the
Arts."

Croce, Benedetto. "Aesthetics." From *Encyclopaedia Britannica,* 14th ed.
Reprinted in *Philosophies of Art and Beauty,* ed. Albert Hofstadter and
Richard Kuhns. Chicago: University of Chicago Press, 1964.

Dagognet, François. *Ecriture et Iconographie.* Paris: Vrin, 1973.

Daley, Peter M. "The Semantics of the Emblem: Recent Developments
in Emblem Theory." *Wascana Review* 9 (1975), 199–212.

Davies, Cicely. "Ut Pictura Poesis." *Modern Language Review* 30 (April
1935), 159–69.

Da Vinci, Leonardo. "Paragone: Of Poetry and Painting." In *Treatise on
Painting,* ed. A. Philip McMahon. Princeton: Princeton University
Press, 1956.

Day-Lewis, Cecil. *The Poetic Image.* New York: Oxford University Press,
1947.

Dennett, Daniel J. "Two Approaches to Mental Images." In *Imagery,* ed.
Block (1981).

Derrida, Jacques. *Of Grammatology.* Trans. Gayatri Spivak. Baltimore:
Johns Hopkins University Press, 1974.

Dewey, John. "The Common Substance of All the Arts." Chapter 9 of
Art as Experience. New York: Putnam, 1934.

Dieckmann, Liselotte. *Hieroglyphics: The History of a Literary Symbol.*
St. Louis: Washington University Press, 1970.

Dijkstra, Bram. *The Hieroglyphics of a New Speech: Cubism, Stieglitz, and
the Early Poetry of William Carlos Williams.* Princeton: Princeton
University Press, 1969.

Doebler, John. *Shakespeare's Speaking Pictures: Studies in Iconic Imagery.* Albuquerque: University of New Mexico Press, 1974.

Dryden, John. "A Parallel of Poetry and Painting" (1695). In *Essays of John Dryden,* 2 vols., ed. W. P. Ker. Oxford: Clarendon Press, 1899, vol. 2.

Dubos, J. B. *Réflexions critiques sur la poésie et sur la peinture.* Paris, 1719; English trans. by T. Nugent, 3 vols., 1748.

Eco, Umberto. *A Theory of Semiotics.* Bloomington: Indiana University Press, 1976.

Edelman, Bernard. *Ownership of the Image: Elements for a Marxist Theory of the Law.* Trans. Elizabeth Kingdom. London: Routledge & Kegan Paul, 1979.

Engell, James. *The Creative Imagination.* Cambridge: Harvard University Press, 1981.

Feyerabend, Paul. *Against Method: Outline of an Anarchistic Theory of Knowledge.* London; New Left Books, 1975. See Chapter 17 on perspective and optical theory.

Fodor, Jerry A. "Imagistic Representation." In *Imagery,* ed. Block (1981).

Fowler, Alastair. "Periodization and Interart Analogies." *New Literary History* 3:3 (1972), 487–509.

Frank, Ellen Eve. *Literary Architecture: Essays Toward a Tradition.* Berkeley: University of California Press, 1979.

Frank, Joseph. "Spatial Form in Modern Literature." *Sewanee Review* 53 (1945), 221–40.

Frankel, Hans. "Poetry and Painting: Chinese and Western Views of Their Convertibility." *Comparative Literature* 9 (1957), 289–307.

Frazer, Ray. "The Origin of the Term 'Image.'" *ELH* 27 (1960), 149–61.

Fresnoy, C. A. du. *The Art of Painting.* Trans. John Dryden. London, 1695.

Fried, Michael. *Absorption and Theatricality: Painting and Beholder in the Age of Diderot.* Berkeley: University of California Press, 1980.

Fry, Roger. *Vision and Design.* London: Chatto & Windus, 1920.

Frye, Roland M. *Milton's Imagery and the Visual Arts.* Princeton: Princeton University Press, 1978.

Furbank. P. N. *Reflections on the Word 'Image'.* London: Secker & Warburg, 1970.

Gage, John T. *In the Arresting Eye: The Rhetoric of Imagism.* Baton Rouge, La.: Louisiana State University Press, 1981.

Garvin, Harry R., ed. *The Arts and Their Interrelations*. Lewisburg, Pa.: Bucknell University Press, 1979. Reprinted from *Bucknell Review* 24:2 (Fall 1978).

Gefin, Laszlo K. *Ideogram: History of a Poetic Mode*. Austin: University of Texas Press, 1982.

Gero, Stephen. "Byzantine Iconoclasm and the Failure of a Medieval Reformation." In *The Image and the Word: Confrontations in Judaism, Christianity, and Islam*, ed. Joseph Gutmann. Missoula, Montana: Scholars Press, 1977.

Gibson, James J. *The Perception of the Visual World*. Cambridge, Mass.: Riverside Press, 1950.

Gilman, Ernest. "Word and Image in Quarles' *Emblemes*." In *The Language of Images*, ed. Mitchell.

——. *The Curious Perspective: Literary and Pictorial Wit in the Seventeenth Century*. New Haven: Yale University Press, 1978.

——. *Down Went Dagon: Iconoclasm and English Literature*. Chicago: University of Chicago Press, 1985.

Giovannini, G. "Method in the Study of Literature and Its Relation to the Other Fine Arts." *Journal of Aesthetics and Art Criticism* 8 (March 1950), 185–94.

Goldstein, Harvey D. "Ut Poesis Pictura: Reynolds on Imitation and Imagination." *Eighteenth Century Studies* 1 (1967–68), 213–35.

Gombrich, Ernst. *Art and Illusion*. Princeton: Princeton University Press, 1956.

——. "Image and Code: Scope and Limits of Conventionalism in Pictorial Representation." In *Image and Code*, ed. Steiner.

Goodman, Nelson. *Languages of Art*. Indianapolis: Hackett, 1976.

Goslee, Nancy M. "From Marble to Living Form: Sculpture as Art and Analogue from the Renaissance to Blake." *Journal of English and Germanic Philology* 77 (1978), 188–211.

Graham, John. "Ut Pictura Poesis: A Bibliography." *Bulletin of Bibliography* 29 (1972), 13–15, 18.

Greenberg, Clement. "Towards a Newer Laocoon." *Partisan Review* 7 (July–August 1940), 296–310.

Guillen, Claudio. "On the Concept and Metaphor of Perspective." In *Comparatists at Work*, ed. Stephen Nichols and Richard B. Vowles. Waltham, Mass.: Blaisdell, 1968, 28–90.

Gutmann, Joseph, ed. *No Graven Images; Studies in Art and the Hebrew Bible*. New York: Ktav, 1971.

Hagstrum, Jean. *The Sister Arts*. Chicago: University of Chicago Press, 1958. For a complete bibliography of Hagstrum's writings through 1982, see Wendorf, ed., *Articulate Images*.

Hatzfeld, Helmut. "Literary Criticism through Art Criticism and Art Criticism through Literary Criticism." *Journal of Aesthetics and Art Criticism* 6 (September 1947), 1–20.

Hazlitt, William. "On the Pleasures of Painting." In *Criticism on Art*. London, 1844.

Heffernan, James A. W. "Reflections on Reflections in English Romantic Poetry and Painting." In *The Arts and Their Interrelations*, ed. Garvin.

Heitner, Robert. "Concerning Lessing's Indebtedness to Diderot." *Modern Language Notes* 65 (February 1950), 82–86.

Helsinger, Elizabeth K. *Ruskin and the Art of the Beholder*. Cambridge: Harvard University Press, 1982.

Hermeren, Goran. *Influence in Art and Literature*. Princeton: Princeton University Press, 1975.

———. *Representation and Meaning in the Visual Arts: A Study of the Methodology of Iconography and Iconology*. Lund, Sweden: Läromedels- förlagen, 1969.

Hill, Christopher. "*Eikonoklastes* and Idolatry." In *Milton and the English Revolution*. Harmondsworth: Penguin, 1977, 171–81.

Howard, William G. *Laocoon: Lessing, Herder, and Goethe*. New York: Henry Holt, 1910.

———. "Ut Pictura Poesis." *PMLA* 24 (March 1909), 40–123.

Hunt, John Dixon, ed. *Encounters: Essays on Literature and the Visual Arts*. London: Studio Vista, 1971.

Hussey, Christopher. *The Picturesque*. London: Putnam's, 1927.

Idzerda, Stanley J. "Iconoclasm During the French Revolution." *American Historical Review* 60 (1954).

"Image/Imago/Imagination." *New Literary History* 15:3 (Spring 1984).

Iverson, Erik. *The Myth of Egypt and Its Hieroglyphs in European Tradition*. Copenhagen, 1961.

Ivins, William M., Jr. *Prints and Visual Communication*. 1953; reprint, Cambridge, Mass.: MIT Press, 1969.

Jakobson, Roman. "On the Verbal Art of William Blake and Other Poet-Painters." *Linguistic Inquiry* I (1970), 3–23.

Jammer, Max. *Concepts of Space*. Cambridge: Harvard University Press, 1954.

Jensen, H. James. *The Muses Concord: Literature, Music, and the Visual Arts in the Baroque Era*. Bloomington: Indiana University Press, 1976.

Kayser, Wolfgang. *The Grotesque in Art and Literature*. Trans. Ulrich Weisstein. Bloomington: Indiana University Press, 1963.

Kehl, D. G. *Poetry and the Visual Arts*. Belmont, Calif.: Wadsworth, 1975.

Klonsky, Milton. *Speaking Pictures: A Gallery of Pictorial Poetry from the Sixteenth Century to the Present*. New York: Crown, 1975.

Kofman, Sara, *Camera Obscura de l'idéologie*. Paris: Editions Galilee, 1984.

Kosslyn, Stephen Michael. *Image and Mind*. Cambridge: Harvard University Press, 1980.

Kostelanetz, Richard. *Visual Literature Criticism*. Carbondale: Southern Illinois University Press, 1980.

Krieger, Murray. "The Ekphrastic Principle and the Still Movement of Poetry; or *Laokoon* Revisited." In *The Play and Place of Criticism*. Baltimore: Johns Hopkins University Press, 1967.

Kristeller, Paul O. "The Modern System of the Arts." *Journal of the History of Ideas* 12 (October 1951), 496–527; 13 (January 1952), 17–46.

Kroeber, Karl, and William Walling, eds. *Images of Romanticism: Verbal and Visual Affinities*. New Haven: Yale University Press, 1978.

Ladner, Gerhart B. "Ad Imaginem Dei: The Image of Man in Medieval Art." Reprinted in *Modern Perspectives in Western Art History*, ed. Eugene Kleinbauer. New York: Holt, Rinehart, & Winston, 1971.

Landow, George P. *Images of Crisis: Literary Iconology, 1750 to the Present*. Boston: Routledge and Kegan Paul, 1982.

Langer, Suzanne K. "Deceptive Analogies: Specious and Real Relationships among the Arts." In *Problems of Art*, New York: Scribner's, 1957, 75–89.

"The Language of Images." *Critical Inquiry* 6:3 (Spring 1980).

Laude, Jean. "On the Analysis of Poems and Paintings." *New Literary History* 3 (1972), 471–86.

Lee, Renselaer. "Ut Pictura Poesis." *The Art Bulletin* 23 (December 1940); reprint, New York: Norton paperback, 1967.

Lessing, Gotthold Ephraim. *Laokoon: oder über die Grenzen der Malerie und Poesie* (1766). Best modern edition, Lesing's *Werke,* ed. Herbert G. Gopfert et al. Munich: Carl Hanser, 1974. Best English translation, Ellen Frothingham, *Laocoon: An Essay upon the Limits of Poetry and Painting*. New York: Farrar, Straus and Giroux, 1969.

Lewin, Bertram. *The Image and the Past*. New York: International Universities Press, 1968.

Lindberg, David C. *Theories of Vision from Al-Kindi to Kepler*. Chicago: University of Chicago Press, 1976.

Lipking, Laurence. *The Ordering of the Arts in the Eighteenth Century*. Princeton: Princeton University Press, 1970.

"Literary and Art History." *New Literary History* 3:3 (Spring 1972).

Lyons, John, and Stephen G. Nichols, Jr., eds. *Mimesis: From Mirror to Method, Augustine to Descartes*. Dartmouth College: University Press of New England, 1982.

McLuhan, Marshall, and Harley Parker. *Through the Vanishing Point: Space in Poetry and Painting*. New York: Harper and Row, 1968.

MacNeish, June Helm, ed. *Essays on the Verbal and Visual Arts*. Seattle: University of Washington Press, 1967.

Malek, James. *The Arts Compared*. Detroit: Wayne State University Press, 1974.

Manwaring, Elizabeth. *Italian Landscape in Eighteenth Century England*. New York: Russell and Russell, 1926.

Materer, Timothy. *Vortex: Pound, Eliot, and Lewis*. Ithaca, N.Y.: Cornell University Press, 1979.

Matthiessen, F. O. "James and the Plastic Arts." *Kenyon Review* 5 (1943), 533–50.

Mitchell, W. J. T. *Blake's Composite Art*. Princeton: Princeton University Press, 1978.

———, ed. *The Language of Images*. Chicago: University of Chicago Press, 1980.

———. "Spatial Form in Literature: Toward a General Theory." *Critical Inquiry* 6:3 (Spring 1980). Reprinted in *The Language of Images*.

———, "Metamorphoses of the Vortex: Hogarth, Blake, and Turner." In *Articulate Images*, ed. Wendorf.

———. "Visible Language: Blake's Wond'rous Art of Writing." In *Romanticism and Contemporary Criticism*, ed. Morris Eaves and Michael Fischer. Ithaca, N.Y.: Cornell University Press, 1986.

Munro, Thomas. *The Arts and Their Interrelations*. Cleveland: Western Reserve University Press, 1967.

Nelson, Cary. *The Incarnate Word*. Urbana: University of Illinois Press, 1974.

Nemerov, Howard. "On Poetry and Painting, with a Thought of Music." In *The Language of Images*, ed. Mitchell, 9–13.

Nichols, Bill. *Ideology and the Image: Social Representation in the Cinema and Other Media*. Bloomington: Indiana University Press, 1981.

Panofsky, Erwin. *Studies in Iconology*. Oxford: Oxford University Press, 1939.

———. "Iconography and Iconology: An Introduction to the Study of Renaissance Art." In *Meaning in the Visual Arts*. Garden City, N.Y.: Doubleday, 1955.

Paris, Jean. *Painting and Linguistics*. Pittsburgh: Carnegie-Mellon University Publication, 1974.

Park, Roy. "*Ut Pictura Poesis:* The Nineteenth Century Aftermath." *Journal of Aesthetics and Art Criticism* 28 (Winter 1969), 155–69.

Paulson, Ronald. *Emblem and Expression: Meaning in English Art of the Eighteenth Century*. Cambridge: Harvard University Press, 1975.

Peirce, C. S. "The Icon, Index, and Symbol." In *Collected Works,* ed. Charles Hartshorne and Paul Weiss, 8 vols. Cambridge: Harvard University Press, 1931–58, vol. 2.

Pelikan, Jaroslav. "Images of the Invisible." In *The Christian Tradition,* 5 vols. Chicago: University of Chicago Press, 1974–, 2: 91–145. A survey of the iconoclastic controversy.

Phillips, John. *The Reformation of Images: Destruction of Art in England, 1535–1660*. Berkeley: University of California Press, 1973.

Pointon, Marcia. *Milton and English Art*. Toronto: University of Toronto Press, 1970.

Praz, Mario. *Mnemosyne: The Parallel between Literature and the Visual Arts*. Princeton: Princeton University Press, 1970.

Read, Herbert. "Parallels in Painting and Poetry." In *In Defence of Shelley & Other Essays*. London: Heinemann, 1936, 223–48.

Rollin, Bernard. *Natural and Conventional Meaning*. The Hague: Mouton, 1976.

Ronchi. Vasco. *The Nature of Light*. Trans. V. Barocas. Cambridge: Harvard University Press, 1970.

———. *Optics: The Science of Vision*. Trans. Edward Rosen. New York: New York University Press, 1957.

Rorty, Richard. *Philosophy and the Mirror of Nature*. Princeton: Princeton University Press, 1979.

Rosand, David. "*Ut Pictor Poeta:* Meaning in Titian's [Poesie]." *New Literary History* 3:3 (Spring 1972), 527–46.

Rowe, John Carlos. "James's Rhetoric of the Eye: Re-Marking the Impression." *Criticism* 24:3 (Summer 1982), 2233–60.

Saisselin, Remy G. "*Ut Pictura Poesis:* Dubos to Diderot," *Journal of Aesthetics and Art Criticism* 20 (1961), 145–56.

Sartre, Jean-Paul. *Imagination: A Psychological Critique.* Ann Arbor: University of Michigan Press, 1962.

Schapiro, Meyer. *Words and Pictures: On the Literal and the Symbolic in the Illustration of a Text.* The Hague: Mouton, 1973.

Scher, Stephen P. "Bibliography on the Relations of Literature and the Other Arts." Published annually in *Hartford Studies in Literature.*

Schweizer, Niklaus. *The Ut Pictura Poesis Controversy in Eighteenth Century England and Germany.* Frankfurt: Herbert Lang, 1972.

Simpson, David. *Fetishism and Imagination: Dickens, Melville, Conrad.* Baltimore: Johns Hopkins University Press, 1982

Smitten, Jeffrey, and Ann Daghistany. *Spatial Form in Narrative,* Ithaca, N.Y.: Cornell University Press, 1981.

Snyder, Joel. "Picturing Vision." *Critical Inquiry* 6:3 (Spring 1980). Reprinted in *The Language of Images,* ed. Mitchell.

———, and Neil Walsh Allen. "Photography, Vision, and Representation." *Critical Inquiry* 2:1 (Autumn 1975), 143–69.

Souriau, Etienne. "Time in the Plastic Arts." *Journal of Aesthetics and Art Criticism* 7 (1949), 294–307.

Spencer, John R. "Ut Rhetorica Pictura: A Study in Quattrocento Theory of Painting." *Journal of the Warburg and Courtauld Institutes* 20 (1957), 26–44.

Spencer, T. J. B. "The Imperfect Parallel Betwixt Painting and Poetry." *Greece and Rome,* 2d ser., 7 (1960), 173–86.

Spurgeon, Caroline. *Shakespeare's Imagery and What It Tell Us.* Cambridge: Cambridge University Press, 1935.

Steiner, Wendy. *The Colors of Rhetoric.* Chicago: University of Chicago Press, 1982.

———, ed. *Image and Code.* Ann Arbor: University of Michigan Press, 1981.

Stevens, Wallace. "The Relations between Poetry and Painting." In *The Necessary Angel.* New York: Knopf, 1951, 157–76.

Sypher, Wylie. *Four Stages of Renaissance Style.* Garden City, N.Y.: Doubleday, 1955.

Tinker, Chauncey Brewster. *Painter and Poet: Studies in the Literary Relations of English Painting.* 1938; reprint, Freeport, N.Y.: Books for Libraries Press, 1969.

Trimpi, Wesley. "The Meaning of Horace's *Ut Pictura Poesis.*" *Journal of the Warburg and Courtauld Institutes* 36 (1973), 1–34.

Uspensky, B. A. "Structural Isomorphism of Verbal and Visual Art." *Poetics: International Review for the the Theory of Literature.* The Hague: Mouton, 1972, 5–39.

Warnock, Mary. *Imagination.* Berkeley: University of California Press, 1976.

Wecter, Dixon. "Burke's Theory Concerning Words, Images, and Emotion." *PMLA* 55 (1940), 167–81.

Weisinger, Herbert. "Icon and Image: What the Literary Historian Can Learn from the Warburg School." *Bulletin of the New York Public Library* 67 (1963), 455–64.

Weisstein, Ulrich. "The Mutual Illumination of the Arts." In *Comparative Literature and Literary Theory,* trans. William Riggan. Bloomington: Indiana University Press, 1973, 150–66.

Wellek, René. "The Parallelism between Literature and the Arts." *English Institute Annual, 1941.* New York, 1942.

Wendorf, Richard. "Jonathan Richardson: The Painter as Biographer." *New Literary History* 15:3 (Spring 1984), 539–57.

———, ed. *Articulate Images: The Sister Arts from Hogarth to Tennyson.* Minneapolis: University of Minnesota Press, 1983.

White, John. *The Birth and Rebirth of Pictorial Space.* New York: Harper and Row, 1967.

Wimsatt, William K. "Laokoon: An Oracle Reconsulted." In *Hateful Contraries.* Lexington: University of Kentucky Press, 1965.

Wittgenstein, Ludwig. *Tractatus Logico-Philosophicus* (1921). Trans. D. G. Pears and B. F. McGuinness. London: Routledge & Kegan Paul, 1961.

———. *The Blue and Brown Books.* (New York: Harper, 1958.

———. *Philosophical Investigations.* 3d ed. Trans. G. E. M. Anscombe. New York: Macmillan, 1953.

Wolfe, Tom. *The Painted Word.* New York: Farrar, Straus & Giroux, 1975.

Yates, Frances. *The Art of Memory.* Chicago: University of Chicago Press, 1966.

Ziolkowski, Theodore. *Disenchanted Images: A Literary Iconology.* Princeton: Princeton University Press, 1977.

Index